Diego Rivera

MY ART, MY LIFE

AN AUTOBIOGRAPHY
(WITH GLADYS MARCH)

DOVER PUBLICATIONS, INC.
New York

IN GRATITUDE

to DIEGO
whose dynamic companionship
was an illumination in my youth;

and to ALFRED
my patient, dearly beloved hus-
band, who helped to sustain and
enrich its radiance

—G. M.

This Dover edition, first published in 1991, is an unabridged
republication of the edition originally published by The Citadel
Press, New York, in 1960. The entire text has been typograph-
ically reset with corrections and with many Spanish accents
added. The list of illustrations is a new feature of the present
edition.

Manufactured in the United States of America
Dover Publications, Inc., 31 East 2nd Street, Mineola, N.Y.
11501

Library of Congress Cataloging-in-Publication Data

Rivera, Diego, 1886–1957.
　　My art, my life : an autobiography / Diego Rivera with
Gladys March.
　　　　p.　　cm.
　　Reprint. Originally published: New York : Citadel Press,
1960.
　　Includes index.
　　ISBN 0-486-26938-8 (pbk.)
　　1. Rivera, Diego, 1886–1957.　2. Painters—Mexico—Bi-
ography.　I. Title.
ND259.R5A2　1991
759.972—dc20
　[B]　　　　　　　　　　　　　　　　　　　　91-22815
　　　　　　　　　　　　　　　　　　　　　　　CIP

Contents

Illustrations

Following page 66

Rivera's archeological museum

Rivera's four wives

With his assistants in the Hospital de la Raza

A self-portrait

With Frida Kahlo

With Siqueiros and Emma Hurtado

Rivera outside his birthplace

Newspaper photos of the Rockefeller Center
 affair. The reconstructed mural

"Water, Origin of Life"

Mural in the Hospital de la Raza

"Sunday Dream"

Mural on the Teatro de los Insurgentes

Edsel Ford. A satirical cubist portrait

Mural in the National Palace

Mural in the Cortés Palace

Peace mural

Foreword

GENETICALLY, THIS BOOK BEGAN as a newspaper interview which Rivera granted me in the spring of 1944. But it did not begin to assume the proportions of a book—even in my mind—until the following year, when we first discussed my writing it. I spent six months with Rivera in 1945, working hard at what he would call "the preliminary sketch." In the years that followed, usually summers, I would go down to Mexico for a month or two to review and supplement my notes and to find out what "news" had occurred since my previous visit. Diego Rivera's was an active and many-sided personality: his mind was quick, his imagination staggering; so there was always much to be added. The interviews which began in 1944 ended in 1957 because my notes, now bulking over two thousand pages, suggested that I might now have all I needed.

From the outset, Rivera framed much of his dialogue in the form of short personal narratives, and these narratives compose the skeleton as well as much of the meat of this book. But a good deal of his talk, too, consisted of anecdotes, unguarded remarks, and opinions on art, people, and politics, which I later interpolated in their proper places in the story.

Fortunately for me, Rivera seemed to be flattered by the continual attentions of a young American woman. I literally walked in his shadow, and he let me go with him everywhere as he spun his tales. Most of our dictating sessions took place while Rivera was engaged in painting, at his studio. But conversations ran over into mealtimes, and I made notes in his car en route to lectures or parties, in his home, and on walks. I met his wives, his daughters, his friends—many of the people who appear in this book.

In collating my notes, I found that much that Rivera had said orally could stand up as writing, or could not be changed without some loss, call it the flavor of his personality. Of course, nobody's dialogue is consistently good, but wherever I pared phrases, unwound sentences, or lopped off tautologies and digressions, I en-

deavored to remain faithful to Rivera's style. Essentially, this is Rivera's own story, told in his words. As such, it may not always coincide with what other people might call "the facts." Élie Faure was one of the first to recognize a dominant quality of the artist's mind: "Mythologer, I said to myself, perhaps even *mythomaniac!*"

Rivera, who was afterwards, in his work, to transform the history of Mexico into one of the great myths of our century, could not, in recalling his own life to me, suppress his colossal fancy. He had already converted certain events, particularly of his early years, into legends. Both Bertram D. Wolfe and Ernestine Evans, who wrote books about him, grappled with this problem. And the reader will react to it according to his purposes as he encounters it here. My task, however, was to be neither judge nor censor. An autobiography must encompass the whole man: what he has made of the facts, as well as the facts themselves.

In addition to recording and organizing Rivera's dictation, and making grammatical and literary changes in the text, I added—always with his approval—material from previously published books, articles, and interviews to fill in such gaps as inevitably appeared. For this reason, however, no claim can be laid to completeness or definitiveness. There were aspects of his life which Rivera did not care to recall, and as his amanuensis, I could only respect his reticence.

The artist's account of his relations with Leon Trotsky, for instance, all but conceals a genuine attraction he felt toward Trotsky's Fourth International. But when I met Rivera, in 1944, he was seeking readmittance into the Communist Party. For this reason, also, his description of his journey to Russia in 1927 omits much that he had earlier confided to his biographer, Bertram D. Wolfe, particularly of his skirmishes with Soviet bureaucrats, artists, and art theorists.

But a man's life is his own, and his summation of it is his own, too. As I go over this book for the last time in manuscript, I think that it is one of the frankest confessions I have ever read. If Rivera now spares the Soviets, he does not spare himself; he certainly does not spare his enemies. And the breadth of his sympathies, the vitality and love for life which runs through his prose as it does through his paintings—who can allow these qualities to a mere factional man?

Essentially, then, this is Rivera's apologia: a self-portrait of a complex and controversial personality, and a key to the work of perhaps the greatest artist the Americas have yet produced.

As I was preparing the final pages of manuscript, I received the news that Diego Rivera had died on November 25, 1957, in his home in San Ángel.

In contrast with so much of his life, marked by the furor of partisan controversy, his death came peacefully.

Up until several weeks before the end, Rivera had been at work, painting with the vigor which had characterized his work for more than half a century. An attack of phlebitis paralyzed his right arm and he was put to bed. A heart specialist, a friend of the family, observed a steady deterioration in his condition.

At 11:30 on the night of November 25th, he rang the bell beside his adjustable hospital-type bed.

His wife, Emma Hurtado, came into the room. "Shall I raise the bed?" she asked.

He replied, "On the contrary, please lower it."

These were his last words.

Dressed in a blue suit and tie and a red shirt, and sheathed in a casket of brown steel, the remains of Diego Rivera were lowered into the earth of the Rotunda of Mexico's Illustrious Sons, Dolores Cemetery. In the same hallowed ground lie the bones of Benito Juárez, Mexico's greatest hero.

GEOGRAPHICAL, GENEALOGICAL

 THE MOUNTAINS OF GUANAJUATO rise seven thousand feet into the clear Mexican air. At their base is a bowl-shaped hollow which, even a small way up the slopes, appears to be strewn with tiles of many colors. The mountains are rugged and lowering, but they hold rich veins of silver. In the year 1550, a mule driver named Juan Rayas discovered the first of Guanajuato's silver mines. Four years later a group of Spaniards settled in a curve of the bowl and thus founded the town. From that time to this, the people of Guanajuato have taken silver from the rocks.

The town is in central Mexico; its houses are flat-roofed, the windows are shadowed and deep, and there is a somnolent air about the afternoons. Even in my childhood the silver-rush days were already only a memory, for most of the veins near the surface of the ground had been emptied. It was other places in Mexico that were luring the fortune hunters and adventurers.

The house of my parents, Diego and María Barrientos Rivera, was located at 80 Pocitos Street, in the heart of Guanajuato. It was like a small marble palace in which the queen, my mother, was also diminutive, almost childlike, with large innocent eyes—but adult in her extreme nervousness.

There was mixed blood on both sides of my family. My maternal grandmother, Némesis Rodríguez Valpuesta, was of an Indian and Spanish mixture. The family of my maternal grandfather, Juan Barrientos, a mine operator, had come from the port of Alvarado, celebrated all over Mexico for its excellent fish, its opulent fruit, and the gaiety and vigor of its Negroid people. It is not unreasonable, therefore, to suppose that my mother passed on to me the traits of three races: white, red, and black.

My father's mother, Grandmother Ynez Acosta, was descended from a Portuguese-Jewish family which traced its ancestry to the rationalist philosopher Uriel Acosta. At fifteen she had married my paternal grandfather, Don Anastasio de Rivera. Don Anastasio

1

was then sixty, a veteran officer of the Spanish army, and the son of an Italian who had also served as an officer in the military forces of Spain. While still in the Spanish army, my paternal great-grandfather had been sent on a diplomatic mission to Russia at the end of the eighteenth century. There my grandfather had been born. No one in Spain knew who my grandfather's mother had been. As my grandfather told my father, many could present themselves as the son of an unknown father, but only he, Don Anastasio, enjoyed the distinction of being the son of an unknown mother. The explanation was that my Italian great-grandfather had married in Russia, his wife died in childbirth, and he brought his son back with him to Spain. It was through Don Anastasio that I could claim the title to Spanish nobility which I afterwards transferred to a relative.

Don Anastasio did not marry till after he had come to Mexico, and at an age when most men are considered old. He was, however, a man of fabulous vigor. At sixty-five he joined Juárez in the war against the French and the Church. When he settled down again, he quickly amassed a large fortune. To his wife, he presented a brood of nine children. He was seventy-two when a twenty-year-old girl, jealous of the attention he still bestowed on my grandmother, gave him poison to drink, and so he died.

Through the long years that followed, in which my Grandmother Ynez raised and supported her children, she never forgot my grandfather, Don Anastasio, with whom she continued to be madly in love. She would tell us that no young man of twenty could have served her as a lover better than he had.

Hearing this over and over again from my grandmother, my naturally fearful mother came to suspect that my father had inherited this terrible virility. And not without reason. My father was a powerfully built man, tall, black-bearded, handsome, and charming. He was fifteen years her senior, but in speaking of his age, my mother would give him additional years in the hope of making him seem less attractive to other women.

TALE OF A GOAT AND A MOUSE

 To these parents, a twin brother and I were born on the night of December 8, 1886. I, the older, was named Diego after my father, and my brother, arriving a few minutes later, was named Carlos. My whole name actually is Diego María de la Concepción Juan Nepomuceno Estanislao de la Rivera y Barrientos Acosta y Rodríguez.

The coming of Carlos and me brought great joy to my parents. At twenty-two, my mother had already had four pregnancies, of which the first three had ended in stillbirths. After each child was born dead, my father had gone out and bought my mother a doll to console her. Now he did not buy a doll but cried with delight.

However, when he was only a year and a half, my twin brother Carlos died. My mother developed a terrible neurosis, installed herself beside his tomb, and refused to leave. My father, then a municipal councillor, was obliged to rent a room in the home of the caretaker of the cemetery in order to be with her at night. The doctor warned my father that, unless my mother's mind was distracted by some kind of work, she would become a lunatic.

The family explained her case to my mother and urged her to study for a career. She agreed, chose obstetrics, and began her studies at once. To everyone's delight, the cure succeeded. My mother's melancholia passed. In school, she proved to be a brilliant student and received her diploma in half the regular time.

At two years old, according to photographs and the tales of my father and mother, I was thin and had rickets. My health was so poor that the doctor advised that I be sent to the country to live a healthy, outdoor life, lest I die like my brother.

For this reason, my father gave me to Antonia, my Indian nurse. Antonia, whom I have since loved more than my own mother, took me to live with her in the mountains of Sierra.

I can still recall Antonia vividly. A tall, quiet woman in her middle twenties, she had wonderful shoulders, and walked with elegant erectness on magnificently sculptured legs, her head held high as if balancing a load. Visually she was an artist's ideal of the classic Indian woman, and I have painted her many times from memory in her long red robe and blue shawl.

3

Antonia's house was a primitive shack in the middle of a wood. Here she practiced medicine with herbs and magic rites, for she was something of a witch doctor. She gave me complete freedom to roam in the forest. For my nourishment, she bought me a female goat, big, clean, and beautiful, so that I would have milk fresh from its udders.

From sunrise to sunset, I was in the forest, sometimes far from the house, with my goat who watched me as a mother does a child. All the animals in the forest became my friends, even dangerous and poisonous ones. Thanks to my goat-mother and my Indian nurse, I have always enjoyed the trust of animals—a precious gift. I still love animals infinitely more than human beings.

I had left my home for Antonia's when I was two years old, and I returned when I was four. Now I was no longer scrawny, but robust and fat. But my body was out of proportion in two respects: my feet were too small for my legs, and my forehead was too high and wide for my face. However, my two years with Antonia had saved me from any early deformation of the mind; until then I had been growing up as the animals, free from human dirt. Many years later, I wondered whether my father had not planned it so, that I might escape the prejudices and lies of adults.

Not long after my return from the mountains, I had my first encounter with adult duplicity. I was five. My mother was pregnant, and she wanted to fool me about the approaching birth. She told me the child would be delivered to her in a box which the train was carrying from afar. That day I waited at the depot and watched all the trains, but no box arrived for my mother. I was furious when I returned home and found that my sister María had been born during my absence.

In angry frustration, I caught a pregnant mouse and opened her belly with a pair of scissors. I wanted to see whether there were small mice inside her. When I found the mouse foetuses, I stomped into my mother's room and threw them directly in her face, screaming, "You liar—liar." My mother became hysterical. She cried out that in giving birth to me she had whelped a monster. My father also scolded me. He told me of the pain I had caused the mouse in cutting her up alive. He asked if my curiosity was so strong that I could be indifferent to the sufferings of other creatures. To this day, I can recall the intensity of my reaction. I felt low, unworthy, cruel, as if I were dominated by an invisible evil force. My father even started to console me.

From that time on, I developed a keen desire to know about the origins of life. I began to teach myself to read, asking everyone I could, night and day, to help me learn the letters of the alphabet.

Later, when I could make out a few words, I practiced reading my mother's obstetrics books and any other books I could borrow from our doctor.

THE THREE OLD GENTLEMEN
WELCOME THE NEW ICONOCLAST

 BESIDES MY MOTHER AND FATHER, my sister and myself, two female relations of my mother lived in the house on Pocitos Street. These two boarders, my Aunt Cesaria and my great-aunt Vicenta, were very religious. My father, who was a liberal and anticlerical, had worked out a truce with them. He did not interfere with their observances and even permitted them to display the religious pictures and images which figure so much in Catholic worship. Around my soul, however, he drew a line; that was off limits to the pious ones. Until I was six years old, I had never been inside a house of worship.

One day, without my father's knowledge, my great-aunt Vicenta risked taking me to the Church of San Diego. She thought I should pray to the Virgin Mary there for my mother's success in her diploma examinations which she was taking that morning.

On entering the Church, my revulsion was so great that I still get a sick feeling in my stomach when I recall it. I remember examining the wooden boxes with their slots on top for the coins, then the man at the door in his long, dirty smock, collecting more money in a tin plate. There were paintings all around of women and men sitting or walking on clouds with little winged boys flying above them.

In my own house, I had inspected my aunts' images of the Virgin Mary and Jesus Christ. I had scratched them and discovered that they were made of wood. I had put sticks into their glass eyes and through their ears to discover whether they could see, hear, or feel anything—always, of course, with negative results.

In the church, my great-aunt Vicenta took her place among the crowd of old men and women, some of whom were kneeling. She whispered to me to beg the Virgin of Guanajuato to help my mother. I had a funny feeling then which I remember vividly. It was a mixture of indignation and an impulse to laugh at the people around me. I did not laugh, but I gave vent to my feelings by scornfully

calling them idiots. My poor aunt and some other old ladies who had heard me tried to explain to me that they were not idiots, that I was only a boy and did not understand such things. My aunt had to be cautious with me because our visit to the church was a secret from my father who had forbidden my ever being taken there.

I said nothing more for the moment but sat quietly, looking at everything around me. I observed the carving on the altar and the images of the Virgin Mary and Jesus, pictured as they were supposed to appear in heaven. Suddenly rage possessed me, and I ran from my aunt and climbed up the steps of the altar. Then at the top of my voice, I began to address the astonished worshipers. I remember the words because each one had a strange sound, each one left a burning imprint in my head.

"Stupid people! You reek of dirt and stupidity! You are so crazy that you believe that if I were to ask the portrait of my father, hanging in my house, for one peso, the portrait would actually give me one peso. You are utter idiots. In order to get pesos, I have to ask someone who has pesos to spare and is willing to give some to me.

"You talk of heaven, pointing with your fingers over your head. What heaven is there? There is only air, clouds which give rain, lightning which makes a loud sound and breaks the tree branches, and birds flying. There are no boys with wings nor any ladies or gentlemen sitting on clouds.

"Clouds are water vapor which goes up when the heat of the sun's rays strikes the rivers and lakes. You can see this vapor from the Guanajuato mountains. It turns to water which falls in drops, and so we have rain.

"At the entrance to this place, I saw boxes to collect money, and a man asking for more money. I also know the priest who comes often to our house to drink my aunt's good chocolate and glasses of liquor. With the money he collects for the church, he pays the painters and sculptors to paint all these lies and puppets. He does this to get more money to make stupid people like you believe that these are truths and to make you fear the Virgin Mary and God.

"In order to have the priest appease these idols to spare you because you are cruel, dirty, and bad people, you give this money to the priest. Does that fear stop the beggars, the poor people, and the jobless miners from sneaking into the houses of the rich people, the grocery stores, the clothing stores of the *gabachos*, and the *haciendas* of the *gringos*, and taking from them a little of what they need?"

At this point some terrified ladies began to scream. They made the sign of the cross in my direction, shouting, "This child is Satan! Satan has appeared in this child!"

The man with the long smock came over to me with a big brass cup full of water which he threw over me, all the while making the

sign of the cross. By now my fury had passed, and I was full of mischievous fun. No longer preaching, I began taunting the worshipers with the worst insults and profanities I had learned up to that time.

Suddenly the priest came out, dressed in an impressive robe crusted over with gold embroidery. In his left hand, he held a big book from which he read loudly while looking at me foolishly. I retreated to the small altar at the right, calculating eventually to take a candlestick and throw it at him.

With my back to the wall so that I could not be attacked from the rear and with my hands clenched, I faced the priest. "What about you, you old fool?" I said. "If there really is a Holy Virgin or anyone up in the air, tell them to send lightning to strike me down or let the stones of the vault fall on my head. If you are unable to do that, Mr. Priest, you're nothing but a puppet taking money from stupid old women. You're no better than the clown in the circus coaxing coins from the public. If God doesn't stop me, then there must be no God."

The priest read on more loudly than before, making funny signs in the air. Nothing happened. The atmosphere was so charged with hatred against me that I looked up to the dome to see if stones were really starting to fall.

Then I took two steps toward the priest and shouted, "You see that your God, your Virgin, and your saints mean no more to me than your old book and your signs." Then I grabbed the candlestick in my hands.

"Get out of here!" I shouted.

Whether he was trying to prevent a scandal or simply didn't know how to cope with a boy like me, I can't tell; but the priest closed his book, covered his head, and ran out. At that moment, I wouldn't have changed places with anyone in the world. I took the center of the altar and, gesticulating with my fists, I shouted, "You see, there is no God! You're all stupid cows!"

Many rough-looking men had joined the old people, but when I said, "There is no God," they put their hands over their eyes and ears and ran away. They pushed each other in their panic to get out of the church, crying as they ran, "The devil is here!"

My great-aunt, melting in tears, gathered me in her arms to carry me out of the profaned church of San Diego. When we reached the street, I expected to be pelted with stones, but the people were too busy shutting their windows and doors against the devil. The streets were as empty as if a herd of wild bulls had stampeded into town.

My great-aunt ran with me through the streets and up into the mountains. She didn't bring me home until late in the afternoon.

When we returned, a crowd of doctors and fellow students were dancing in the street with my successful, pretty mother. They were celebrating my mother's passing her examinations.

If that morning I came to know the feeling of triumph, I learned the nature of jealousy that afternoon. No one paid me any attention.

That night, however, as I was blowing out the candles before going to bed, three old gentlemen called at my house. They wore top hats and black riding boots and behaved in a very formal manner. Stiffly they requested an audience with Don Diego de Rivera.

My mother, supposing that they had come to see my father about fighting a duel, paled as she called him. But my father, who never avoided a fight or an adventure, came out immediately. On seeing them, he pretended not to know them, though actually they were friends of his. One of the gentlemen asked if they could speak with his son, Diego. Hearing my name, I came forward saying, "At your command, sirs."

My visitors took off their hats, and the eldest, looking stately in his big white mustache, made me this speech:

"We come to you here, in the name and as representatives of the eleven freedom veterans in Guanajuato. We men are liberals, veterans of the wars against invaders, and fighters for reform and liberty. Our brotherhood keeps up the fight for freedom and the rights of men. After today we consider you our younger brother, and we have come to invite you publicly to join our group. We sit every day in the Union Garden at the time of the evening *paseo*. No fanatic, conservative, or Catholic would dare sit with us without fearing to be condemned to hell. Therefore, we never suffer intrusion.

"We veterans have fought with arms, thoughts, writings, and speeches against clericalism. You are a legitimate son of our brotherhood and as much our brother as is your father. Both he and your grandfather have been distinguished members of our order. No wonder you have performed such a feat at the outset of your life—a feat superior to any of ours. Not one of us has ever used the freedom of speech and thought inside of the house of religion itself! We congratulate you, young wolf. Will you shake hands and join us?"

With great pride, I shook each man's hand. I felt so full of new learning and vanity that I left home with them that evening, without asking my parents' permission. From then on, I was permitted to sit with them whenever I chose, on their special benches in the park. And these graybeards of between fifty and eighty talked to me as if I were their peer, although much of their conversation was beyond me.

My Three Ambitions

 At the age of six, I had three ambitions.

The first was to be an engineer. Everyone in Guanajuato, in fact, already called me "the engineer" because I loved mechanical toys. I would also go out to the railroad depot to watch the trains come in and depart. After a while, I made friends with some of the railroad workers, and they would take me for short rides in the cab, even allowing me to hold the throttle and blow the whistle. I would return home from these journeys filled with excitement and wild plans for the future.

My second ambition was to become the lover of a beautiful girl named Virginia Mena.

My third ambition was to be accepted by a group of local women whom I adored. These women were prostitutes who served the Guanajuato miners. The miners paid them in gold and silver which they spent on fantastically gorgeous clothes. Many times they got into murderous fights which left them scarred from their ears to the corners of their mouths.

My first two ambitions were never realized. But to my dying day I shall never forget those whores. I became their pet and they my love.

I Begin to Draw

 As far back as I can remember, I was drawing. Almost as soon as my fat baby fingers could grasp a pencil, I was marking up walls, doors, and furniture. To avoid mutilation of his entire house, my father set aside a special room where I was allowed to write on anything I wished. This first "studio" of mine had black canvas draped on all the walls and on the floor. Here I made my earliest "murals."

9

I still have a drawing that my mother preserved from the time I was two years old. It represents a locomotive with a caboose, going uphill.

My favorite subjects in childhood were machines—especially trains, locomotives, and train crashes. Then came battles, besieged trains falling from bridges, and occasionally mountains, with the mines showing inside them.

WE MOVE TO MEXICO CITY

 FROM THE AGE OF THIRTEEN, when he enlisted in the war against the French invaders, my father had dedicated his life to freedom and progress. He fought against the French for seven years; at twenty, he returned to Guanajuato with the rank of major. Feeling now that education was the great need of the country, he left the army to become a teacher, then an inspector of the rural schools of the state. During his inspection tours, he saw the misery and ignorance in which the people lived. He became deeply moved and was seized with a burning zeal for reform. Never a man to hold his tongue, he gave vent to his feelings in a journal he edited called *The Democrat*. In impassioned articles, he took the side of the oppressed—the miners and the peasants. As a result, he incurred the enmity of fellow officials.

This enmity extended to the other members of my family; my performance in the Church of San Diego had already given us a bad name in the town. We were subjected to petty persecutions. My mother was frightened by frequent street riots and demonstrations. One day she fell into a panic, sold everything except a few personal belongings, and went off with my sister and me to Mexico City. I was not quite seven at the time.

When my father returned home from an inspection tour, he was somewhat taken aback. However, he soon learned from neighbors where we had gone, and he followed us willingly. He had recently lost money in unlucky mining speculations, and a change of scene must not have appeared unattractive. But the home we found was a poor one in a poor neighborhood. My father had to take a small clerkship in the Department of Public Health. My mother set up as a midwife, but it was some time before she was able to build up a practice.

As for myself, our poverty diet undermined my resistance, and I came down first with scarlet fever and then with typhoid. Then my mother became pregnant again and was sick much of the time. The new baby, a boy named Alfonso, lived no more than a week.

Schools

 In the third year our lot improved, and we moved into a better neighborhood in the northern part of the city, close to where the Monument of the Revolution stands. Nearby was an immense open area which, with the district of San Rafael, comprised the *ejido* of Mexico City—that is, the communal land of the Indian population. It was an ideal playground and here, with other children, I romped and went fishing in the canals.

At eight, I entered my first school, the Colegio del Padre Antonio. This clerical school was the choice of my mother, who had fallen under the influence of her pious sister and aunt. Except for a French teacher named Ledoyen, a former officer of the French army and a communist, there was nobody and nothing in the school that I liked, and I left it after a few months.

I was next sent to another clerical school, the Liceo Católico Hispano, conducted by an intelligent priest, Father Servine. Here I was given good food as well as free instruction, books, various working tools, and other things. I was put in the third grade, but having been prepared well by my father, I was soon skipped to the sixth grade.

My First Experience of Love

Of great importance to me at this period was my first experience of sexual love. My mistress was a young American teacher at the Protestant school. She was eighteen years old and as beautiful and sensitive a creature as any I have known. Though I was only nine, I was already virile. It excited her to discover in me an unsuspected, deep-rooted masochism, and she would thrill me by reciting stories about the holy martyrs. With her, I came to manhood suddenly and completely and was spared the torment of solitary yearning which is the usual lot of a growing boy.

She gave me her voluptuous body, the summit of earthly delight. And she prepared me for the arms of my second mistress, a generous Negroid girl, wife of an engineer on the Mexican Central Railroad. When her husband was away, I joined this lass in a nearby pasture. I was then twelve or thirteen and already a student in the San Carlos School of Fine Arts.

The Beginning and End of a Military Career

I was eleven when I entered the School of Fine Arts. The year before, I had done very little drawing. Between my first and second loves, I concentrated all my energies in making sketches of fortifications and plans of battle. I also drew up campaigns of military conquest and programs of government. I put myself in command of five thousand Russian troops, which I fabricated by gluing drawings of soldiers on cardboard in such a way that the little figures stood erect. I was not only the commander of this Russian army but of all Russia, the Tsar, his generals and ministers, and even the revolutionaries. I helped other boys I played with make similar armies of allies and enemies.

Carlos Macías, my cousin, now an engineer with the General Electric Company, was France, my ally. Manuel Macías, today a successful lawyer whose clients include all the old-regime Mexican families, was England. Auria Manon, the rich landlord's son, was Spain. Juan Macías was Germany. And Porfirio Aguirre, world-famous archeologist and authority on American culture, was Mexico.

When my father discovered the charts and programs I had drawn up, he seemed much impressed but said nothing. One evening, however, he came home apparently excited, and holding up a pile of my documents in his hands, he demanded to know where I had copied them from. I flew into a rage, and for the first and only time in my life, I insulted my father. Instead of becoming enraged, however, my father merely smiled.

Calming down, I asked him, "Why do you think I'm such a fool that I have to copy from anybody?"

My tone convinced him that the documents were original, and he told me to come with him. As I walked beside him into the street, I thought he was taking me to the dormitory of some school. I assumed that he disapproved of my preoccupation with military affairs, for which I had neglected my studies. But I was mistaken. The place he led me to was no school but an impressive, large building before which a soldier in full uniform was standing. In the room we entered were several fierce-looking, gray-haired men sitting behind a large table.

My father introduced me to them. "This is Diego de Rivera, my son. He is the author of the military and political documents you have examined, gentlemen."

The oldest of the men stood up. My father then said to me, "You have the honor to stand before General Don Pedro Hinojoso, Minister of War of the Republic of Mexico. All the other gentlemen are also heroes of Mexico, veterans of the wars of liberation against invaders and traitors."

One by one, each of the old men formally introduced himself. I felt the same thrill of pride I had felt when I had been invited to join the veteran fighters of Guanajuato. Having had military instruction in school where I had been appointed a group leader, I made the correct military response and stood at attention.

General Hinojoso said, "Can you give your word of honor, as the son of a veteran fighter and comrade-in-arms, that these documents originated with you?"

"My general," I replied, "I give you my word of honor that all these drawings and writings are completely mine."

Hearing this, all the men rose and General Hinojoso left his seat, came to where I was standing and embraced me.

"My son," he said, "I greet you as the youngest soldier of the Mexican Army."

I was ashamed to feel a certain liquid forming in my eyes, but I saw the same thing happening in the eyes of the general, my father, and the others. I don't know whether it was I who suddenly became mature that night or whether all men, even generals, are really boys behind their adult masks.

Then my documents were spread out upon the table, and the generals began examining them and asking me questions. How much was actual enthusiasm on their part and how much was the product of the cognac I saw on the table I cannot say, but they began to shower me with praise.

However, one very severe-looking man said, "My boy, you obviously have a native genius for strategy. But even more important is a knowledge of the organization of an army. Do you know anything about that?"

There was a large blackboard standing against the wall. In response, I walked over to it. "General," I said, "do me the honor of asking me whatever questions you wish on that subject. I will answer as well as I can."

Questions rained on me, my father joining in the examination. When the grilling was over, I could see that all doubts had disappeared.

Then General Hinojoso banged on the table. "Damn it, Diego," he shouted, "you're a born soldier. But that, my boy, places a great responsibility upon you. I hope, before you get too old and useless, you'll realize what a military fighter can do, not only for the liberty of Mexico but also for the liberty of all the people of the world. Damn it, boy, you were born in my home town, and now you must consider yourself one of my friends. You must know what being revolutionary means. After all, your father and your grandfather were revolutionaries. Don't fail, boy! A man may have the talent to make war, but he has the right to use it only for the freedom of mankind."

Then the old soldier coughed, stood up, gave the military salute, and left the room.

All next day I ran around to assure myself of the army commission I felt entitled to. Hinojoso, himself, gave me a paper requesting Congress to pass a law permitting the War Minister to make the necessary exceptions in order to induct me. I also obtained the President's endorsement of the petition. Before the day was over, I had secured passage of a law that would have enabled me to enter the Military Academy at the age of thirteen instead of eighteen. I was then only ten years old, but in the three years before I might enter

the Academy, General Hinojoso offered to give me any help I asked for.

He said, however, that I was at liberty to prepare myself for my military career in any way I wished. If I desired, he would send me abroad, or I could study at home. I could even stay with him in his home.

"I have no sons or family," he said, when I came to his house to tell him about the passing of the law, "and I know your father would not object if you became my son as well as his. You have everything you need here to become a real technician in your chosen profession."

With grave solemnity, he conducted me to a library of thousands of books on bookshelves covering all the four walls.

I was a little disappointed to see only books; I had expected to be led into an arsenal.

After a while, the minister closed the door behind me and I was left standing alone in the middle of the vast library.

Looking around, I saw the model of a battleship in a corner of the room. I studied it carefully, marveling at its craftsmanship. I had never seen a model as finely detailed, with guns, hull, rigging, keel worked out with such perfection that my imagination could board it without trouble and sail off to all corners of the world. I stood transfixed until the general returned. It took all my strength of mind not to tell him that, rather than become a soldier, I now much preferred to be a sailor.

My response had been an esthetic one; the art of the ship-model builder had suddenly and completely blotted out my military interests. When my father came in later to discuss the curriculum of the military preparatory school he proposed to send me to, I was so repelled by the idea of the regimented life I would lead there that I literally ran out of the room and into the open air.

It was then, I think, I knew that whatever false roads I took afterwards, art was my destiny and would find me everywhere I went.

At the San Carlos School of Fine Arts

 Soon afterwards, I enrolled in the San Carlos School of Fine Arts. The classes were held at night; by day I continued to go to elementary school. For the next two years, I led this burdensome existence. What sustained me was the discovery of the pre-Conquest art of Mexico, for which I conceived a passion that was to influence my entire artistic life.

When I was thirteen, I received an art scholarship enabling me to attend San Carlos by day. I was, at first, a model student, industrious and obedient. Determined to learn all that tradition could teach me, I accepted whatever the teachers prescribed. My hard work earned me the highest grades and every possible prize.

My older classmates became jealous of me and lost no opportunity of embarrassing me. For my part, I sought to be accepted as one of them despite the handicap of my extreme youth. One of my proudest achievements toward this end, when I was fourteen, was winning a competition for making up the dirtiest possible original expression. My prize-winning obscenity was: "Copulate with your mother and gargle with her menstrual juice."

From then on I was nicknamed *Chilebola*, which means "extra hot chile." To live up to this imposing title, I adopted a tough swagger and would fight anybody at the drop of a hat.

Physically I was still a fat, oversized little boy, but I possessed a tremendous store of energy, almost all of which I put into learning how to paint.

Yet I was not happy artistically. The further I progressed in the academic European forms, the less I liked them and the more I was drawn to the old Mexican art. I particularly detested having to copy engraved replicas and plaster casts.

Reaching the breaking point, I revolted noisily by organizing a strike with other discontented students. The immediate object of our protest was a priest accused of sexual corruption. Actually, we were demonstrating against the Mexican dictator, Porfirio Díaz, who was now openly flouting the anticlerical provisions written into the Constitution by Juárez. Of all living men, Díaz was most to blame for the stultification of life and art in Mexico. And it is to him that Mexico, today, owes its wedding-cake palace architecture and insipid public statuary.

The student demonstration turned into a riot. As its leader, I was summoned before the authorities and expelled.

Thus ended my formal training in art. Aside from a period of eight months in later years, when I was invited back to the San Carlos as its director, I would have no further connection with any academy.

I was sixteen at the time I left the art school, the age when most students are first admitted.

THREE EARLY MASTERS

 AMONG THE TEACHERS at the San Carlos, three stand out in my memory. The first was Felix Parra, a conventional painter himself but possessed with a passionate love for our pre-Conquest Indian art. He communicated this enthusiasm to me with such success that it has lived on in me, through many changes of taste and fortune, to this day.

The second was José M. Velasco, whom I regarded as the world's greatest painter of landscapes. From Velasco, I learned the laws of perspective, and it was he, rather than Parra, whom I followed when I studied on my own. I traveled up and down the country, painting Indians, forests, houses, streets, and churches, all more or less in the manner of this master.

The third was Rebull, a man in his seventies, who had been a pupil of Ingres. One day, when a class of about fifty students was painting a model, he singled me out. He found fault with my drawing, but he said, "Just the same, what you're doing interests me. First thing tomorrow morning, come to my studio." The other students flocked around to see what had interested old Rebull enough to extract an invitation to his studio, to which he had admitted no student for twenty years. They could see nothing and ascribed his enthusiasm to a senile whim.

But the next day the old man told me what he had discovered in my work was an interest in life and movement. Such an interest, he said, is the mark of a genuine artist. "These objects we call paintings," he went on, "are attempts to transcribe to a plane surface essential movements of life. A picture should contain the possibility of perpetual motion." Rebull made me more aware than I had yet

been of the laws of proportion and harmony, within which movement proceeds, and which are to be discerned in the masterpieces of all ages.

POSADA

 ABOUT THIS TIME, I met and came under the influence of the great folk artist José Guadalupe Posada, the most important of my teachers. Posada was not connected with any academy nor was his work to be found in any fashionable home. He was an engraver with a shop in the Calle de Moneda. A small, fat man, he etched illustrations for the songs, jokes, and tales which wandering minstrels brought to the folk of Mexico. In his lifetime, he did more than 15,000 of these etchings, all printed on sheets of colored tissue paper and sold from door to door.

Posada had no place in the official circles of Mexican art, and he was unconcerned about immortality, though he has achieved it where more respected artists of his time have failed and are now forgotten. He knew as much about form and movement as any man I have ever met. It was he who revealed to me the inherent beauty in the Mexican people, their struggle and aspirations. And it was he who taught me the supreme lesson of all art—that nothing can be expressed except through the force of feeling, that the soul of every masterpiece is powerful emotion.

Of course the import of this teaching was lost upon me then— and for many years afterwards. Finding myself in art was to be a long and painful process. Looking back upon my work today, I think the best I have done grew out of things deeply felt, the worst from a pride in mere talent.

Pre-Conquest Art

 Meanwhile I painted, and although I now took some pride in my work, I was also often depressed by a generalized sense of inferiority. It was a racial feeling, not unlike that felt by many artists in the United States. And like many of them, it finally would bring me to Europe. But in my (Mexican) case its roots were not specifically the same.

Before the coming of the Spaniards, the Mexican Indian artists had shown great force and genius. Like all first-rate art, their work had been intensely local: related to the soil, the landscape, the forms, animals, deities, and colors of their own world. Above all, it had been emotion-centered. It was moulded by their hopes, fears, joys, superstitions, and sufferings.

Under the tyranny of the Spaniards, the half-breed descendants of these great Indian creators turned away from the native sources that had given Mexican art its power. Feeling inferior to their conquerors and oppressors, they sought to raise themselves to equality by imitating the accepted models of classical European art.

It was the response of men reacting to a tradition of defeat—and this tradition was within me, too, buried in my subconscious. Yet I was continuously aware of the greatness of pre-Conquest art. Within and without, I fought against inhibiting academic conventions, trusting my emotions to guide me in painting canvases I am still not ashamed to have done. Among these are my "Pisafoo," "Tuni," "White Sensitive," and "White Sensuous"—works whose purity of feeling gives them a value which transcends their rather wicked subject matter.

An Experiment in Cannibalism

 In 1904, wishing to extend my knowledge of human anatomy, a basic requisite for my painting, I took a course in that subject in the Medical School in Mexico City. At that time, I read of an experiment which greatly interested me.

A French fur dealer in a Paris suburb tried to improve the pelts of animals by the use of a peculiar diet. He fed his animals, which happened to be cats, the meat of cats. On that diet, the cats grew bigger, and their fur became firmer and glossier. Soon he was able to outsell his competitors, and he profited additionally from the fact that he was using the flesh of the animals he skinned.

His competitors, however, had their revenge. They took advantage of the circumstance that his premises were adjacent to a lunatic asylum. One night, several of them unlocked his cages and let loose his oversize cats, now numbering thousands. When the cats swarmed out, a panic ensued in the asylum. Not only the inmates but their keepers and doctors "saw cats" wherever they turned. The police had a hard time restoring order, and to prevent a recurrence of such an incident, an ordinance was passed outlawing "caticulture."

At first the story of the enterprising furrier merely amused me, but I couldn't get it out of my mind. I discussed the experiment with my fellow students in the anatomy class, and we decided to repeat it and see if we got the same results. We did—and this encouraged us to extend the experiment and see if it involved a general principle for other animals, specifically human beings, by ourselves living on a diet of human meat.

Those of us who undertook the experiment pooled our money to purchase cadavers from the city morgue, choosing the bodies of persons who had died of violence—who had been freshly killed and were not diseased or senile. We lived on this cannibal diet for two months, and everyone's health improved.

During the time of our experiment, I discovered that I liked to eat the legs and breasts of women, for as in other animals, these parts are delicacies. I also savored young women's breaded ribs. Best of all, however, I relished women's brains in vinaigrette.

I have never returned to the eating of human flesh, not out of a squeamishness, but because of the hostility with which society looks upon the practice. Yet is this hostility entirely rational? We know it is not. Cannibalism does not necessarily involve murder. And human flesh is probably the most assimilable food available to man. Psychologically, its consumption might do much to liberate him from deep-rooted complexes—complexes which can explode with the first accidental spark.

I believe that when man evolves a civilization higher than the mechanized but still primitive one he has now, the eating of human flesh will be sanctioned. For then man will have thrown off all of his superstitions and irrational taboos.

My First Grant

 In 1902, at the age of sixteen, I was receiving thirty pesos a month as a scholarship from Teodoro A. Dehesa, Governor of the State of Veracruz.

It was my father who got me this stipend. He had first tried to secure a grant from the Governor of Guanajuato, a dull man who had no interest in art and who promptly refused. But Dehesa was of a different sort. Cultured and liberal-thinking, he was the leader of what might be called the progressive wing of the Díaz government. He survived in Díaz's reactionary administration only because he had once dramatically earned the dictator's lasting gratitude. When the latter was a revolutionary himself and only an insignificant army colonel, he had been sentenced to death, and Dehesa had saved him from the firing squad. Dehesa's qualities were well known throughout Mexico, and my father had for some time resolved to speak to him about me when his affairs took him to Veracruz.

MURILLO ATL

 IN THE SAME YEAR that the scholarship went into effect, the great Mexican painter Murillo Atl returned to Mexico from Spain. An eye disease had halted his painting career, and he had brought back no canvases. What he had brought instead was a fanatical enthusiasm for neo-impressionist art. He was mostly under the influence of the Italian-Swiss neo-impressionist Giovanni Segantini, but he was hardly less excited by the neo-impressionists of Paris. Atl had a great feeling for color and a passionate love for landscape, which he communicated with a missionary zeal.

Like me, Atl was politically an anarchist, a product of the discontented middle class. Our common political and artistic interests brought us very close. Through hard life experience, I later came to reject anarchism for the more realistic politics of social-democratic action and still later, of communism. Atl's violent individualism took him to the extreme right and ultimately into the role of fascist agent.

But in 1904, Murillo Atl was the dominant influence among aspiring young artists discontented with academicism. Unable to paint, he devoted his tremendous energy and his prestige to turning his disciples upon the path of neo-impressionism. Both Joaquín Clausell, the great landscape painter, and myself owe a great deal to Atl in this respect.

Atl fired me with the desire to go to Europe. My greatest enthusiasm in contemporary European art was then Cézanne, with whose work I had become familiar through reproductions. However, before I went on to France, I decided to stop in Spain, believing that it would provide a necessary plastic transition between Mexico and modern Europe.

In 1905, I expressed this desire to Governor Dehesa. He told me that, if I had a one-man exhibition and succeeded in selling my paintings in Mexico, he would provide traveling and living expenses for four years' study abroad. I would receive three hundred francs a month, a sum that proved barely enough to exist on but then seemed like a tremendous fortune to me. I worked for a year preparing for my show, doing landscapes mainly. One of the best of these, "Citlaltépetl," which I painted in Jalapa, is now part of the

22

Antebi collection in Mexico. I favored pastels, because with them I could most easily achieve divisions of color. But I also painted with solid oil colors which I mixed myself with the help of Francisco de la Torre and Alberto Garduño, using Mexican copal gum as the base. Atl also gave his assistance.

When I had enough paintings, Atl organized my exhibit, I not being then, or ever since, capable of handling such practical affairs. Atl invited critics, writers, and newspapermen and, of course, potential buyers, sometimes using devious means to induce them to attend. The show went so well that everything, to the last sketch, was sold. I joyously reported this to Governor Dehesa, and he granted me the promised subsidy.

The needy Atl organized shows for many young painters as a means of supporting himself. He told the artists after the exhibition was over, "Boys, for you the honor and the glory, for me the base material profit."

But in my case Atl not only gave me every cent we collected but contributed money of his own. He also presented me with a letter of introduction to the Spanish painter Eduardo Chicharro, with whom he had made friends while living in Madrid. Chicharro, then a medal winner with an international reputation, enjoyed the patronage of the richest families in Madrid. This kindness of Atl I very much appreciated. Cézanne had just died, and with that idol gone, I decided to study longer in Spain than I had first planned. Chicharro had an open workshop, and he was interested in color. To me, this compensated for his academic manner, with which I was already acquainted.

PASSAGE OF ANGER

 A FEW MONTHS before leaving for Spain, while painting in the shadow of Mount Orizaba, the great volcano of Veracruz, I witnessed the earliest of the many terrible clashes that were to occur between the people and the despot Díaz.

It happened like this. Along the foothills of Orizaba were textile mills where Mexican peasants toiled for long hours under inhuman conditions. Petty regulations were enforced by the millowners to

keep the workers at the level of beasts of burden. Infractions of the rules resulted in brutal beatings by the foremen. Wages were paid not in cash but in tokens redeemable in the company store. Since these wages were not enough even to keep an Indian peasant alive, the workers were continually in debt.

In the winter of 1906, the millowners increased the number of hated regulations while cutting the miserable wages. Without plan or organization, the outraged workers walked out of the mills.

With the naive trustfulness of Mexican peasants, they decided to appeal to the "Father of His People" for help. A delegation of pajama-clad and sandal-shod workers trudged to Díaz's palace. Díaz promised to take care of his "children," and there was no hint of what was to follow in his reception of the delegation.

The way he took care of them was to send troops who shot down men, women and children gathered in streets. To this day, I can see the still bodies of the victims lying lifeless in the widening pools of their blood.

As the strike went on, the terrible soldiers returned. I put aside my brushes and joined the millworkers. Once the sabre of one of Díaz's mounted policemen struck me on the back of my skull, near the nape of the neck. I was thrown into prison with other strikers, and the stale prison bread was the most wonderful food I have ever tasted.

After my release, I found myself so paralyzed by helpless anger and frustration that I was unable to paint anything.

I boarded the ship that was to take me to Spain, still in the grip of horror. I could not sleep. Often I would stand at the bow alone, singing and yelling. My fellow passengers must have thought me a madman. How could I explain the scenes of carnage which I could not make myself forget?

And yet my chants and cries on shipboard remained more the wild shouting of a Nietzschean than the steely anger of a true revolutionary. Though my social and political ideas had grown more elaborate, they had also become less direct, clear, and biologically truthful than when, at six, I had spoken from the pulpit in the Church of San Diego. But I can truthfully say that the final crystallization of my political ideas began at this time.

MY SPANISH FRIENDS

 I ARRIVED IN SPAIN on the 6th of January, 1907. I was twenty years old, over six feet tall, and weighed three hundred pounds. But I was a dynamo of energy. As soon as I located Chicharro's studio, I set up my easel and started to paint. For days on end, I painted from early dawn till past midnight.

For diversion, I wandered through Madrid's wonderful Prado Museum and other galleries where the masterpieces hung.

My contact with Spanish art, however, affected me in a most unfortunate way. The inner qualities of my early works in Mexico were gradually strangled by the vulgar Spanish ability to paint. Certainly the flattest and most banal of my paintings are those I did in Spain in 1907 and 1908.

The Spanish masters to whom I was most drawn were Goya, Velázquez, and El Greco. I also found new delights in the Dutch, Flemish, and Italian masters and in the Castilian, Catalonian, and Aragonese primitives. And of such ever-living masters as Brueghel, Lucas Cranach, Hieronymus Bosch, and Patinir, I became a reverent disciple.

I performed some study exercises in the room of the Goya portraits at the Prado, copying not individual paintings, but making composites, in order to achieve a fuller comprehension of the style of this master. Three of these Goya exercises now hang in well-known Goya collections, two in the United States, and one in Paris. I shall not, however, disclose the identity of these forgeries; let the experts have fun.

I performed a similar exercise with El Greco. The result was so inferior to the Goyas that I never did another. Nevertheless, it too hangs in a collection of genuine "El Grecos" and still awaits detection.

These frauds were not my doing actually. While in Madrid, I met Luis de la Rocha, an amiable and obscure young painter, who acted as a sort of guide and secretary to me in his country. When he saw me about to destroy the composites, he asked me to give them to him. Rocha frankly told me what he meant to do. "Diego, I'm your friend. I'm glad to have been able to give you my time, and I've tried to help you all I could during your stay in Spain. We're both-

poor boys, but I'm much poorer than you. As you know, my father has learned how to turn new paintings into old ones and market them abroad. Since you're going to destroy these, let me and my family have them. We need the money."

So I gave him the paintings to recompense him for his services; also to give myself the enjoyment of seeing the experts hoaxed. But I never expected my youthful exercises to succeed on the scale they did.

In Spain, I also made friends with the great Spanish writer Marquis Ramón del Valle Inclán, and with Ramón Gómez de la Serna, who was winning recognition as an important writer of the new generation.

The younger Ramón was the most productive writer I have ever known. At the age of nineteen, Serna had already written a pile of books that reached a height of thirty inches. Some day a discerning critic should make his way through the forests of this strange literary genius. Serna's work carried on or anticipated every modern and ultramodern literary tendency of our time.

The elder Ramón had a mind as comprehensive as that of any of the giants of the Spanish Golden Age. His books show marvelous political sense, as well as a wide-ranging imagination, and an individual and flavorous style.

Valle Inclán lacked his left arm. In a cafe brawl, an inferior literateur had broken it with a cane, so injuring it that it had to be amputated. Valle Inclán romanticized the loss in dozens of fantastic stories. His imagination took off on any theme. From a visit to Mexico, he built an Odyssey of adventure replete with numerous sultry amours. He would draw me into his narratives as eyewitness or as a new object for his inventions. For all his fantasizing, he had the sensitivity to capture the essential quality of life in my unhappy, comic, and beautiful country, and his *El Tirano Banderas* remains one of the most moving books about Mexico.

Through Serna, I met the most curious man in all of Spain at that time, the homeless anarchist philosopher Don Silverio Lancza. This madman dreamed of a Utopia where total equality prevailed and all men were aristocrats and artists. I hope his writings, with their beautiful violence of language, will someday be "rediscovered."

Also through Serna, I met one of the most fascinating personalities and one of the finest painters of Spain in the early twentieth century. Dario de Regoyas' paintings of the Spanish countryside and Spanish life show a perception as profound as anything by Goya. He was a marvelous colorist and one of the most outstanding of the neo-impressionists.

The only good mural painter in Spain, Areta, was also a good comrade of mine. All of these friends and I moved in the same circles.

Desolate Landscapes

 TOWARDS THE END of my stay in Spain, I became so sick from my excesses in eating, drinking, and working that I put myself on a vegetarian diet and fresh-air regimen. I took long hikes through the countryside, stopping along the way to become better acquainted with the Spanish peasantry. About this time, I also developed and indulged a sudden voracious appetite for reading. I immersed myself in the works of Nietzsche, Huxley, Zola, Schopenhauer, Darwin, Voltaire, Kropotkin, and, above all, Karl Marx. In books, I sought ideas. I read very little fiction, which did not satisfy me then and has not since because of its unreality. I read too much, instead, books on mathematics, biology, and history—subjects which have continued to interest me to this day though I mainly use my leisure time to observe life itself.

As I have said, I did very little painting of any worth during my year and a half in Spain. Aside from my art study and varied reading, what I gained most from Spain was what I saw of the Spanish people and their condition.

At the beginning of the century, industrial Madrid consisted of a few small factories. The working class was small and unorganized, largely a lumpen proletariat, a proletariat in rags, lacking in any initiative for social change. Most of the common people were *picaros* or thieves. Having no legitimate ways of earning a living, they turned to lawless ones—rackets and crimes—in order to survive. They were shiftless, cunning, picturesque, sorrowful, and tragic.

On the whole, nevertheless, the people of Madrid bore their life with courage. This courage did not inspire them to revolt but imbued them with an ironic acceptance of suffering. The very idioms of their slang expressed this resignation. Sympathizing with their misery, the local police treated them with corresponding understanding tolerance. It was not unusual to see a municipal policeman taking a poor wretch whom he had collared, not to the lockup, but to a tavern to buy him a drink.

In contrast to this burlesque gendarmerie was the infamous *Guardia Civil*, the direct successor to *La Santa Hermandad*, the Holy Brotherhood, military arm of the monarchy and the Inquisition. This sinister force was heir to the most sadistic Spanish traditions. It was cruel and treacherous, and was openly dedicated to the protection of the upper classes and the maintenance of their privileges and distinctions. It helped to make the social system of Spain one of the most unjust and backward in the world and shielded the darkest of religious fanaticism. To everyone who sought to bring freedom and justice to Spain, the *Guardia Civil* was the unremitting enemy.

Its ranks were made up of the most arrogant, ignorant, and reactionary sons of Spanish upper *bourgeois* families. These young toughs needed no instructions to serve their class interests. They expressed open and aggressive contempt for their "inferiors," the lower middle class and, of course, the workers. Class division was, nevertheless, less distinct in Madrid than in the more industrial sections of the country: the metallurgic districts of the north; the industrial sections of the southeast; Catalonia; and the mining area around Almadén. There the *Guardia Civil* used its iron fist openly, as I was able to see at first hand.

I am sorry to say that the Spanish Church worked side by side with these gangsters. Priests, bishops, cardinals, monks, and nuns gave an aura of sanction to their activities, spreading over the people a dark blanket of superstition and ignorance which smothered every impulse toward change, so that such rebellions as occurred were always sporadic, violent, and impregnated with despair.

Checkbooks in My Fingers

 Just before my departure from Spain, I played a passive but stellar role in an interesting occurrence at Chicharro's studio.

During the last exhibition I had there, the master painter Don Joaquín Sorolla y Bastida paid the workshop a visit. He desired to see what the youth of the time was doing in art. Sorolla had an attractive personality, and was very sure of himself. His style was academic and marked by a photographic realism, but his talent was genuine and his mastery of technique exceptional.

On the day of his visit, Sorolla took a look around at the walls hung with many paintings. Arrested by a picture of an old iron-smith's shop painted by me, he gave it a long and close look. (This painting, "The Blacksmith Shop," is now in the collection of Marte R. Gómez in Mexico.)

"Who did that, Eduardo?" he asked. His voice sounded so severe that I expected scathing criticism.

Chicharro answered, "The Mexican."

"Where is this Mexican?"

"There," and Chicharro pointed to me.

"The Mexican" was my Madrid nickname, given to me because of the large sombrero I always wore, my head being so large that no ordinary-size Spanish hat would ever fit me.

"Come here, boy," said Sorolla.

I went to him, murmuring, "At your orders, *patrón*."

Looking straight into my eyes, Sorolla said, "Give me your right hand, my son."

He took the hand I held out in a strong grip. Then clasping it at the wrist, he said, "Show me your fingers." After touching each, one after the other, he asked, "Don't you know what you have there?"

"No, *maestro*," I replied, perplexed.

Sorolla chuckled. "All right then, boy, I'll tell you. In this finger you have a checkbook of American dollars, here a checkbook for pounds sterling, here a checkbook for Spanish pesetas, here a checkbook for Argentine pesos, and here a checkbook for French francs. I tell you, son, I know what I'm saying. I've been to all these countries with my paintings. You don't look rich, my boy; neither was I at your age. My father was an ironsmith like the one in your painting. Yet I came back from my travels abroad with many check-books. I guarantee you, you damned Mexican, that if you paint day and night, you'll have twice as much money as I have. I say this because Eduardo has told me you're an exceptionally hard worker."

All my workshop companions looked at me with envy, but Chicharro with tenderness and admiration. Don Joaquín Sorolla then shook hands with me.

As soon as he was gone, Chicharro said to me excitedly, "Have you heard what he said? Sorolla has never before said anything like it to any other artist. And he certainly knows what he's talking about. The future is yours."

The next day, as if anticipating the wealth Sorolla had prophe-sied for me, I gambled in a local casino. I ran a stake of 500 pesetas, which I had received for one of my paintings, up to 3,500 pesetas. Three days later, fortified by my winnings and accompanied by my friend Valle Inclán, I left Madrid for a tour of Europe.

Along the way, I was troubled by Sorolla's prophecy. Though, like any poor boy, I was tempted by the idea of becoming rich, I did not want to become enslaved to the checkbook, to become a commercial painter. I knew how one climbing the mountain of worldly success can slip down into the river below without being conscious of the descent until he is already drowning.

With such thoughts, I arrived in Paris one spring morning in 1909.

ART STUDENT IN PARIS

 THE PARIS AIR was foggy, the sun barely visible. Some Spanish friends met Valle Inclán and me at the railway station and took us to the Hotel Suez on the Boulevard St. Michel, which catered mainly to Spanish and American art students. I was assigned the very same room in which that remarkable artist Julio Ruelas, precursor of surrealism, had recently died. It was small but it had a big window overlooking the boulevard.

Paris had been my goal. My roving now ended, I set to work and soon fell into the usual routine of the art student, studying the museum collections, attending exhibitions and lectures, and working in the free academies of Montparnasse. I also did open-air work along the Seine River. At night I joined groups of fellow students in the cafés in warm discussions of art and politics.

Among these students were several Russians who had suffered exile and lived among professional revolutionaries. Their life was one of black misery, sustained only by reports of riots in Russia and their own Utopian dreams.

In my painting, I sought a way to incorporate my increasing knowledge and deepening emotions concerning social problems. Two great French revolutionary artists, Daumier and Courbet, lit my path as with great torches. In their work they had achieved a synthesis very much like that which one day would liberate me.

Yet, though aware of their examples, I was slow and timid in translating my inner feelings on canvas. I worked at my paintings in an indifferent, even listless way, lacking the confidence to express myself directly. My work of the period from 1909 through the first half of 1910, though it shows certain superiorities to my Spanish

canvases, still looks academic and empty. Today it seems like a collection of masks and disguises to me.

I have often tried to find an explanation for the incongruity between my understanding of life and my way of responding to it in this period of my painting. Probably the natural timidity of youth was a factor. But more potent, though I was little aware of it then, was my Mexican-American inferiority complex, my awe before historic Europe and its culture.

I know now that he who hopes to be universal in his art must plant in his own soil. Great art is like a tree which grows in a particular place and has a trunk, leaves, blossoms, boughs, fruit, and roots of its own. The more native art is, the more it belongs to the entire world, because taste is rooted in nature. When art is true, it is one with nature. This is the secret of primitive art and also of the art of the masters—Michelangelo, Cézanne, Seurat, and Renoir. The secret of my best work is that it is Mexican.

Private Property

 APART FROM ITS MASTERPIECES, I was observing the people of France. One characteristic of the French excited my curiosity—their reverence for private property, and especially of property in land. Their attitude toward land was positively religious; beside it all ordinary human values disappeared.

The neighborly greeting of one peasant to another was a growl. Yet he would never think of taking one fruit from that other's tree or one grain from his bin—and not because he was afraid of the owner or of the priest. What he was afraid of was transgressing the holy law of property. That fear produced a ferocious honesty.

I observed, too, that in the urban industrial workers, the petite bourgeoisie and intellectuals, this same worship of landed property lay just under the surface. Even the maddest, gayest, and richest whores and the most Bohemian of the artists dreamed of retiring to the country and working their own land with their hands. A large part of the upper bourgeoisie, including the corrupt politicians, were touched by this mania to own and cultivate land.

Only in the very heart of the big industrial centers could people be found who were conscious of a new, more humane way of life.

These few realized that the factory was changing the earth and would one day pull the peasants out of their ruts and bring an end to class society.

Unfortunately the mass of lower-class workers in Paris looked upon those of their comrades who revealed any class consciousness as devils or as carriers of some loathsome and contagious leprosy. Time and time again, these wretches found themselves fighting alone, going down under police clubs, and being shipped off to penal settlements like Devil's Island.

I remember an incident which occurred but a few weeks after my arrival in Paris, one early morning in a café near the main market.

Although there was nothing outwardly to distinguish this café from others, it mainly catered to the wealthy. Among its upper-class clientele were certain beautiful kept women who, bored with their "paying lovers," came here to pick up "heart lovers." The men they affected were the denizens of the legendary world of painting and literature. That is why I was there with other hungry artists: to find a woman to pay for a meal.

A worker, whose fatigue showed in every line of his face, came into the café, went up to the bar, asked for a drink, and put down his money. The owner, who was standing behind the bar, would not serve him. On being pointedly ignored, the offended worker quietly asked if it was the rule here not to serve anyone who earned his bread with his hands. The owner signalled to a waiter who served as bouncer. The worker understood the situation at once. He angrily informed the owner that no pimp such as he could treat a worker like this. He invited the owner to come out from behind the bar to find out how a worker's fists felt on his dirty pig face.

Though he was bigger and stronger, the owner did not accept the challenge. He made a gesture with his thumb and, as if by magic, two policemen appeared in the café. The owner pointed to the worker, whom one of the cops took by the scruff of his neck to pitch him out. When the worker resisted, the other cop smashed his fist in the worker's face; then, stepping back a few steps, he drew his pistol.

Not being equipped to deal with this kind of attack, the worker stopped struggling but cried out, *"Voilà la liberté!"* ("That's liberty for you!")

Infuriated by the catcalls of the bystanders, the policeman again struck the worker who then shouted, *"Et la fraternité!"* ("And brotherhood, too!")

At this, my friends and I leaped to his aid, precipitating a little battle of the class war.

No More Cézannes

As I HAVE PREVIOUSLY SAID, I came to Europe as a disciple of Cézanne, whom I had long considered the greatest of the modern masters. I had hoped to study under him, but Cézanne having died before I reached France, the best I could do was look for his paintings. I was still too shy to go where they were mostly to be found, in the homes of private collectors. I, therefore, did my hunting on the Rue Lafitte where the more celebrated dealers in modern paintings had their shops. When I came upon a Cézanne, I would stand rooted before it, studying and enjoying it.

One day I saw a beautiful Cézanne in the window of Ambroise Vollard, the dealer who, I learned later, had been the first to take an interest in Cézanne. I began looking at the canvas at about eleven o'clock in the morning. At noon Vollard went out to lunch, locking the door of his gallery. Returning about an hour later and finding me still absorbed by the painting in his window, Vollard threw me a fierce glance. From his desk in the shop he looked up, from time to time, and glared at me. I was so shabbily dressed he must have taken me for a burglar.

Suddenly Vollard got up, took another Cézanne from the middle of the shop and put it in the window in place of the first. After a while, he replaced the second canvas with a third. Then he brought out three more Cézannes in succession. It had now become dark. Vollard turned on the lights in the window and inserted still another Cézanne.

Though his expression remained glowering, he finally turned on all the lights in the gallery, and with hungry, affectionate gestures, began to remove paintings from the walls and arranged them on the floor where I could see them from the doorway. Among these was the wonderful "Card Players." I stared enraptured, oblivious of a hard rain which had begun to fall and was now drenching me to the skin.

Finally, coming to the doorway, Vollard shouted, "*Vous comprenez, je n'en ai plus.*" ("You understand, I have no more.")

When at last I started to leave, Vollard walked to the door, obviously intending to tell me something. But afraid that he was angry, I hurried away.

33

It was late at night when I arrived at my studio, and I was burning with fever. My thermometer read 104°F. The fever continued for the next three days. But it was a marvelous delirium; all the Cézannes kept passing before my eyes in a continuous stream, each one blending with the next. At times I saw exquisite Cézannes which Cézanne had never painted.

To this day, I feel grateful to Vollard for the gruff benevolence he extended to me that day outside his shop. On my way home I had noticed the time on an illuminated public clock—half past two. Probably no man has ever stood so long as I, admiring masterpieces in the street under a furious rain. But what art dealer has ever kept his shop open so late just to please one poor, fascinated student?

When Picasso brought Vollard to my studio in Paris in 1915, I told him that I would always be thankful to him and the reason why. Vollard threw up his hands again as he had done then and exclaimed, laughing, "I *still* have no more!"

THE SUN WORSHIPPERS OF BRUGES

 THE SUMMER OF 1909 I went to Brussels, where I remained a short while to paint. Here I came upon María Gutiérrez Blanchard, a painter friend I had met in Spain. María was a hunchback, standing little more than four feet from the floor. But atop her deformed body was an extremely beautiful head. Hers were, also, the most wonderful hands I have ever seen. Her physical tragedy was reflected in her works, through which she later became recognized as one of the leading artists of Paris.

With María was a slender blonde young Russian painter, Angeline Belloff: a kind, sensitive, almost unbelievably decent person. Much to her misfortune, Angeline would become my common-law wife two years later.

From Brussels, together with María and Angeline, I went to Bruges to meet an old friend, Enrique Friedman, a Mexican painter of German ancestry. We were an odd-looking pair, Friedman and I, loaded down with our paintboxes, canvases, easels, and other painting gear. The Bruges children ran after us, and when we set up our easels, they crowded around and made such a racket it was impossible for us to work.

After much discussion, Friedman and I hit upon a complicated but successful solution of this problem. First we applied to the local police for permanent residence permits. A polite and friendly inspector came to call upon us personally with the required application forms, one item of which called for a statement of religious belief.

When we came to it, I nudged Friedman and asked the inspector, "Is it essential to declare our religion?"

"Yes, sir," he replied. "Though the Catholic religion is our official faith, this is a free country, and people may practice whatever religion they wish. We merely ask you to give us that information so that you will be permitted to do so."

We responded with an amiable, "Thank you, sir," and proceeded to fill the blank with the words "sun worshipper."

The inspector showed no surprise. "So, gentlemen," he said, "as in many of the oldest cultures, I see you worship the necessary astral body and spring of all life on earth. Your religion is much older than Christianity. It will be protected according to the law of our democratic country."

To this day, I don't know whether the inspector was naive or whether, in his sober Flemish way, he had decided to play ball with us. The following sunrise found Friedman and me standing naked before the big window of our chamber, which faced east and also looked out on the fish market where the Bruges housewives gathered early. Being young men, Friedman and I were not bad to look at, and we attracted an appreciative audience. When we came outside later, we found two uniformed men with bicycles waiting for us. The protection of Belgian law was thus being given the visiting sun worshippers, and for a few days, we were able to paint away in peace.

Then suddenly, we lost our bodyguards. One day all the police of Bruges were sent to the nearby fashionable resort town of Ostend La Magnifique. The Tsar of Russia was expected to arrive there for a brief vacation. The children were immediately upon us—and worse than before. New measures were needed. But what could we do? At last Friedman and I devised another complicated plan based on the fact that Angeline was a Russian.

Together we went to our landlord and asked him to purchase two Belgian pistols, unofficially and without a police permit. I explained that, as a Mexican, I was an ardent collector of good firearms, especially those of Belgian manufacture. Friedman, I said, also desired a Belgian pistol, because he admired fine workmanship. Since Belgian firearms were world renowned, and nowhere more so than in Mexico, we were particularly eager to get good specimens.

As I talked on, our big, blond landlord's big round eyes grew bigger and rounder. Raising his hands in agitation, he asked, "Gentlemen, are you serious about this?"

In reply I whispered, "I'll give you one day to get the pistols and a month's rent in advance."

The man's mouth opened and closed without sounding a word.

At dinner the same day, however, our friend the police inspector, obviously tipped off by the landlord, paid us a social call. He asked if we'd like to play a friendly game of billiards. Friedman was an expert player, and we accepted the invitation. In the course of the game the local police budget changed hands, the inspector proving to be a third-rate amateur. Or perhaps our questions were too distracting. We asked him about the whereabouts of the Tsar and the police measures being taken to protect him. Our stratagem worked so well that, shortly after, another police inspector arrived and went into an immediate huddle with the landlord. The latter took him down to the wine cellar, where we had chosen to dine on snacks of ham and smoked fish and sample the landlord's wines. The landlord went upstairs again, but the inspector, pretending to be following him, took up a post where he could overhear us.

Pretending not to know about this, Friedman called up to the landlord, "Boss, don't forget. Early tomorrow morning we must have the pistols my friend asked for. Better come down now and let's have the directions to Ostend. We want to use the side road, not the highway. If you misdirect us or fail to get us the pistols, you won't be good for much in the future. And if you go and tattle to the police, it will be worse for you!"

The man answered in a trembling voice, "Believe me, gentlemen, I swear to you that tomorrow the pistols will be here. I swear it by the health of my soul. I'll also give you the directions you want to Ostend."

We then went upstairs. As soon as we appeared, he took out a map and hastily began explaining the routes. When we got up to our room, we exploded in gales of laughter, speculating on what might happen yet.

At dawn the next day, our house was surrounded by a new variety of police on bicycles, probably the gendarmes of a nearby town.

When we went out to paint as usual, the gendarmes stood on all sides. Nobody, not even adults, dared to approach us.

That night the landlord took us down to his wine cellar and gave us the pistols we had requested. After paying him the sum agreed upon, Friedman said, "We're going to keep these pistols here in your wine cellar. You will give us one key to the cellar and keep the other. In that way, we'll know that no one else can gain entry here. If our arms are disturbed, we'll be sure of the culprit."

So it was that, until the Tsar of Russia departed from Ostend, the children of Bruges left us alone.

BEGGARS IN TOP HATS

 FROM BRUGES we made a voyage to England on a small freighter. We arrived at the mouth of the Thames River at eight o'clock one lovely, fog-free summer morning of 1909. Two hours later, we disembarked on a London dock.

In London, Angeline and I spent much time together visiting the museums. I especially enjoyed seeing the Turners and Blakes. But I spent many more hours walking around the streets of London which, at every hour, seemed to be a city of the poor.

At dawn, the homeless and jobless overran the sidewalks to rummage through the garbage. Even these despairing people demonstrated the impeccable good manners of the English. No matter how hungry he appeared to be, I never saw an Englishman dip his hand into the waste can until all the women had had their turns. And every one of His Majesty's subjects observed the rule that he put his hand into it only once.

Also in the morning, I would sometimes see a gorgeously uniformed coachman carting away the snoring hulk of some wealthy rake in an ornate carriage, lackey and master both oblivious of their fellow countrymen scrounging for their breakfasts of refuse.

I sometimes wondered why, on this kind of diet, the people of London didn't die at a prodigious rate. Then I discovered that there was actually a law, backed up by heavy fines, forbidding the mixing of waste food with any other kinds of waste. In other words, garbage cans were legally recognized as the free cafeterias of the vagrant and the poor.

I was also struck by the crowds of working-class men and women crossing London Bridge of a morning, dressed in the cast-off clothes of the upper bourgeoisie. It was a pathetic carnival, these wrecks of humanity incongruously adorned in evening gowns, satin shoes, garden-party top hats, and cutaways. The people who wore them did not come by these hand-me-down luxury garments free. They bought them in the second-hand shops where they were cheaper than the shoddy new ready-made clothes designed for ordinary men and women.

I discovered, too, that English law dealt leniently with pimps and prostitutes, despite the formally rigid attitude of the Anglican Church toward their sinful profession. Necessity outargued the moralists. When night fell over the streets of London, hundreds of young girls, some of them mere children, began the dreary search for a man with a few shillings in his pocket. Along the walls, groups of boys waited for their girl friends to return from the hunt. Of course, in the myopic eyes of the law, these boys weren't pimps nor were the little girls prostitutes; they were too young.

For the poor, there were also certain places under bridges and along the river front, where at night, sleeping was permitted. The only provision for payment for these open-air dormitories was this. In the morning, a squad of policemen would arrive. One by one, they would wake up the sleepers, line them up, count them off, and give a broom to the last man in the line. This fellow would have to sweep away the rubbish left by all the occupants of the site. Then the newly arisen were permitted to go.

I was also an interested spectator of long, silent columns of workingmen demonstrating in the public squares and parks of the city. Under the marble arches at the park entrances, I listened to all kinds of speakers, from Presbyterian ministers to socialists and anarchists. I made a drawing of an orator who had roused dockworkers to go on strike and some sketches of striking workmen in a clash with the police in Trafalgar Square.

A QUALIFIED SUCCESS

 ON THE WAY BACK TO PARIS, I experienced a siege of home-sickness. In the British Museum, I had again come upon my first love in art, the art of pre-Conquest Mexico. I began to realize that, in the heavy atmosphere of European culture, I had begun to lose my bearings. Suddenly I felt an overmastering need to see my land and my people.

Back in Paris, the desire did not leave me. For some time, I had been thinking about making a trip back to Mexico at the end of 1910. Now this idea became almost an obsession.

Before that, however, I wanted to show something of my work in one of the large exhibitions.

My compatriots considered acceptance at the official French Salon d'Automne as the apex of artistic recognition. Consequently, I made that my goal. Yet I couldn't help feeling that I would be compromising my artistic integrity. Every true master of modern French painting had been rejected by this or similar academic salons which fostered pompous mediocrity and academicism.

However, if I succeeded in getting my work shown, my subsidy would be extended another two years. I needed this time to carry out a plan I had formulated: to digest all the forms of modern painting the better to eliminate them from my own artistic idiom. Thus I decided to make the sacrifice.

As my entry for the exposition, I worked on a canvas called "The House on the Bridge," which I had started in Bruges three months before. I tried to do my best by pushing myself to a maximum of emotional sincerity. At the same time, I also hoped that my entry would be rejected by the jury. This would prove that the jury was unfit to recognize even a measure of sincerity, and would link me with the masters whom I admired.

I was in conflict as well over the sheer economic issue. It was good, of course, to have the grant from the government of Veracruz and be free to pursue my own plan of artistic development. But I also wanted to be able to face life by myself, to solve my economic problems by my work. I had begun to feel restive under patronage, fearing that dependence might sap my strength. With such inner conflicts driving me almost to the point of despair, I grimly worked on my project for three long months.

At last the time arrived for me to send the painting to the jury. I awaited the jury's decision with apprehension. Whatever it was, it must disappoint me. Acceptance would be a reproach, but rejection is always a blow.

Then the word came: my painting would be shown.

I will always remember the anguish this news gave me. When my comrades congratulated me, I quarreled with them violently. For me to be congratulated over acceptance by the Salon d'Automne was an insult.

Nevertheless, on opening day, I managed to find a small measure of balm. Two thousand artists were represented by about six thousand canvases, and in this vast conglomeration, my painting really seemed to stand out. Though it looked academic, it was touched with a quality of sensitivity which set it apart from its more vulgar neighbors. I began to take heart for my future.

During the period of the exposition, I undertook an extensive study of the most recent creations of the Paris school. When the show ended, I went to Brittany for the summer to work at new paintings to bring back to Mexico. It was now that I began to shed some of my old feeling of inferiority. The work I did in Brittany contained good plastic qualities. Belonging to this period is my painting "Shipwreck," which possesses an architectonic grandeur and even a certain poetical quality.

In the fall, I returned to Paris to get ready for my trip home. Rolling up all my completed paintings, I departed for Spain, stopping there only long enough to pick up other canvases I had left in the care of a friend. I sailed from Santander to Mexico in September, 1910.

WHERE I WAS IN 1910

 BETWEEN THE SUMMER OF 1909 in London and that fall of 1910, some of my ideas about art had been strengthened and others had been changed. I understood certain deficiencies of the work I had done in Europe. Also, I began to see my objectives in life as a human being and how my art could serve them. More valuable than technical lessons from European painting and sculpture were the lessons I had gained from observing European life. I now had a vision of my vocation—to produce true and complete pictures of the life of the toiling masses.

The workers I had seen in Europe were brothers of the poor in Mexico, from whom sprang everything I have ever loved. Deep inside me, I had discovered an enormous artistic reservoir. It was of the kind that had enabled the American genius Walt Whitman to create, on a grander scale than anyone had before, the poetry of the common people, working, suffering, fighting, seeking joy, living and dying.

As yet this was like a vision I had seen in sleep with the passivity of a dreamer. When I sought to put it into form, it eluded me. It was too original, and I was not mature enough to realize it.

Perhaps my adolescence had been excessively prolonged, as a kind of punishment of the man for stealing years from the boy. My real coming to maturity coincided with my second return to my homeland in 1921. It was as sudden as my advent into sex, hand in hand with my first mistress. Between 1910 and that marvelous year, I often felt as if I were two people. One painted and was unhappy with whatever he did; the other knew what he must do but could not do it. At times I thought I was suffering from a pathological condition which kept me imprisoned in a painful mental darkness.

In 1910, I was twenty-four years old and far from a failure commercially. The work I had sent back from Europe had made a strong impression, and many commissions awaited me at home. Governor Dehesa had instructed me to arrange a show of my paintings before the end of the year in connection with the centennial celebration of Mexico's Independence.

Yet I was restless, dissatisfied, impatient.

HOMECOMING!

 I CAN HARDLY REMEMBER ANYTHING of my voyage from Spain to Mexico. All I have retained is a marvelous vision of the Azores emerging from the sea. In the distance, they look like a series of mountain tops, then an idyllic landscape with majestic waterfalls spilling down the mountains.

As soon as I disembarked in Mexico, I was struck as by a gigantic shock. My whole being tingled. I seemed on the verge of a magnificent discovery that would reveal the meaning of my life and the life around me. But all too soon the feeling passed, and I returned to my normal state of mind.

On the way home, I was busily making observations, particularly of color. The faces of Europeans had been clear against more or less dark backgrounds. In Mexico, the backgrounds were luminous and the faces, hands, and bodies dark against them. This discovery suggested new things I could do in my paintings. I was deeply moved by the panorama of landscape on my journey across the tropical and semitropical expanses of my homeland. When I finally reached the heights surrounding Mexico City, I could almost feel the landscape permeating me.

Other emotions awaited me at home. My family was then living in a three-story house on Carcuz María Street, near the Merced market. It was not unlike a house we had lived in during my childhood, and when I saw it for the first time, the resemblance precipitated a flood of memories. Climbing up the stairway, I saw my mother half-way up. She turned, a look of astonishment on her face. Planning a surprise, I had sent no message that I was coming.

When I was almost beside her, I saw her eyes widening with a strange look. She was staring over my shoulder at something that seemed to affect her like an apparition. Instinctively, I turned my head in the direction of her gaze. Outlined against the entranceway was the silhouette of a thin, tall Indian woman who, when she saw my eyes, stretched her arms out to me.

I bolted down the stairway, my blood racing. As the woman took me in her arms, the light seemed to dim. I could only gasp, "Antonia!" It was my old Indian nurse. She kissed me all over my face, and I returned her kisses. My arms held her body tremblingly.

She cried, "My child, I have arrived in time. Eight days ago I dreamed about you in my house in the Sierras where you lived as a child. When I awoke, I began walking here, feeling that every step was bringing me nearer to you. I was not deceived. I reached here in time to take you in my arms before your own mother did."

At that moment, I recalled the strange feeling I had had on leaving the ship.

My mother was weeping and looking at Antonia strangely. In a tone of sadness mixed with defiance, she said, "Yes, I am certain that you dreamed this news about him. I know you possess him, because I never have. That is why I have been so sick and unhappy. But if only because I gave birth to him from my own body, you shall never be able to claim him truly as yours."

My Indian foster mother, twice as tall and twice as beautiful as my real mother, looked angrily at her.

"Yes, it is true," she replied. "You gave birth to him. But if it were not for me, he would not be alive. You were not able to keep his life going. I was. That is why he is more mine than yours. Were you able

to see him when he was far away and to count your steps so that you could meet him the moment he arrived? Could you? If you could not . . ."

At that, her voice broke. My mother took her in her arms.

Holding one another, the two began to cry, desperately, hopelessly, the sorrow of all womankind in their voices. Watching them, I could feel myself growing small, thin, insignificant, empty. What could I offer to compare with this stupendous expression of love?

Then I started to laugh and laugh. I took both of them in my arms and kissed them with drunken madness. After we had all calmed down a bit, it occurred to me that my great-aunt Vicenta was not in the house. With new sorrow, my mother told me that she had only recently died. She took me to the deathbed in which my great-aunt had lain just four days before. Her absence added to my feeling of emptiness.

As I stood looking down at the counterpane, something live crawled painfully out of a nearby dresser drawer and across the floor toward me. It was my childhood pet, my dog Blackie, now blind and so feeble with age he could hardly wag his tail. When he reached my feet, he lay down and began making strange sounds. I bent down and took his head in my hands. He touched my cheek with his tongue, then became limp, and with just a slight convulsion, died.

My return home, the clairvoyant arrival of Antonia, her crying scene with my mother, the news about my great-aunt Vicenta, the death of Blackie, who it seemed had only waited for me to come back to die—all occurring together, threw me into a state of terrific confusion. I remember little else about that day, except that my father appeared, summoned from his office by my sister, and that as he greeted me with warm explosions of affection, I suddenly lost consciousness.

A Witchcraft Cure

 A NUMBER OF BLANK DAYS PASSED. I was very ill. Most of the time I was in a coma. In brief intervals of wakefulness, I would see Antonia beside my bed, silent and immobile. My mother was away most of the day, hunting for a bigger house for all of us to live in. One day, when she came home with medicine prescribed by a doctor friend, Antonia vehemently restrained her from giving it to me.

I was still in bed and still feverish when my periods of consciousness began to lengthen. Since I awakened delirious many times in the night, Antonia remained at my bedside night and day.

She saw to it that the soft light of the clay lamp was constantly replenished with the animal grease which fed it and that the door to the corridor was closed to keep out any stronger light. For most of my illness, Antonia went without sleep. Around her erect form hung an almost visible aura of authority. When my father and mother visited me, she allowed them to come no further than the half-open door, where I could barely hear them whisper. She only fed me meals she had bought and prepared herself.

Convalescence brought with it a feeling of renewal and rebirth. Now Antonia permitted herself an occasional nap.

One morning, she came in to dress me, as she had begun to do each day. She combed my hair as she had when I was a child in the mountains. Then she took me in her arms and kissed me. I was suddenly afraid.

"What do you mean by this?" I asked fearfully. "Do you intend to leave me?"

Antonia laughed. Despite her age and her primitive life, her teeth were still strong and gleaming.

"No, my child. How could I leave you? I could never leave you, and don't you forget that. I mean never! No matter how far you may go, no matter how quickly you may travel on the path you are to follow after this day, no matter how many roads you must take, no matter what difficulties you encounter in building your tower, I'll be with you always. If need be, I'll cross seven rivers and seven seas and seven countries and each of them thirteen and twenty times to come back to you. As long as the sun shines, I will be with you always, my child, always."

With that, she laughed gaily and then began an incantation which was part of a magic rite symbolizing the transference of the spirit of life from one thing (an egg, in this instance) to another (me).

She took the egg from the space between her breasts and handed it to me. It was as warm as if it had been newly laid. Then she unwrapped a bone needle from a cotton cloth and pierced the egg at each end.

Kissing the egg, she said, "Now, my child, you kiss it and drink its inside as quickly as you can."

I did as Antonia bade me. The egg was emptied in a gulp.

Antonia took the hollow shell from my hands. All at once she began to chant loudly, joyously, in her native Tarascan. Singing, she led me into the kitchen, where she prepared a small wood fire. When the fire was ablaze, she threw the shell, the needle, and what seemed to be a small package into its midst. She vigorously fanned the flames with a straw fan, the volume of her voice rising.

Suddenly, as if they had leapt from some great hearth in my throat, the words of Antonia's song came to me, and I began to sing along with her. When the needle, the shell, and the package were consumed in the fire, Antonia put her left arm around my neck and kissed me many times while continuing to fan the fire with her right hand. Between her kisses, I heard the word "never" repeated over and over again. After a while she released me.

Putting the fan in my hand, she said to me, "Wait for me but don't stop fanning the fire until the last cinder turns to ash."

I did as she asked, not even thinking it strange. Antonia left the kitchen, and I fanned till nothing but ashes were left in the fireplace. Then I sat down and waited for her return. I waited all that morning and afternoon. By nightfall, seeing my vigilance unrewarded, my mother declared, "What a terrible and peculiar person Antonia is! What has happened to her? She left just like that without even saying good-bye."

During the next several days, my mother and father made inquiries about her of the police. They feared she might have met with an accident. Four days after her disappearance, they put an announcement in the papers, but with no response.

I, however, knew Antonia better than my parents. I realized that her departure was no more mysterious than her arrival had been. Little by little, I began to accept it.

At the end of dinner one night, my mother asked me with tears in her eyes, "But after she came to meet you by a real miracle, don't you have any feelings for Antonia? Aren't you worried about her? Are you the monster I feared you were when you opened the live mouse to see how a child comes to life?"

I had no language to answer my mother. She became furious at my silence and screamed hysterically, "My son, I am less than a dog to you. Isn't it so? Answer me at once!"

Without being able to control myself, hard as I tried, I burst into loud laughter. Then I sang the Tarascan song Antonia had sung to me the last time we were together.

My mother's eyes grew wide. Real terror showed in her face. Glancing at me as if she feared that I would do her some harm, she got out of her chair and ran to the living room where my father was working at his books. After a while, I grew quiet. I went to find my mother, to placate her.

Approaching the living room, I heard her whisper to my father, "It is necessary to do something for the boy. I'm afraid he's out of his mind."

My father laughed softly. "No, *Chiquita*, he's all right. You gave birth to him, but that one gave him life. No matter where she is, he feels she will always be with him and will never leave him."

"*Por Dios!* You have gone as mad as the boy. What do you mean? Where is Antonia now? What has happened to her? Why will she never leave him? I don't understand. Why is it my destiny to live with people as crazy as the two of you?" And my mother began to cry bitterly.

Stealthily I went away. I walked out of the house into the street. The night was clear, familiar and warm.

No, Antonia would never leave me.

REVOLUTIONARY WITH A PAINTBOX

 HAVING REGAINED MY STRENGTH, I began to paint again. I was determined to exorcise the Spanish influences remaining in me. I worked chiefly on landscapes into which I tried consciously to infuse a strong Mexican character. Of these, I know only one that has been preserved; it is a landscape in the Paul Antebi collection in Mexico City.

The effect of these efforts did not prove lasting. When I returned to Europe in 1912, I experienced a complete regression in style. In-

Toledo, I did a painting which, though it suggests a growing awareness of naturalism and cubism, shows the influence of El Greco. This painting was purchased for the King collection in New York; about twenty-five years ago, it was in the possession of a Mrs. Murphy, who loaned it for an exhibit sponsored by the New York Museum of Modern Art. In the same year in Paris, I painted a portrait which shows a similar Spanish derivation. Titled "The Man with the Umbrella," it appeared in an exhibition organized by the Mexican artist Ángel Zarraga. I do not know what was the fate of this work, nor do I much care.

During the four years I had been away from Mexico, the political situation had deteriorated, and unrest was reaching a revolutionary pitch. Díaz, sensing that the end of his thirty-year dictatorship was near, yet unwilling to relinquish absolute power, was resorting to open terrorism.

One day a friend of mine named Vargasrea and I had a lunch appointment with a third comrade, General Everaro Gonzales Hernández, in a popular restaurant in Mexico City. Vargasrea and I were late, because I had been painting in a distant part of the city, and it took us longer to get to the restaurant than we had anticipated.

On our arrival at the restaurant, we found General Hernández rolling in agony on the floor. He had been poisoned, but no doctor had been summoned by the frightened waiters and customers.

Gasping his last breath, he told Vargasrea to sell his horse, his saddle, and his side arms and use the money to pay his debts. These possessions, he said, were all he had left in the world. And then he died. Thanks to our being delayed, Vargasrea and I almost certainly escaped being poisoned, too. Many other opponents of the dictatorship had died after eating an apparently harmless meal.

As a contribution to the revolution, I designed a huge poster, copies of which were distributed among the peasants throughout all Mexico. Its message to the poor, ignorant farmers was that divine law did not forbid them to repossess the land which rightfully belonged to them. The corrupt Church of the time had been preaching the converse.

The slogan dominating the poster read: THE DISTRIBUTION OF LAND TO THE POOR IS NOT CONTRARY TO THE TEACHINGS OF OUR LORD JESUS CHRIST AND THE HOLY MOTHER CHURCH.

Since the majority of the peasants could not read, the message was illustrated by a painting showing a family plowing their field behind a team of oxen. Above the oxen hovered a benevolent image of Christ fondly gazing upon his children, whom he blessed for preparing the field for growing.

My paintbox might symbolize my state of mind at this time. Underneath the tubes of color was live ammunition, which I carried to partisans behind the government lines. Many of these revolutionary fighters were friends of my childhood and early youth.

Every district of Mexico City had its network of underground cells. I was sometimes invited to speak to the members, usually about painting. I fulfilled my assignments to the letter, but I also seized upon every pretext to inspire my audience to greater revolutionary fervor.

But, the poster excepted, I did not do a single sketch expressing my revolutionary feelings. My eyes were, however, transmitting to my brain continuous, vivid images, which have never lost their distinctness. When I later painted scenes going back to this period, I seldom had any need of preliminary drawings.

A PLOT TO KILL DIAZ

 FROM TIME TO TIME, I continued working on landscapes. I also began to prepare an exhibition of the paintings I had brought back from Europe. I went about this task with inward repugnance because of my dissatisfaction with these works. However, I was badly in need of money. I wanted to return to Europe to resume my studies, and I had not forgotten Angeline.

I was helped in my preparations for the exhibition by my friend Francisco Urquidi, then Secretary of the School of Fine Arts, and its Director, Lebrija. My former teachers José Velasco, Felix Parra, and José Posada also took part in arranging the show.

Perhaps because I was bored and disgusted, I hatched a plot with Lebrija and the architect Eduardo Hay to give the exhibition a more worthwhile purpose. Our aim was nothing less than the assassination of Díaz, which we believed would save the lives of many brave Mexican freedom fighters.

The exhibition was to open at eleven o'clock in the morning on November 20, 1910. My part in the plot was to smuggle explosives

into the school in my paintbox. My friends, the officials of the school, pulled wires to get Díaz to attend the opening. We were elated when we received word that Díaz had accepted their invitation.

I arrived at the school long before eleven and met Lebrija. A tall and gaunt Don Quixote, he was nervously wringing his hands in impatience.

He said, "All right, Diego, we are awaiting the command of the *pestilente*," and his eyes shone with a bright unnatural fire.

As I climbed the stairway, paintbox in hand, I saw Urquidi staring down at me. He didn't say a word but practically pushed me into his office, took the box, opened the small steel safe which contained the school funds, and locked the paintbox inside it.

"It will stay there till the right moment," he declared, embracing me warmly and whispering in my ear, "*Viva la Revolución.*"

But, unfortunately, the right moment to open the safe never came. A few minutes after the explosives had been stowed away, the Chief of Police arrived at the school, accompanied by plainclothesmen, uniformed police, and soldiers of the regular army. Politely, he asked for Lebrija, the Director, who, I knew, was now too scared to come down. I told the Chief that he had not yet been seen.

At last, having screwed up his courage, Lebrija appeared, exchanged introductions with the visitors, and took them on a tour of the school as he was expected to do. Along the way, the police examined everything they came upon—except the safe. Which goes to show how their respect for property can be used against the police.

I was with Urquidi, near the door of his office, when the police approached. The Chief stepped forward to shake hands with Urquidi, who then introduced me. When the cops looked around, Urquidi made a gesture as if to open the drawers to show them that nothing was hidden there, but the Chief stopped him.

"What do you mean, architect?" he asked good-humoredly, and then ordered his men to leave the building. Then, promising to return with the President to see my paintings, he bowed himself out.

But instead of Díaz, his wife, Doña Carmen Romero Rubio de Díaz, patroness of the arts and philanthropy, arrived as the President's representative. It was she who officially opened the exhibition. Señora Díaz asked permission to make the first purchase. She paid handsomely for "Pedro's Place," actually the most important canvas in the show. It pictured a group of Basque fishermen and their wives returning from work. This painting, as well as many others of my early and late years, is today in the collection of Solo Hale in Mexico.

Before leaving, Señora Díaz congratulated me with a fine aristocratic smile. But I was really disappointed; there had been no occasion to open the steel safe.

Perhaps the Chief of Police was cleverer than we were. I prefer to believe that Señora Díaz was cleverer than he and the men who had hoped to murder her husband.

Dehesa

 Though our plot against Díaz fizzled, the exhibition was a huge success. Of all my paintings only two were not adorned with the cards of purchasers when the opening day was over.

But the day had had its bad side. At four o'clock in the afternoon, I had received the news of the heroic resistance and death of a brother revolutionary, Aquiles Serdán. With the support only of his wife, his brother, two sisters, and a neighbor, Serdán had stood off the entire garrison of Puebla. His aged mother had passed the ammunition for the guns. When the troops finally broke into his house, his little daughter was shot down by an officer. The child had been found still holding some cartridges in her hand.

A few months later, the memory of Serdán and his family would revive the flagging spirits of the revolutionaries and help to bring about the downfall of Díaz.

After the exhibition, I went to the south, where I joined Zapata's peasant partisans in the state of Morelos. Much of the time I worked with a former schoolmate named Penioroja. An able mechanic, Penioroja had invented a small, simple bomb, so designed as to blow up only the baggage cars of trains. This saved the locomotives, which were useful to the rebels. It also spared the lives of the passengers, most of them the very people for whom the revolution was being fought.

Penioroja's valuable invention was just the size of my paintbox. That is why, in this period, my artistic output showed no appreciable increase.

At the end of six months as an active rebel, I received a message from Don Antonio Rivas Mercado, an old and trusted friend who was also an official in the Díaz government, asking me to come to

see him at once. He had sent this request with one of his coachmen. As soon as I had digested the words, I jumped into the coach and was driven away.

I found Mercado waiting for me. He immediately directed that I pack a valise with only the barest necessities and arms and tell my family that I had to leave the city for a few days. I was to say that I was visiting the farm of one of Mercado's friends, where I would find interesting subjects to paint. When I told this story in a hasty leave-taking in my home, my mother showed anxiety, but my father seemed to understand perfectly.

Bag in hand, I now rode to Don Antonio's house a second time.

He said, "You might well say you've been lucky to have a friend in the Díaz government. Unless you leave in my carriage at once and get as far from Mexico City as you can by tonight, without being seen, you'll certainly find yourself before a firing squad. The order for your arrest and execution for treason has already been issued. Fortunately, the Chief of Police is a relative of mine and a good friend of your father. He was the one who passed on the warning to me. He promised, even if he gets fired, to hold up the order till seven o'clock tonight. Good luck."

Urgency in his face, he embraced me. I hurried out and lay down flat on the floor of the carriage. The coachman, already instructed, took the road towards Puebla, passed through Tlaxcala, and arrived late at night in Apizaco. There I felt safe enough, seeing no government soldiers about, the partisans being in control of much of the territory in this region.

The next day I boarded a train to Jalapa, the home of my sponsor, Governor Dehesa. This noble man, always highly esteemed by all the old liberals, was still respected, even by the revolutionaries. The City of Jalapa was surrounded by insurgent troops, but because of Dehesa they hesitated to lay siege to it.

As the train approached Jalapa, it was halted by a party of guerillas. Their chief and an armed escort climbed into my car to look for arms and ammunition. The partisan leader asked the passengers if any of them wanted to give money or clothes for the revolution. Everyone in the car contributed something.

I removed my ammunition belt with its revolver, and I presented it to one of the partisans. He laughed aloud.

"Do you carry such an arsenal with you that you can afford to make a present of these?" he asked. "With what are you, yourself, going to fight?"

Looking directly into his face, I recognized the worn, tired features of my uncle, Carlos Barrientos.

We shook hands warmly.

"Diego, where are you going? Did you come here to stay with us?" he asked.

"No, Uncle, I'm going to Jalapa."

"All right. In that case, you can give us your arms and get as many weapons as you need from Governor Dehesa. I understand now why you offered them. Good. The more we have, the better. You can tell Governor Dehesa that he has nothing to fear from us. We know him to be a real liberal, always opposed to the damned reactionaries. Tell him we're sorry he can't be one of us, but we realize that, as a man of honor, he has to show loyalty to his old friend, Díaz."

On my arrival in Jalapa, I went directly from the depot to confer with the Governor. He greeted me warmly, and when I gave him my uncle's message, he was deeply moved. A sad smile passed across his face. He said not a word, but shook his head in a gesture of gratitude while tears gathered in the corners of his eyes.

After about a minute of thoughtful silence, he asked, "And why can't I join them? They are my own people, really my sons. My big brother Díaz mistook his way. Nothing can again stop the revolution. There may be a long fight, but once the people are aroused, they always win. But should I renege on my old friendship with Díaz for that? Could the historians of the future be sure of my motives? Would it not be thought that I joined the uprising to be on the winning side? I fought beside Díaz when he was a persecuted rebel and trapped like a mad dog. Also, my boy, I'm old. You like me because my door and my hand have always been open to anyone who wished to enter my house."

What he had said was true. In fact, the hinges of his doors were rusted because, in all the years of his administration, they had never been closed.

Dehesa then asked me my plans, and when I told him that I wanted to return to Europe, he expressed his gratitude for the trust I had shown him, an official of the Díaz government. He gave me some messages to bring to the rebel leaders, saying that he would send an escort party with me.

I took my leave and went to my room. While I waited for the escort, I changed into a rough riding habit. Dehesa's guard arrived at the same time as my friend, the painter Argüelles, and everyone's eyes opened wide on seeing my costume.

Argüelles exclaimed, "*Caramba!* What a big bandit you look like in that getup!"

When I glanced at myself in the mirror, I had to agree with my friend. I certainly looked big and tough.

In the insurgents' camp, the leaders refused to deal with anyone but me. I gave Dehesa's messages to them and afterwards they gave me a message of friendship to bring back to the Governor.

At the rebels' invitation, Argüelles and I spent four or five days in the camp. As we were preparing to leave, one of their chiefs approached me.

"Why are you going, Rivera? If you live long enough to be an old man, you will realize that you could not have fared better anywhere in the world than right here among us." He threw back his head proudly and gestured toward the wonderful landscape.

I thanked him but told him I knew the only road I must travel.

For the truth was that this phase of the revolution was almost at an end. The peasant irregulars of Orozco, Zapata, and Pancho Villa were sweeping on to certain victory. There was no more I could do now. I knew that the masses who were toppling the leaden throne of Porfirio Díaz were not ready to take power for themselves. Díaz's henchmen would be supplanted by "professional politicians" and petit bourgeois time servers who would move quickly to harness the strength of the people. There would be a show of reform, but the social and economic inequalities which had given rise to the revolution would appear again out of the smoke and dust. And there would be more conflict and violence.

Perhaps, at a later time, when I had found myself as a man and an artist, I would return to my beautiful homeland and teach the people what they must learn.

So I went back to Jalapa and delivered the rebels' message to Governor Dehesa. Then I took time out to paint a landscape. I used the nearby forest as a foreground and limned the majestic mountains in the distance.

About a week later, I sailed for Havana. There I booked passage to Europe.

SEA DUTY

 I SAILED ON THE *Alfonso Trece,* an old Spanish steamer, overdue for the scrap heap. The *Alfonso,* however, was the easiest vessel to board with my irregular papers. Her destination, Spain, was also the least difficult country through which to enter Europe.

The ship remained in Havana for about three days. From Havana, the journey to the nearest Spanish port usually took eighteen or nineteen days. This voyage, however, lasted seven days longer.

The third day out of Havana, I perceived a great deal of uneasiness among the officers and for a good reason. The *Alfonso* was short of lifeboats and other rescue equipment. A gale was blowing, piling up high seas in which the old steamer rolled dangerously. The passengers grew sick, and every day fewer of them showed up in the dining room.

Finally, there were only three coming to meals. I was one. The other two were both sea captains. Naturally, we became good friends.

The younger of the captains, a Catalonian named Roig, was about thirty-five and full of sharp Mediterranean humor. His conversation was as tangy as garlic and as light as olive oil. Roig was a minor executive of El Valle Nacional, a wealthy tobacco firm, infamous for its exploitation of its workers during the Díaz regime, and he himself was anything but gentle. In addition to supervising the virtually enslaved tobacco workers, he made commercial sea voyages to South America with cargoes of tobacco products, vanilla, and indigo, which he traded for algaroba in Peru and coffee in Brazil. When the opportunity presented itself, he was not averse to enlarging his exchequer by smuggling contraband.

The older sea captain possessed the almost unpronounceable name of Huruchaustegui. He had sailed in such faraway waters as the Indian Ocean and the Melanesian and Micronesian Seas. He could recall experiences of seventy years before. He must have been at least eighty-five. This venerable sailor was returning to Spain to die in peace on his native coast. Captain Huruchaustegui spoke a strange language which consisted of almost no Spanish, a little Japanese, more Chinese, and a great deal of Malayan. Though it was almost impossible for anyone to understand him, he would make long speeches throughout the day.

Each morning, the two captains and I would meet for breakfast. The crew, aware that my companions were captains and I their friend, made us the delighted recipients of the choicest food and the most devoted service. Our dining-room steward wore his pants rolled up high above his knees, because the sea washed in through all the doors.

With so few customers the ship's cook had opportunity to use all his art, and we encouraged him with congratulations and applause. Breakfast was so enormous that we only had time to smoke two or three cigars before lunch was served. Besides, there really was no reason to leave the dining room.

What marvelous lunches we had! No soups, because it would have been impossible to eat them, but unbelievably juicy steaks, delicious red snappers, and huge sweetmeated crabs.

When the dishes were ready, the steward would place them before the older captain who, making the sign of the cross over his head and chest, would then commence to cut the meat into three equal parts. As he served, he would chant, "In the name of the Father," putting the middle part in his plate, "in the name of the Son," in the Catalonian's plate and "in the name of the Holy Ghost," in mine.

Many bottles of wine were likewise emptied in honor of the Holy Trinity. We made each other laugh and sing, and each of us would retell the story of his life without any of the others listening, caring, or understanding.

On the eighth day of this ecstatic regime, the first mate entered the dining room and politely asked permission of the captains to have a few words with me privately. We were about to be served our lunch-hour liquor, and I assumed the mate was going to speak to me about the way we had been swilling the ship's supply of intoxicants.

It turned out, however, to be nothing of the kind. "Above everything," he began, "I first convey to you and the two captains, your friends, the apologies of our Old Man, who would have liked to enjoy the good company of you hard-boiled mariners and guests of his ship. I want to tell you, personally, how sorry I am, too, not to have partaken of your company, as the rules require. But I'm certain you understand the situation. You're all good enough sailors to know there's a chance of our going under. And we know that when things are as they are, only real seaman can eat and drink as you've been doing. The trouble is we're carrying civilian passengers who have no understanding of our precarious situation.

"The Old Man and I have literally not closed our eyes for the past two days. The Old Man sleeps at the commander's desk, standing

up. He's practically through. The men below are in the hands of the ship's doctor.

"The tradition of the sea authorizes the skipper to ask a meritorious service from any professional seaman traveling on his ship during an emergency. Therefore, my boy and comrade, you must excuse me for asking, but would you please convey the Skipper's request to your captain friends. He asks them to take one turn every three days at the commander's desk, and you, if you will, shall divide my time with me."

I replied promptly and with gusto, "Fine, I'll tell the captains pronto and I know they'll be as greatly honored as I am. But, my friend, I'm not really a seaman. I could as easily be a substitute Pope as a substitute sailor."

"Stop talking like that, my boy! Do you think I came to talk to you without first studying the passenger list? You're the Mexican painter, Diego Rivera. All right; but as good a painter as you may be, no damn fool in the entire world could eat, drink, and have such fun when he knows his ship might sink momentarily if he didn't have the stuff of a true sailor. So that's settled."

I didn't attempt to argue with him. I remembered my feelings as a child when I had seen the ship model in General Hinojoso's library. I thought of boyhood days on the beaches of Veracruz, where I had battled the surf raised by the furious north wind. I returned to the table and gave the captains the message. They responded with whoops of joy, the Catalonian Roig twirling his mustaches in anticipation.

When I got back to the first officer, I asked, "Listen, friend, who is in charge downstairs, below deck, right now?"

"Only the cargo master. Both of the officers are out of service," he said.

"Then I will go downstairs and stay there until one or the other of these men recovers sufficiently to replace me."

"But how dare I allow that? That's the hardest service on the ship."

"Two of your men are out. Have you the right to refuse replacement?"

The first officer stiffened, looked me square in the eye as he touched his hand to his cap, and said smiling, "You're right, Mexican. That's the way of your country. Thank you!"

He left to get me service togs and soon returned with a helmet with microphones over the ears and a pair of coveralls for protection against the heat. When I had dressed, he gave me two long whips and a pistol.

"These are to preserve your authority," he explained.

I started downstairs toward the hold. Here, through clouds of smoke and black dust, I could see the cargo. I knew that the heavy crates had to be shifted frequently in order to keep the ship balanced; that if the ship tipped too far, the skidding boxes would smash the hull. I could see a pair of soot-stained mariners engaged in the backbreaking work of lifting an enormous crate.

I walked past them, threw my whips and pistol in a corner, and adjusting my helmet, shouted to the men, "Listen, comrades, I'm nothing but a Mexican passenger. I'm here because I was asked to help. I'm as interested as you are in stopping this ship from going to hell and taking us all with it. A Mexican comrade does not need whips or guns to keep his Spanish comrades working. Isn't that so? So I'm going to tell you what the man upstairs ordered, and you're going to do it."

After looking me over, they shouted back, "Go ahead, we're with you!"

The men worked on without pause or complaint though, by now, they were on the verge of exhaustion.

I was inspired to pitch in with more energy than I had believed I possessed. In the darkness of a ship's hold there is no way to measure the passing of the hours except in variations of pain and fatigue. Three or four times I was asked from above whether I needed to be replaced. Looking at the valiant sailors, on the point of collapsing before my eyes, I angrily answered "No!" I held my post until the rolling of the ship subsided and the danger was past.

Before we arrived in Santander, my port of debarkation, the captain of the *Alfonso* gave a banquet for his passengers, honoring the bravery and courageous services of the two captains and the Mexican painter. More important, he presented gifts of three thousand pesetas to each of my captain friends and two thousand pesetas to me, which I admit I appreciated more than the glory.

The captains and I spent all our money together along the way from Santander to Madrid and Barcelona, trying to have an even better time ashore than we had had in our first days at sea. When our money ran out, I took regretful leave of my shipmates and entrained for Paris. In September, 1911, I was in Paris again.

REUNION WITH ANGELINE

 In Paris, I immediately went to see Angeline Belloff. Our reunion was rapturous. Both of us had agreed to wait until this moment to see whether our love was strong enough to withstand the test of separation.

We now decided to live together.

For the next ten years that I spent in Europe, Angeline lived with me as my common-law wife. During all that time, she gave me everything a good woman can give to a man. In return, she received from me all the heartache and misery that a man can inflict upon a woman.

We later had a son, the only son I have ever sired, who died of meningitis before he was two years old.

In a little while, I had set up a comfortable ménage and recommenced my studies and experiments in painting.

PICASSO

 In 1913 I had reached the cubist phase of my development. I worked hard at my cubist paintings all through that year and the first half of 1914, because everything about the movement fascinated and intrigued me.

It was a revolutionary movement, questioning everything that had previously been said and done in art. It held nothing sacred. As the old world would soon blow itself apart, never to be the same again, so cubism broke down forms as they had been seen for centuries, and was creating out of the fragments new forms, new objects, new patterns and—ultimately—new worlds. When it dawned on me that all this innovation had little to do with real life, I would surrender all the glory and acclaim cubism had brought me for a way in art truer to my inmost feelings.

But in 1913-14, nothing was more exciting in art than the cubist movement. Shortly after the beginning of 1913, to prepare for the Salon d'Automne, I went to Toledo, Spain, to do a series of paintings which openly connected me with the movement. I later used some of these Toledo canvases in my first one-man show in Paris in 1914.

At about this time I also painted three memorable noncubist works: a portrait of my elegant fellow artist Adolfo Best; a big ferris wheel; and a foreground of the Montparnasse Station.

I could see the latter from my studio window and, in the painting, I tried to give an impression of the trains in motion. It was a large canvas, and my friends were so impressed with it that they urged me to send it to the Independent Artists Exposition, which I did. A good friend of mine on the placement committee gave the work the best space in the show. It proved to be one of the most popular canvases, and reproductions of it were published in several art reviews. It was even caricatured among a selection of the best paintings of the shows of the year.

On another journey to Toledo, I completed certain canvases I had started there and did many new ones. I brought all these paintings back with me to Paris in the fall of 1914, dividing most of the completed ones between the Salon and the Independents and sending the remainder for display in Prague and, later, the United States.

In 1914 I was already beginning to be referred to by the critics as one of the more interesting members of the cubist movement. I was even gaining a certain fame among the *avant garde*. Best of all, I was living on the practice of my art, and painting as I liked.

The greatest of the cubists and my idol at the time was Pablo Picasso. I was eager to meet this already celebrated Spaniard, but my shyness prevented me from approaching him directly. Somehow, however, Picasso learned of my feelings toward him and one day he sent me a message through a mutual friend.

This friend, the talented Chilean painter Ortes de Zarete, came to my apartment early one morning. "Picasso sent me to tell you that if you don't go to see him, he's coming to see you."

I accepted the invitation with pleasure and gratitude and immediately accompanied Zarete to Picasso's, together with my friends the Japanese painters Fujita and Kawashima, who were posing for a canvas I was then doing. This was a portrait showing two heads close to one another in a color scheme of greens, blacks, reds, and yellows. Typical of my work of this period, it owed not a little to Mondrian, a good friend and neighbor, with whom I had been exchanging ideas and artistic experiences.

ssed in the costumes used for the portrait, my Japanese mod-els looked picturesque and amusing. Both wore long toga-like robes and sandals. Their hair was cut in bangs over their foreheads and encircled with colored ribbons. They appeared to have stepped out of a schoolbook of ancient history.

I went to Picasso's studio intensely keyed up. My feelings were like those of a good Christian who expects to meet Our Lord, Jesus Christ.

The interview was marvelous. Picasso's studio was full of his exciting canvases; grouped together they had an impact more powerful than when shown by dealers as individual masterpieces. They were like living parts of an organic world Picasso had himself created.

As for the man, will and energy blazed from his round black eyes. His black, glossy hair was cut short like the hair of a circus strong man. A luminous atmosphere seemed to surround him. My friends and I were absorbed for hours, looking at his paintings. Our interest so pleased him that he let us see his most intimate sketchbooks. Finally, Zarete and the Japanese said good-bye and left; but when I made a motion to go, Picasso asked me to stay and have lunch with him, after which he went back with me to my studio.

There he asked to see everything I had done from beginning to end. I had completed my painting "Sailor Eating and Drinking," and several others that I liked: a second portrait of Adolfo Best called "The Man in the Stilograph" (now in the collection of the sculptor Indenbaum); and the still lifes "Balalaika" and "Bottle of Spanish Anise."

After I had shown Picasso these paintings, we had dinner together and stayed up practically the whole night talking. Our theme was cubism—what it was trying to accomplish, what it had already done, and what future it had as a "new" art form.

With this meeting, Picasso and I became great friends. He brought all his own friends to visit my studio: the writers Guillaume Apollinaire and Max Jacob; the painters Georges Seurat, Juan Gris, and others. Picasso's enthusiasm for my work caused a sensation in Montparnasse. My contemporaries who felt kindly toward me were gratified and those who did not were surprised and outraged.

Being accepted by the master of cubism himself was, of course, a source of tremendous personal satisfaction to me. Not only did I consider Picasso a great artist, but I respected his critical judgment, which was severe and keen.

My enthusiasm for Picasso has not lessened, though today I would qualify it by two reservations. It seems to me that, in every one of his periods, Picasso has shown more imagination than originality, that everything he has done is based upon the work of some-

body else. Also, I have come to feel that Picasso appeals chiefly to the emotions of the upper classes. In contrast with an artist like Renoir, for instance, he lacks a genuine universality. Renoir's first paintings were bought by such ordinary people as his wood dealer and his butcher. It would be hard to imagine Picasso's canvases hanging in any kind of worker's home.

In Paris, Picasso and I used to have the best times, especially when we were by ourselves. Then we would say things about other painters which we would never tell anybody else.

We would walk through the art galleries and take off on other artists' styles on the backs of match boxes. In a spirit of pure mischief, we would often play tricks on our women acquaintances, among whom I had acquired a terrible reputation.

When one of them would come to his studio, Picasso would hide me behind a door. In the course of the conversation, Picasso would happen to mention my name. This would inevitably provoke a stream of epithets from his unsuspecting guest. Picasso would laugh heartily, shrug his shoulders, and say, "Well, *I* said he was an angel."

WAR

 IN MY ONE-MAN SHOW at the Galerie Weill, at the beginning of 1914, I showed both Spanish and French landscapes, still lifes and portraits, including those recently completed of Fujita and Kawashima, "Young Girl with Artichokes," and "Young Girl with a Fan." This, my first European one-man show, was an emphatic declaration that Rivera had become a cubist.

Two works I painted about this time, in which I still feel some pride, are a large canvas called "The Girl Friend" and a portrait of the sculptor Jacques Lipschitz, commonly known as "The Man in the Sweater." Though I had still not mastered the cubist idiom, the latter painting, in particular, was well received. Even today it is admired. Not long ago it was included in an exhibit of modern portraits in the New York Museum of Modern Art. It is a well-constructed canvas, done with warmth and grace.

In the summer of 1914, I painted "The Clock," a surrealistic work with a humble alarm clock, a Russian balalaika, and an advertisement of Shustow cognac in the foreground; and a blue sketchbook and a Mexican motif, a multicolored serape, in the background. I favored the clock because clocks havez always been important to me. For some reason, I cannot fall asleep without one ticking underneath my pillow. I carry a clock with me everywhere I go, on boats, trains, and planes.

At the end of my show, in the pre-war months of 1914, Angeline and I made a trip to the Mediterranean island of Majorca, the largest and most beautiful of the islands off the coast of Barcelona.

Among the friends who accompanied us were the beautiful dancer Varmanova and her Russian poet husband; the sculptor Jacques Lipschitz; a student friend of his named Landau; and an English painter whom we called Kenneth. Myself excepted, no one in our group believed that war would come. Angeline and our friends were all pacifists. Unable to conceive of violence on a large scale, they dubbed me "The Wild Cowboy" for believing that the "civilized" nations of Europe would soon fall upon one another in mass orgies of killing.

Despite my conviction that war was inevitable, I had joined my friends when they risked their necks in workers' demonstrations against war, and now I wished with all my heart that I would be proved wrong. It was not, however, long before they began to see how events were tending. On French Independence Day, July 14, 1914, we were all drinking and making merry when the news of the Austrian Archduke's assassination reached us, and it was reported that fighting was already going on in the Balkans.

Soon after, we took the ferry to Barcelona, where we heard the ominous report that Russia had just declared war upon Austria. However, Russia's allies, England and France, had not yet acted. Our company could not decide what to do, and it was with a feeling of helplessness that we reembarked for Majorca. As we neared the coast, we saw an English destroyer firing at a German submarine.

We stayed three months longer on the wonderful, isolated island, feeling as remote from the conflict on the continent as if we were in the South Seas. Finally, mobilization orders came for the Russian poet and the English painter, both of whom were reserve officers. The rest of us, Lipschitz who had tuberculosis, Landau who simply didn't want to be killed, and myself, citizen of a noncombatant country, huddled together in Barcelona for several days.

We had run out of money. We had expected to go back to Paris and there sell some of our work, but that was now impossible. Landau, whose father was a banker, succeeded in getting some cash, which he divided with the rest of us.

It didn't amount to much. My subsidy from the Veracruz government had vanished with the downfall of Madero in 1913, and Angeline and I had only one other source of money we could count on. Angeline had been commissioned to paint the Russian national emblem on the wall of the Russian consulate in Barcelona. The payment she received made it possible for us to exist a few more days.

Our situation was further aggravated by the surprise arrival of my mother and my sister from Mexico. Fearing that I might go off to the front, they had come to see me for what they thought might be the last time. So great had been their concern that they had not thought to arrange for passage back nor did they have the money to do so. Angeline and I now had to sell everything we owned to pay for their return tickets.

No sooner were they gone than another unexpected guest arrived, my cousin Juan Macías. He suddenly appeared one day in the doorway of our flat. He had been studying in Germany, where he had been the pet, not only of his tutors, but apparently, also, of many beautiful young fräuleins. Juan was short but well built and exceptionally strong, and his favorite amusement was to have me punch him hard in the stomach, with all my might.

"Harder," he would say. "That didn't hurt at all."

For the mere pleasure of seeing the lovely boulevards of Barcelona, Juan accompanied me when I went painting street scenes. The girls of the town would sometimes gather round us in the belief that we were carnival artists. I, of course, wore my Mexican costume. Juan, having left Germany in a hurry, had brought along only the formal clothing he had been wearing—a derby hat, a long jacket, a fancy dark-gray waistcoat, striped pants, and dapper shoes. It was easy to mistake him for a circus manager or a minor diplomat who had gone astray on his way to a consular reception.

Juan's tutor and other German friends had convinced him that Germany had become his second fatherland and that he owed some service to that nation. As his first assignment, he had been requested to return to Mexico and buy lemons, used in the manufacture of citric acid, important in war chemistry. A German-American electrical concern had given him a large sum of money to carry out this task.

Juan decided that he could act more effectively with a title of nobility, and that had been his reason for coming to see me. He knew I could revalidate my family title before the Spanish court simply by paying the required taxes. Through my paternal grandfather and father, I was entitled to the rank of marquis under the then existing Spanish monarchy.

Though I ridiculed the scheme, I paid the taxes from money Juan gave me and then renounced the title in his favor for a further sum.

With this latter money, Angeline and I were able to leave Barcelona. We journeyed to Madrid, where we decided to remain awhile and work. It was now impossible to paint in France, and many other artists had already left Paris to work in Madrid. Among these were Robert Delaunay, the remarkable colorist, a man full of vitality and pretension; his Russian wife, also a talented artist; Marie Laurencin and her husband, a gifted and wealthy German painter who had refused to fight against France for the German bankers; and our old friend María Gutiérrez Blanchard, who was now doing original and beautiful work. We also met two of my countrymen, the writer Alfonso Reyes and the architect and art critic Jesús Guizo y Acevedo, whom a turn of Mexican politics had forced to remain in Madrid.

While in Majorca, I had continued my experiments with cubism. I had attempted to achieve new textures and tactile effects by mixing substances like sand and sawdust in oils. Utilizing the results, I had done several interesting landscapes. In Madrid, I now painted some portraits with unusual textures, the most notable being ones I did of Guizo and Ramón de la Serna. All of these paintings contained innovations later employed by the surrealists. At that time, however, they were part of my cubist experiments.

I also did a painting of a Madrid bull ring which still interests me today. This canvas and a landscape of Majorca are in the collection of Alfonso Reyes. Another Majorca landscape is owned by my first Mexican wife, Lupe Marín.

During my stay in Madrid, Serna arranged a showing of the works of some of the refugee artists. He dubbed our group *Los Íntegros,* because of our wish to express ourselves with complete integrity. The peculiar subject matter of our paintings was thus also given a certain moral varnish, always necessary in Madrid.

The public of Madrid, however, accustomed to a diet of precooked academicism, responded coldly to Serna's exhibit. The reaction of the native artists and intellectuals veered between indulgent pity and outright contempt; the ordinary people laughed openly and made jokes about our subjects and techniques.

Just after this unfortunate experience, I completed my portrait of Serna. The stir it created was quite unlike anything I might have imagined.

Placed in the window of the gallery which had housed the exhibition of *Los Íntegros,* it immediately attracted crowds of arguing and jeering people. Men and women fought and pushed to get a closer view. Traffic on the boulevard came to a virtual standstill. Three days later, the Mayor of Madrid himself ordered the painting removed from the window.

The portrait showed the head of a decapitated woman and a sword with a woman's hair on its point, plainly the weapon which had beheaded the woman. In the foreground was an automatic pistol. Beside it and in the center of the canvas was a man holding a pipe in one hand, in the other a pen with which he was writing a novel. He had the appearance of an anarchistic demon, inciting crime and the general overthrow of order. In this Satanic figure everyone recognized the features of Serna, notorious for his opposition to every conventional, religious, moral, and political principle. But the Spanish people, I believe, responded to something more than an effective caricature. The portrait of Serna caught the prevailing spirit of violent disintegration. It gave a presence to their deepest fears with an intensity which their own academic painting had not prepared them for.

After the spring of 1915, I left Madrid for Paris. I took with me all the paintings I had done in Spain except the Serna portrait, which I had given to Serna himself.

Your Painting Is Like the Others'!

 Angeline remained in Madrid while I reconnoitered the situation in Paris. My new paintings caused a sensation in the art colony. Opinion was sharply divided, however. Some critics hailed my latest work. Others, notably the orthodox cubists, proposed excommunicating me because of the exoticism they found in it. And the latter were not entirely wrong. When I study the paintings of this period now, I realize that they distinctly show the influence of the pre-Conquest tradition of Mexican art.

Even the landscapes I did from life in Europe were essentially Mexican in feeling. I recall that, at this time, I did a self-portrait in order to bring into focus the inmost truth about myself. The clearest revelation, however, came from a cubist canvas, "The Zapatistas," which I painted in 1916. It showed a Mexican peasant hat hanging over a wooden box behind a rifle. Executed without any preliminary sketch in my Paris workshop, it is probably the faithful expression of the Mexican mood that I have ever a

Picasso visited my studio to see my new paintings; he had, of course, heard of the controversy concerning them. He looked and was pleased, and Picasso's approval turned practically the whole of opinion in my favor.

Dealers now took me up. Yet, though I had "arrived," I was still searching for a medium which would better express what I had seen and wished to communicate, a medium which used cubist freedom and invention, but without the tangle of conventions which cubism had now accumulated.

What was behind this discontent with the work I was doing, which was souring my success? In part, it was the conviction that life was changing, that after the war nothing would be the same. I foresaw a new society in which the bourgeoisie would vanish and their taste, served by the subtleties of cubism, futurism, dadaism, constructivism, surrealism, and the like, would no longer monopolize the functions of art.

The society of the future would be a mass society. And this fact presented wholly new problems. The proletariat had no taste; or, rather, its taste had been nurtured on the worst esthetic food, the very scraps and crumbs which had fallen from the tables of the bourgeoisie.

A new kind of art would therefore be needed, one which appealed not to the viewers' sense of form and color directly, but through exciting subject matter. The new art, also, would not be a museum or gallery art but an art the people would have access to in places they frequented in their daily life—post offices, schools, theaters, railroad stations, public buildings. And so, logically, albeit theoretically, I arrived at mural painting.

My ideas found little favor with most of the painters with whom I discussed them. The few who thought there might be something in them said, "Theoretically, Diego, your stand may be correct, but where is the example? Your painting is exactly like that of the others."

How right they were! I had to demonstrate my ideas in the only one convincing way—in my work.

My archeological museum, "a composite of Aztec, Mayan and 'Rivera Traditional' styles."

Angeline Belloff

Frida Kahlo

Lupe Marín

Emma Hurtado

MY FOUR WIVES

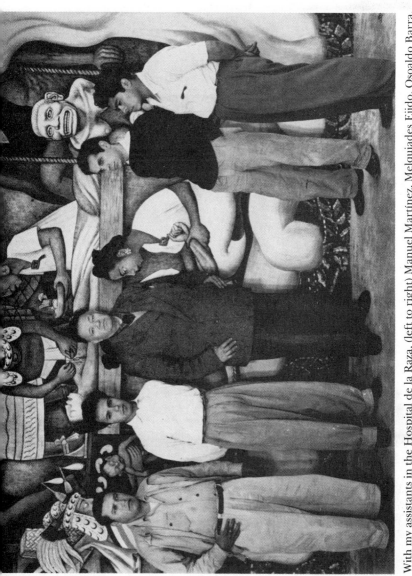

With my assistants in the Hospital de la Raza, (left to right) Manuel Martínez, Melquíades Ejido, Osoaldo Barra, and Marco Antonio Borregía.

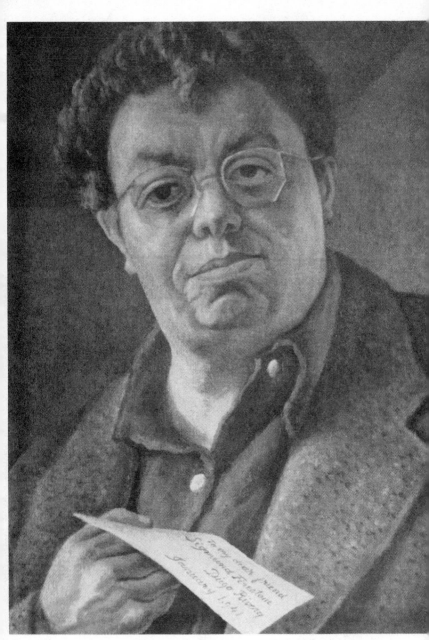

A self-portrait, painted for Sigmund Firestone.

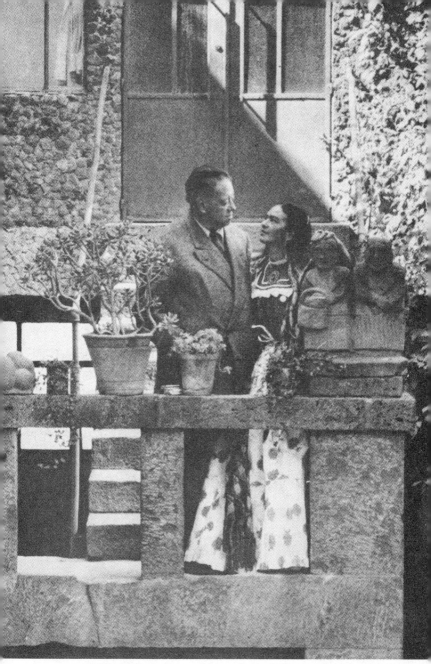

Frida Kahlo and I, outside our home in Coyoacán.

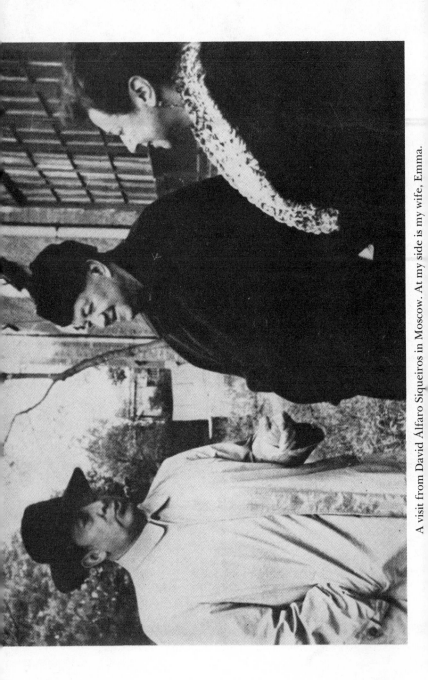

A visit from David Alfaro Siqueiros in Moscow. At my side is my wife, Emma.

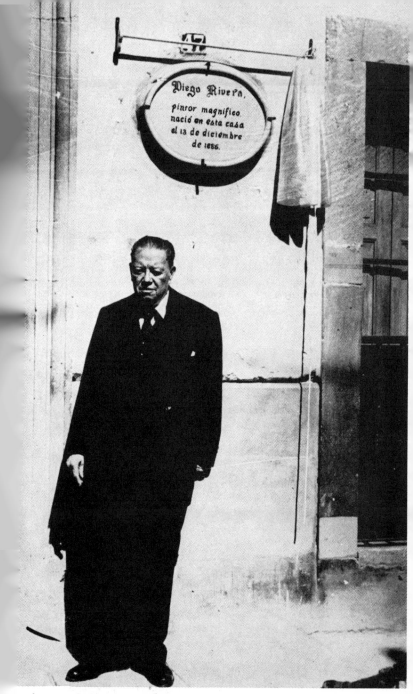

Diego Rivera,
pintor magnifico,
nació en esta casa
el 13 de diciembre
de 1886.

s photograph of me was taken in December, 1956, on the occasion of the
eiling of a plaque outside the house in Guanajuato where I was born.

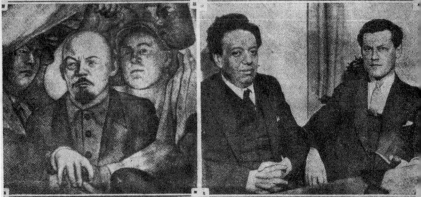

Contemporary newspaper photos covering the Rockefeller Center fracas. At left is the portrait of Lenin on which opposition to my mural was focused. At right, I am seated with my attorney, Philip Wittenberg.

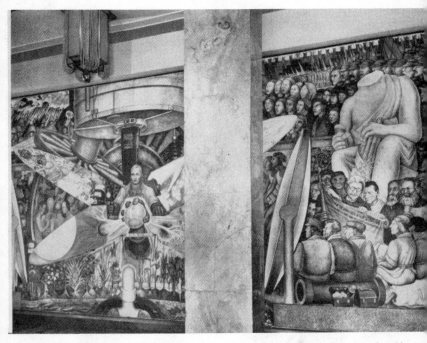

The reconstructed "Rockefeller mural" in the Palace of Fine Arts, Mexico City.

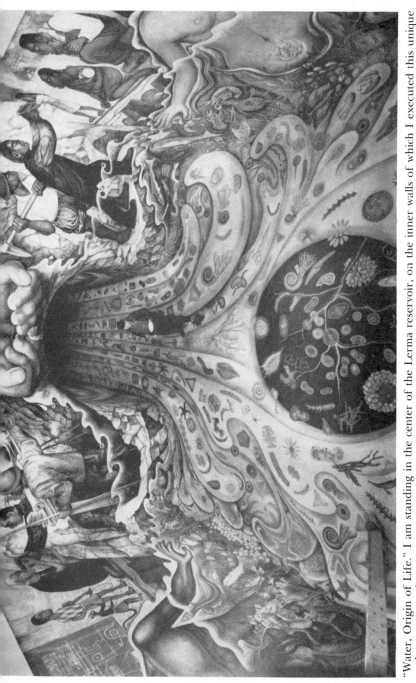

"Water, Origin of Life." I am standing in the center of the Lerma reservoir, on the inner walls of which I executed this unique underwater mural.

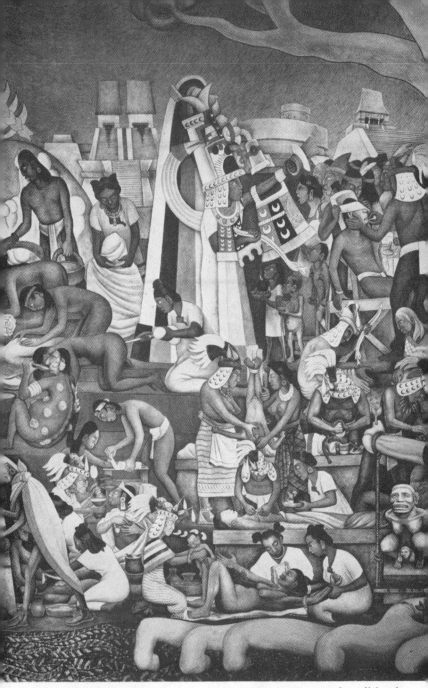

Mural in the Hospital de la Raza, depicting the history of medicine in Mexico.

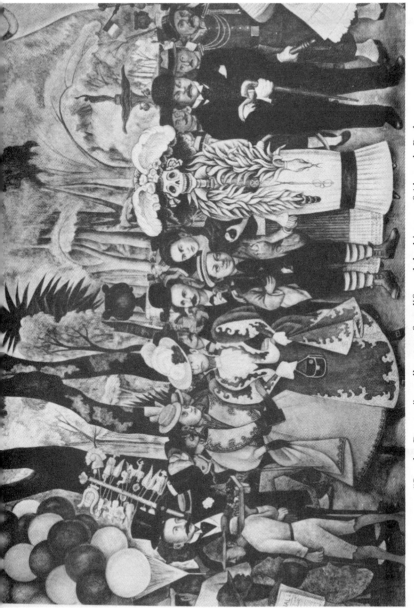

"Sunday Dream," an allegory of my life and the history of Alameda Park.

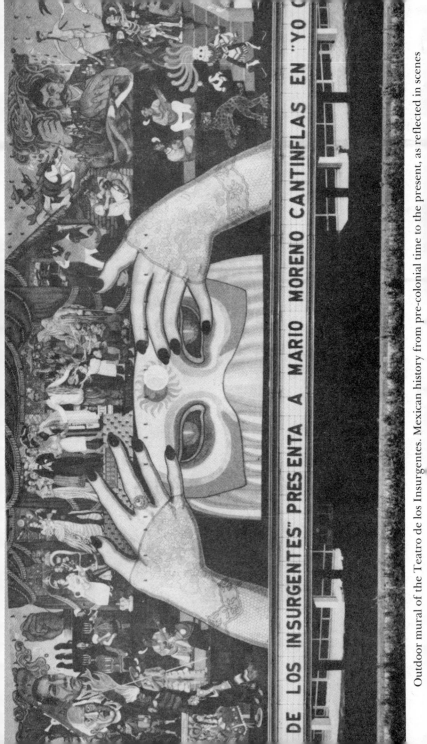

Outdoor mural of the Teatro de los Insurgentes. Mexican history from pre-colonial time to the present, as reflected in scenes

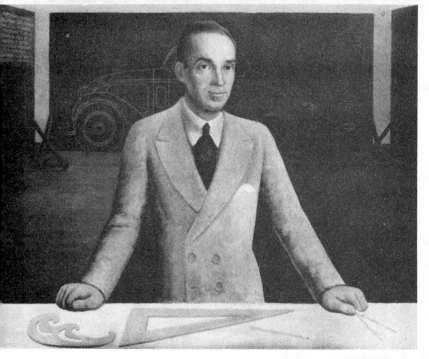

Portrait of Edsel Ford, my bene-
factor in Detroit

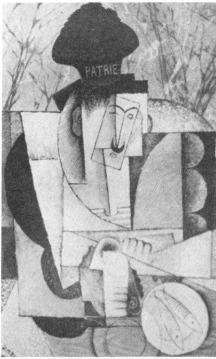

A satirical cubist portrait of my Pa-
risian period.

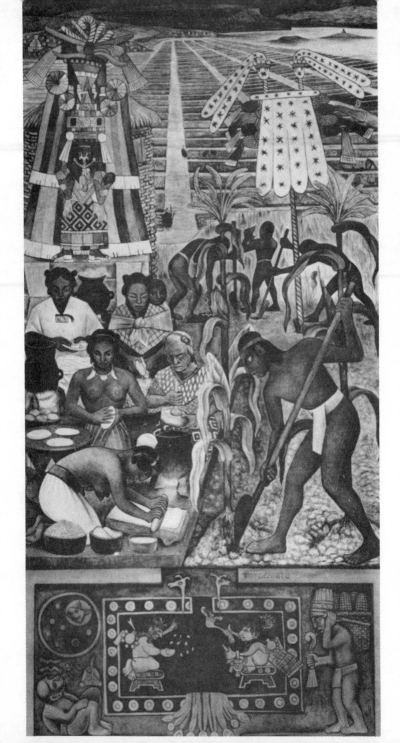

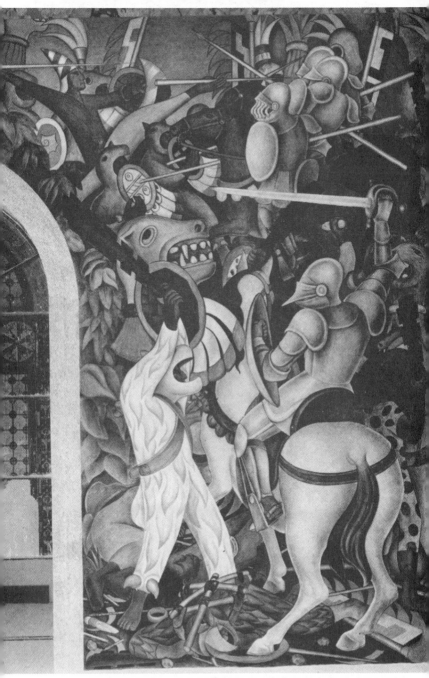

Battle scene in the Cortés Palace mural, Cuernavaca.

(opposite page) A section of my mural in the National Palace, depicting the cultivation of corn.

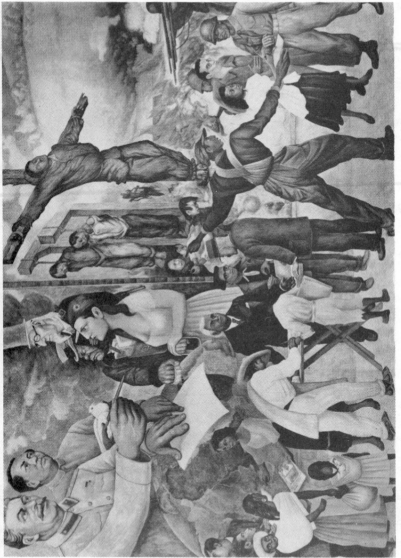

My peace mural. Mexican workers collect signatures for peace petitions, while in the background, Stalin and Mao offer Uncle Sam, John Bull, and Belle Marianne the choice of peace or destructive war.

MARIEVNA

I STARTED ON THE NEW PATH one beautifully light afternoon in 1917. Leaving the famous gallery of my dealer, Leonce Rosenberg, I saw a curbside pushcart filled with peaches. Suddenly, my whole being was filled with this commonplace object. I stood there transfixed, my eyes absorbing every detail. With unbelievable force, the texture, forms, and colors of the peaches seemed to reach out toward me. I rushed back to my studio and began my experiments that very day.

Nevertheless, the beginning proved painful and tedious. In the process of tearing myself away from cubism, I met with repeated failures. But I did not give up. It was as if an invisible force was pushing me onward. During the worst hours, I would find comfort in the precept of my old Mexican tutor, Posada, to paint what I knew and felt. And I realized that what I knew best and felt most deeply was my own country, Mexico.

In this agonizing period, I got no encouragement from Rosenberg, who was disconcerted to see me leaving the profitable high-road of cubism for a risky plunge into the unknown. Rosenberg expressed doubt, then disapproval, and finally rage. He threatened to close the art market to me if I persisted in my waywardness, and for a time, he actually succeeded in making his threat good.

My contract with Rosenberg ran from 1915 to 1918, during which years he expected me to rise to the pinnacle of painting fashion, and he could not forgive me for wrecking his grandiose hopes. Poor man, he was simply incapable of realizing that I was on the way to doing something whose value could not be figured up in so many francs or canvases or years, in accordance with the manner of reckoning to which Rosenberg was accustomed.

When Rosenberg saw that his arguments had no effect, he turned his mind and energies and one other, more substantial commodity, his money, to prejudice art critics and fellow painters against me.

It was as a result of Rosenberg's efforts that a chapter about my life came to be written. It appeared in a book by the poet André Salmon called *L'Art Vivant* under the title "L'Affaire Rivera." Salmon declared that I had departed from cubism because that school of expression had ceased to please me, and also because Pi-

casso and Braque so thoroughly dominated the cubist movement that there was no important place in it for me.

The first assertion was true enough. My path in modern painting had led from neo-impressionism into cubism and was now leading in a new direction away from cubism. Though I still consider cubism to be the outstanding achievement in plastic art since the Renaissance, I had found it too technical, fixed, and restricted for what I wanted to say. The means I was groping for lay beyond it.

As for my being envious of Braque or Picasso, I will say this. I recognized and accepted Picasso's mastery in cubism from the beginning. I readily proclaimed myself Picasso's disciple. I do not believe it possible for any painter after Picasso not to have been influenced by him in some degree. I have always been proud that Picasso was not only my teacher but my very dear and close friend.

Coming to my defense and advocating my right to paint as I wished, Guillaume Apollinaire wrote a novel in which, conscious of his approaching death and yet in complete control of his expression, he depicted the feelings of an artist in conflict with the vulgar world of the dealers.

Apollinaire's last novel was one of the most forceful and beautiful books I have ever read. It was unfortunately never published for, when Apollinaire died, Rosenberg and other dealers bought the manuscript from his widow and suppressed it, if they did not destroy it.

My artistic problems, muddled enough by the intrigues of the dealers, were further complicated by the advent into my life of Marievna.

After I had returned to Montparnasse from Spain and sent for Angeline to rejoin me, I began associating with a group of Russians who gravitated around the writer Ilya Ehrenburg. Among these companions was a gifted young woman painter named Marievna Vorobiev. Outside the circle of her fellow Russians, Marievna seemed to have no friends in Paris. Pitying her loneliness, Angeline and I began inviting her to our home.

By those who knew her, Marievna was regarded as a sort of "she-devil," not only because of her wild beauty but also because of her fits of violence. When she took offense, she did not hesitate to kick or claw whoever she thought had injured her—suddenly, without argument or warning.

I found Marievna terribly exciting, and one day she and I became lovers.

In 1917, I left Angeline and lived with Marievna as my wife for half a year. Inevitably, it was an unhappy union, filled with an excruciating intensity which sapped us both. At last we agreed that it

was impossible for us to live together any longer. Before we parted, however, Marievna asked for one last tryst. But this meeting proved frustrating because she had begun to menstruate.

As I was leaving her hotel room, intending to return to Angeline, Marievna embraced me. A knife was hidden in her sleeve, and as I kissed her for the last time, she carved a wide gash in the back of my neck, in the same place where, years before, the mounted policeman of Díaz had struck me with his sword.

All at once I began to hear many small golden bells ringing, each note clearer than the one before, the carillon ending with a cathedral-like chime whose reverberations seemed to penetrate to the center of my brain. And then dead silence.

As I lay on the floor unconscious, Marievna cut her throat.

Neither of us died, however. A few days later Marievna was again sitting at the café tables with a bandage around her neck which, the war having just ended, was quite in fashion. On the day of the Armistice, I saw Marievna celebrating the return of peace in the Paris streets, the cynosure of a throng of white, yellow, and black soldiers, all rejoicing in their escape from further risk of death.

About six months after I had resumed living with Angeline, Marievna began taking a stand before the door of our house. She would display herself there day and night. It was not long before I was aware of the increased size of her abdomen and realized the purpose of her action. She was pregnant and she was accusing me of deserting her with child.

When the child, a girl, was born, Marievna exhibited her as living proof of my infamy. She succeeded in turning many of my friends, Ehrenburg included, against me. Not content with this, when Mexican officials came to Montparnasse to coat themselves with esthetic varnish, Marievna complained to them about the terrible thing she said I had done.

Ashamed of the awful behavior of their compatriot and enraptured by the beauty of Marievna's work, they purchased many of her paintings to compensate her for the damage done to her by Rivera. She achieved similar results with sentimental American collectors. They began pestering me with appeals to repent and help her. Of course, I paid no attention to them. The child Marika, now grown up and married, is a lovely woman and an accomplished dancer. For many years, she too wrote me letters and sent me photographs in the hope of softening my flinty old heart. I never responded. The past was past. Even if, by the barest chance, I was really her father, neither she nor Marievna ever actually needed me.

Some years after we parted, Marievna met and captured the hearts of both Maxim Gorky and his son. Marievna loved the virility

of Gorky *fils* and the genius of Gorky *père*. In their contest for
Marievna's favors, father and son became permanently estranged.
Because the son was a Bolshevik at that time, the father became an
anti-Bolshevik, and it was years before he returned to Russia after it
became Soviet.

AN END AND A BEGINNING

 DURING THOSE SIX STORMY MONTHS with Marievna, I had
done almost no work. Now I put all my energy again into
my painting. Unfortunately, the painting I was now do-
ing found no buyers. Angeline and I were down and out.
Our flat was bitingly cold. When our little son, born just before my
affair with Marievna, became sick, there was no money for doctors
or medicine or, for that matter, for food, and the baby died.

This innocent death terribly depressed me. I had looked forward
to the birth of Angeline's child. In 1917 I had done a series of three
portraits of her to commemorate her motherhood, the first show-
ing her before her pregnancy, her sensitive face tilted at an angle
above her long, slender neck in a characteristic attitude for which
our friend Serna had affectionately nicknamed her "The Blue-
bird." The second showed her during pregnancy and accentuated
the maternal roundness of her belly. In the third portrait, I painted
her with our son Diego, Jr., her breast exposed, and the child suck-
ling.

Only once before had a death moved me so strongly. Shortly be-
fore the war, a major political figure emerged from the French left.
Everybody, myself included, went to hear the speeches of Jean
Jaurès. Jaurès was an orator of incendiary vigor, with a mind like a
steel trap. Seeing and hearing Jaurès address the masses and watch-
ing the response of the many thousands who composed his audi-
ence, had been an inspiration. When Jaurès died at the hands of a
"patriot assassin," it was as if a part of me had also been struck
down.

With the memory of Jaurès, I associate the day I saw for the first
time, in Paris, a huge mass of people all moving together, enthusi-
astic but orderly, in a powerful solidarity of faith and purpose. This
vision I later transposed in many ways in heroic murals where, also,

the hero was not an individual but a mass. Particular leaders emerged from this mass but only as its antennae and speakers, to receive, formulate and transmit the collective thoughts, aspirations and dreams of their unnumbered fellows.

Following the death of my son, I intensified my labors to rid myself of modernist residues in my work. By the end of 1919 I felt that I had cleansed myself sufficiently to take the next step and, by research and study, prepare myself for my new career as a mural painter. To obtain the money I needed to live and travel, I turned to a brother Mexican, the engineer Alberto Pani, then serving as Mexican Minister to France. Pani, who was later to figure in one of the great Rivera art scandals, bought my portrait "The Mathematician," and commissioned portraits of himself and his wife. With the money I received for these, I went to Italy to study the frescoes of the old masters.

In Italy

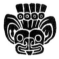 My Italian travels took me from Milan southward to Florence, Rome, Naples, and Pompeii; and then northward, along the Adriatic coast, through Venice. I spent a year and a half in Italy, from January, 1920 to July, 1921.

My stay in Italy did not begin well. No sooner had I arrived than I wanted to leave. Among other things I could not bear the Italian habit of spitting everywhere—in the street, in ships, in hotels, in restaurants. Everybody spat, including the loveliest and most refined ladies. I remember a banquet at which I met the cream of Italian society, where the most conspicuous objects were gleaming brass cuspidors.

But I soon learned to make allowance for this revolting custom. There was so much to see in Italy—the marvelous treasures of Michelangelo and Giotto, Paolo Uccello, Piero della Francesca, and Antonello da Messina. I could not bear to go to bed. While traveling in trains, I went third class, slept through the trip, and in that way saved time as well as money. To this day, I can sleep in trains and automobiles and wake up as refreshed as if I had been cradled in a soft hotel bed.

During my seventeen months in Italy, I completed more than three hundred sketches from the frescoes of the masters and from life. Many of the latter depicted street clashes between socialists and fascists which occurred before my eyes. I often sketched while bullets whistled around my ears.

When I had reached the point where I thought I could apply what I had learned about mural painting, the question arose, In what country should I begin? I had had enough of France. My friend David Sternberg, the Soviet People's Commissar of the Fine Arts, had invited me to Russia. I was tempted to go. But the call of my country was stronger than ever. And a turn in the political situation seemed to favor my prospects. The landlord dictator, Venustiano Carranza, had been overthrown by the peasants and workers who supported Álvaro Obregón. An artist with my revolutionary point of view could now find a place in Mexico—a place in which to work and grow.

Good-bye, Europe. Good-bye, Italy. Good-bye, France. Good-bye, Spain. For a second time, the exile was coming home.

I Am Reborn: 1921

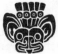 My homecoming produced an esthetic exhilaration which it is impossible to describe. It was as if I were being born anew, born into a new world. All the colors I saw appeared to be heightened; they were clearer, richer, finer, and more full of light. The dark tones had a depth they had never had in Europe. I was in the very center of the plastic world, where forms and colors existed in absolute purity. In everything I saw a potential masterpiece—the crowds, the markets, the festivals, the marching battalions, the workingmen in the shops and fields—in every glowing face, in every luminous child. All was revealed to me. I had the conviction that if I lived a hundred lives I could not exhaust even a fraction of this store of buoyant beauty.

The very first sketch I completed amazed me. It was actually good! From then on, I worked confidently and contentedly. Gone was the doubt and inner conflict that had tormented me in Europe. I painted as naturally as I breathed, spoke, or perspired. My style

was born as children are born, in a moment, except that this birth had come after a torturous pregnancy of thirty-five years.

For the first six months, nevertheless, I painted no frescoes but supported myself with a succession of bizarre jobs. One was as art advisor for a publishing house that never published a book; another was as chief of propaganda trains—a governmental scheme that came to nothing; and a third was as director of a workers' school which never opened its doors.

Then, at last, I was given a wall to cover at the National Preparatory School of the University of Mexico.

LUPE

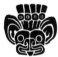 ONE DAY as I was busily working in the studio I had recently set up, I was visited by the beautiful singer Concha Michel. She said to me, "Comrade Rivera, you're a *cabrón* (bastard)!"

I laughed. "Agreed, comrade."

"Men call those women who like to go out with every man they please *putas* (prostitutes). You, Comrade Rivera, are a *puto*, since you go out with every woman you can."

"Correct, comrade," I responded.

"And what's more," Concha said, "you're shameless."

"I admit it."

"And you're in love with me; you're crazy about me; but you say nothing to me about your feelings because you fear me, knowing that I'm not a *puta*. You also know that I wouldn't leave the brave, stupid, and fairly honest man I'm living with to take up with a *cabrón* like you. And that's not all I wish to say, either. In spite of the fact that you have said nothing to me because you're such a shameless *puto*, I'm as much in love with you as you are with me. You're so tricky and treacherous, though, that I'm not sure you won't get me to run away with you one of these days."

I replied, "All you say is correct, my dear friend, but if you're going to run off with me sooner or later, why not right now?"

"I've already taken steps not to make that mistake, the wisest possible under the circumstances. I realize that the only thing that can

keep us apart is another woman who is handsomer, freer, and braver than I am. So I have sought her out. And I have brought her straight here to you!"

Concha walked to the door, called "Lupe!" and stepped aside.

A strange and marvelous-looking creature, nearly six feet tall, appeared. She was black-haired, yet her hair looked more like that of a chestnut mare than a woman's. Her green eyes were so transparent she seemed to be blind. Her face was an Indian's, the mouth with its full, powerful lips open, the corners drooping like those of a tiger. The teeth showed sparkling and regular: animal teeth set in coral such as one sees in old idols. Held at her breast, her extraordinary hands had the beauty of tree roots or eagle talons. She was round-shouldered, yet slim and strong and tapering, with long, muscular legs that made me think of the legs of a wild filly.

Concha introduced her. "My friend Lupe Marín from Guadalajara. Come into the room."

Lupe walked in slowly, her green eyes focusing upon the drawings I had been preparing, as it happened, for my National Preparatory School mural.

She stopped to gaze at me as at some inanimate object. Inclining her head, she looked me over from head to toes.

At last she turned to Concha. "Is *this* the great Diego Rivera?" she asked. "To me he looks horrible!"

Concha smiled with satisfaction. "Horrible, eh? All right. Everything is settled. Nothing can stop what's going to happen now!" And with that prophecy, she grabbed her things and ran out of the studio.

Lupe remained standing, silently glancing around the room. Finally her eyes fixed on a bowl on my work table. The bowl was filled with a pyramid of beautiful fruit.

"Why are those fruit there? Are you painting a still life?" Lupe asked.

"No, Lupe, they are there to be enjoyed both by looking and by eating."

"Can I eat some?"

"Of course, Lupe. Please eat all you want."

She sat down on a high draftsman's bench, took a banana with both hands, and peeled it skillfully like an ape. She ate the fruit rapidly, then casually threw the skin against the wall behind her. She took another piece of fruit and silently repeated this operation. Then another and another until there was nothing left in the bowl.

"Could you send someone out to buy me some more to eat?"

"Surely," I replied, and did as she asked.

When she had devoured a second mound of fruit, Lupe said, "I was hungry. I had not eaten anything for two whole days."

She rose and came toward me. "Shall I sit for you?"

"With much pleasure."

I began her first portrait, then a second and a third. Then I made four or five study heads for the auditorium, in addition to about twenty hands. After that day, we were together so much that it became a trial for both of us to be apart. By mutual consent, we became lovers.

One night, during a political meeting held in the house of a friend, Lupe sauntered in. She greeted everybody and then seriously and formally asked for the floor. In the curious silence which ensued, she delivered an excellent speech, using political, social, professional, and personal arguments to prove to her listeners that if Diego Rivera were not entirely a fool, he would marry her.

As soon as she was done, I rose to second her.

That night we began living together, in the sight of all, as man and wife.

An Apparition of Frida

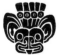 A few days after Lupe and I set up housekeeping, we went to the auditorium where I was to begin my mural. While painting, I suddenly heard, from behind one of the colonial pillars in the spacious room, the voice of an unseen girl.

Teasingly, she shouted, "On guard, Diego, Nahui is coming!"

Nahui was the Indian name of a talented woman painter who was posing for one of the auditorium figures.

The voice said no more, but another time, when I was at work with Nahui, I heard it again, "On guard, Diego, here comes Lupe!"

One night, as I was painting high on the scaffold and Lupe was sitting and weaving down below, there was a loud hubbub. It came from a group of young students shouting and pushing against the auditorium door. All at once the door flew open, and a girl who seemed to be no more than ten or twelve was propelled inside.

She was dressed like any other high school student but her manner immediately set her apart. She had unusual dignity and self-assurance, and there was a strange fire in her eyes. Her beauty was that of a child, yet her breasts were well developed.

She looked straight up at me. "Would it cause you any annoyance if I watched you at work?" she asked.

"No, young lady, I'd be charmed," I said.

She sat down and watched me silently, her eyes riveted on every move of my paint brush. After a few hours, Lupe's jealousy was aroused, and she began to insult the girl. But the girl paid no attention to her. This, of course, enraged Lupe the more. Hands on hips, Lupe walked toward the girl and confronted her belligerently. The girl merely stiffened and returned Lupe's stare without a word.

Visibly amazed, Lupe glared at her a long time, then smiled, and in a tone of grudging admiration, said to me, "Look at that girl! Small as she is, she does not fear a tall, strong woman like me. I really like her."

The girl stayed about three hours. When she left, she said only, "Good night." A year later I learned that she was the hidden owner of the voice which had come from behind the pillar and that her name was Frida Kahlo. But I had no idea that she would one day be my wife.

I continued working on the National Preparatory School mural. The school was in an old baroque building constructed in the first half of the eighteenth century. The surface I worked on was the arched front wall. In the lower center was an antique pipe organ, and I incorporated both the arch and the organ into the design of my mural; the former, by repeating the suggestion of a rainbow arch in the colors and disposition of the allegorical figures rising symmetrically from both sides of the wall; the latter, by blending its lines into the pyramidal Tree of Life which I depicted in the center.

The subject of the mural was Creation, which I symbolized as everlasting and as the core of human history. More specifically, I presented a racial history of Mexico through figures representing all the types that had entered the Mexican blood stream, from the autochthonous Indian to the present-day, half-breed Spanish Indian.

In the Tree of Life were four symbolic animals in which were recognizable features of the lion, the ox, the caribou, and the eagle. At its apex was the torso of a hermaphroditic man, his arms outstretched to the right and left.

To the right, at the foot of the tree, sat a nude male, his back to the beholder, in conversation with Knowledge and Fable. Behind them sat figures representing the Poetry of Passion, Tradition, and Tragedy. On a slightly higher plane, a rising group of figures represented Prudence, Strength, Justice, and Continence, with Science the topmost figure.

To the left of the tree sat a female nude posed for by Lupe. She was listening to Music blowing a gold double reed and watching

Dance. Seated at the side of Music was Song, also modeled by Lupe in purple skirt and red shawl, and directly behind these two, Comedy.

The three theological virtues, Faith, Hope, and Charity, and, above them, Wisdom, completed the figures on the left side.

The "rainbow" of human forms was closed by a blue half circle under the keystone of the arch, from which poured three rays of light materializing in hands pointing downward and to the sides of the mural, toward the earth, and signifying solar energy, the life source of all.

The mural covered a thousand square feet. Each figure was twelve feet tall. The process I used was the ancient wax encaustic. I labored continuously for an entire year until the spring of 1922. Yet, though my interpretation of the Creation was essentially progressive, I was dissatisfied when the work was done. It seemed to me too metaphorical and subjective for the masses. In my next mural, begun in 1923, in the courtyard of the Education Building, I would come closer to my purpose.

While I was at work on the National Preparatory School mural, Lupe began to worry increasingly about how her family would react when they learned about our irregular union. So one day, for her peace of mind, I acceded to her wish for a church marriage.

I had just returned that morning from Puebla, a revolutionary stronghold. The Communist Party in that city was forming a united front with the forces of Calles and Obregón against reactionary followers of the late General Huerta.

Wearing a red ribbon in my hat and high boots on my feet, I brought Lupe, dressed in an ordinary dress instead of the traditional lace, before the parish priest. The latter happened to be the same Father Servine who had directed the Liceo Católico where I had studied as a boy.

Father Servine could hardly believe that we were serious about getting married. We had neither the rings to exchange nor the customary ritual money. However, from the pockets of witnesses, we managed to obtain not only a sufficient quantity of small silver but also two makeshift rings, one of copper, the other of horn. Both seemed to symbolize fittingly our bizarre union.

In the same year that I completed the Preparatory School mural, I took one of the most important steps of my life—I became a member of the Communist Party.

Then, together with my painter friends David Álfaro Siqueiros and Xavier Guerrero as coeditors, I began writing for *El Machete*, the official newspaper of the Mexican Communist Party, and continued to do so until my expulsion from the Party.

THE MEXICAN RENAISSANCE

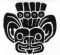 WHILE I WAS WORKING on my Preparatory School mural, a group of young painters began to collect around me, some of whom, fascinated by an art form new to them, became my assistants. Soon we were banding together to win acceptance for social art. We found an ally in Lombardo Toledano, the young director of the school, and thanks to him, four of my young friends were given wall space in the school equal to mine before I had even finished my own work. Scarcely had all this activity gotten under way when passionate discussions about the new art reverberated through all social strata of the city. When the Minister of Education, who had so far remained uncommitted, realized what repercussions our efforts were creating at all levels of society, he adopted our ideas and—luckily for our work—proclaimed from above the usefulness of monumental painting on the walls of public buildings.

Our group then formed the Syndicate of Technical Workers, Painters, and Sculptors. Its members included José Clemente Orozco, David Álfaro Siqueiros, Xavier Guerrero, Jean Charlot, Carlos Mérida, Ramón Alba, Fermín Revueltos, and the youthful Máximo Pacheco.

We applied for and received work under financial arrangements identical to those of house painters. Soon frescoes blossomed on the walls of schools, hotels, and other public buildings, in spite of violent attacks by the bourgeois intelligentsia and the press under its influence. But the workers of town and country strongly supported us—and our enemies did not prevail.

We began to have a strong influence, also, on art students of the country who were penned in at the academies.

These students had been mincing their way through a well-behaved impressionism, reflecting what had been done in Paris around 1900. It goes without saying that we disturbed this sedate regime. Art instruction changed orientation completely. Free art schools opened everywhere, and thousands of workers and children of workers brought forth remarkable productions. Their work fused quite naturally with ours, creating the art movement which European and American art critics have dubbed the "Mexican Renaissance."

The Ministry of Education and Chapingo

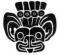 Immediately after the decoration of the Preparatory School, I was commissioned to paint the loggias of the two large courtyards and the stairwell in the Ministry of Education.

For several months before beginning my work in this government building, I roamed the country in search of material. It was my desire to reproduce the pure, basic images of my land. I wanted my paintings to reflect the social life of Mexico as I saw it, and through my vision of the truth, to show the masses the outline of the future.

The Ministry building is a huge rectangle of stone and masonry two blocks long and three stories high. It is divided into two unequal halves, the larger of which I called the Court of Fiestas and the smaller the Court of Labor, according to the murals I painted on their walls.

I arranged my work as follows: on the ground floor of the Court of Labor, I painted frescoes of industrial and agricultural labor; on the mezzanine level, frescoes of scientific activities; and on the upper floor level, frescoes representing the arts—sculpture, dance, music, poetry, folk epic, and theatre.

In the Court of Fiestas, I used a similar and also analogous scheme: on the ground level, frescoes of the great mass folk festivals; on the mezzanine level, frescoes of festivals of predominantly intellectual importance; and on the top floor, the Great Song frescoes based on the folk music of the people, music which expressed the people's will and revolutionary wishes from the time of the country's independence up to the revolution.

I also painted both walls of a steep stairway and of a corridor leading to the elevator. In all this work, each fresco was individual and separate in itself, yet all were interrelated.

Before beginning to paint, I studied the quality and intensity of the sunlight which hit a particular wall, and the architectural details—the arches and columns—and how they broke the sunlight and framed the space. Like the building itself, my colors were heavier, solider, and darker at the base than they were as the structure rose toward the luminescent sky.

Working sometimes as many as seven days a week and eighteen hours a day, and with only one break for a short trip to Russia, I spent over four years on the 124 frescoes which cover more than five thousand square feet. At odd moments during this time, I painted thirty-nine other frescoes in the Agricultural College at Chapingo.

The work of the people that I depicted in the Court of Labor was weaving, cloth-dyeing, farming, and mining. As in life, the workers' lot is not easy: I showed the miners, for example, entering a mine in one panel and emerging in the adjacent panel, weary and exhausted. Interspersed with such scenes were others demonstrating how the people might achieve their redemption. In one fresco, I painted a rural school teacher at her noble work while armed peasants stood guard; in another, partisans fought to liberate the peons. Several of the other frescoes depicted the redistribution of the land.

In the Court of Fiestas, I represented a contrasting mood of Mexican life. Here, the people turned from their exhausting labors to their creative life, their joyful weddings, and their lively fiestas: the Burning of the Judases, the Dance of the Deer, the Tehuanas Dance, the Dance of the Ribbons, the Corn Harvest Dance, the May Day Dance, and others. In addition, I depicted what could become a great source of happiness for the Mexican Indian if it could but be realized—scenes showing the self-sufficiency of the *ejidos*, the land given the Indian to farm.

Along the stairway, I continued painting in the same happy, prophetic spirit. I did an interpretive painting of the Mexican landscape rising from the sea to hills, plateaus, and mountain peaks. Alongside this representation of the ascending landscape was an accompanying symbolic view of the progress of man. Allegorical figures personified the ascending stages of the social evolution of the country from a primitive society through the people's revolutions, to the liberated and fulfilled social order of the future.

At the head of this stairway, I painted what, in my estimation, is one of my best self-portraits. I included myself in a trio of workers chiefly responsible for the building and its decoration. Here I figured as the architect. The other figures were the stonecutter and the painter, their identities also deliberately masked.

As my work went on, I kept experimenting with and making discoveries in the techniques of painting on wall surfaces. For example, after much trial and error, I found that for best results, the lime I used had to be burned over a fire made only with wood and then stored in rubber bags for three months. The rubber keeps the lime from absorbing carbon dioxide from the air.

Gradually, I worked out the procedures which I have followed more or less to the present day.

Before painting, I have my helpers prepare a surface of three or four plaster coats, the last a mixture of lime with fine marble dust. After the next-to-last coat has been applied, I make my charcoal outlines, to scale, directly from my paper sketch.

My helpers knife out a deep stencil of this outline before putting on the last layer of surface. This final coat is applied late the night before, or at dawn of the day I begin to paint, for the painting must be finished within six to twelve hours, before it dries, so that the color can be absorbed into the plaster. On a dry surface, paint eventually flakes off.

When I first arrive, I paint all the outlined figures in gray on the section which has been prepared for that day. At this time, too, I make all last-minute revisions. Then I do the final work in color, using pigments which have been ground especially for me by my helpers and mixed with distilled water into a paste.

At the end of a day's work, I stand back at a fair distance to study and criticize what I have just done. If, as sometimes happens, I am dissatisfied, I have the whole area cleaned and a new coat of lime laid on. Then I redo the work the next day. I started this practice of criticism and revision from the very beginning, and I have adhered to it to the present day.

During my work in the courtyard of the Ministry of Education, there occurred the first of the many controversies which were to mark my mural-painting career.

In a fresco on the ground floor of the Court of Labor depicting fatigued miners stumbling from their pits, I painted the words of a revolutionary poem by Gutiérrez Cruz. The poem exhorted the miners to shape the metal they extracted into daggers and seize the mines for themselves. An immediate storm broke in the press. José Vasconcelos, the Minister of Education through whom I had received my government commission, begged me to remove the offending poem; he said that it was making his job of explaining the whole composition impossible. The Painters' Union demanded that I stand my ground. The clamor grew louder. I finally yielded to Vasconcelos, and one of my helpers chipped the words off the wall. The Minister of Education, however, also compromised by allowing me to paint, in the adjoining panel, a peasant and a worker embracing one another. On this panel, I painted some verses from a somewhat milder poem by Cruz. New outcries were heard, but this time everyone stood firm and the storm blew over.

By the middle of 1927, I had completed my work in the chapel of the Agricultural College at Chapingo. The underlying theme of

this composition was a principle set forth by Zapata, which I stated in one sentence in a conspicuous portion of the mural overlooking the main stairway: *Here it is taught to exploit the land but not the man.* This sentiment was certainly appropriate for an agricultural college.

Like the murals in the Ministry of Education Building, those at Chapingo consisted of a series of frescoes. I painted them on walls within which an altar had stood in the chapel (now the school auditorium) of the old Spanish baroque building. As in the Education Building, my frescoes overflowed into the halls and stairway of the school.

In the entrance hall, I depicted the four seasons of the year, the recurrent cycle in the life of the land. In the chapel itself, I represented the processes of natural evolution. The bottom wall was dominated by a large female nude, one of several symbolizing The Fertile Land, and shown in harmony with man, whose function in agriculture I represented by having him hold the implements of his labors. Within the earth, I showed spirits, using their powers to aid man. One, for example, was a sphinx emerging from her flaming cave with arms outstretched to catch the flying spirits of the metals and put them to the service of industry.

My symbol for Nature was a colossal, dreaming woman. Securely clasped in her hands was an equally symbolic phallic plant. Around her I depicted the elements Wind, Water, and Fire, formerly uncontrollable, now, at the bidding of Nature, willing servants of man.

I used as my model for Nature the voluptuously beautiful nude figure of Lupe Marín. I used her again, this time pregnant, to represent The Fecund Earth. I drew her thus from life, for she was twice pregnant during the time I worked in Chapingo. Our first daughter, Lupe, nicknamed Pico ("pointy head"), was born in January, 1924; our second daughter, Ruth, or Chapo ("black as crude oil"), was born in the year the mural was completed, 1927.

I used Lupe's gorgeous nudity yet a third time to depict Earth enslaved by monopoly. In this representation, she was a bound prisoner surrounded by three symbolical oppressors, Clericalism, Militarism, and Capitalism.

Clericalism, standing above her, was in the black garb of the priest. Militarism, standing before her, wore a helmet, gas mask, gun, cartridge belt, and high boots, and flourished a drawn sword. Capitalism, sitting beside her head, was a fat man with a protruding belly, nude to the hips. His nose was gross and bulbous, his lips thick and sensual, his chin double, his eyes crafty, his ears extended outward from his skull. Beside him was a bulging bag of money.

The Chapingo frescoes were essentially a song of the land, its profundity, beauty, richness, and sadness. The dominant tones were violet, green, red, and orange. The work covered almost fifteen hundred square feet of wall space. After it was done I also designed the carvings for the two wooden doors at the entrance to the chapel.

In 1927, my fame established, I was invited by the Russian People's Commissar, Lunacharsky, to visit the Soviet Union as a guest painter for the Tenth Anniversary celebration of the October Revolution.

I was, of course, delighted. Lupe was furious at the exaltation I showed, because I was going without her. It was about this time that our marriage began to fall apart.

Lupe was a beautiful, spirited animal, but her jealousy and possessiveness gave our life together a wearying, hectic intensity. And I, unfortunately, was not a faithful husband. I was always encountering women too desirable to resist. The quarrels over these infidelities were carried over into quarrels over everything else. Frightful scenes marked our life together.

One night, for instance, Lupe served me a dish of fragments of some Aztec idols I had just bought. She explained that, since I had spent my money on the idols, there was none left to buy the food.

On another occasion, she found me making love to her sister, and left me in a scorching fit of anger. Later I went to fetch her in her parents' home in Guadalajara. The reconciliation was even more violent than the quarrel had been.

On other occasions, Lupe would tire me out with long denunciatory harangues and bitter arguments. The more we lived together, the more unhappy she seemed to become, and I welcomed the invitation to the Soviet Union as a pretext to get away from her.

Though Lupe and I have not lived together for many years, the memory of her exquisite nude body, which I painted in my very first mural, has remained with me. I have used this memory even in some of my most recent work. The curves and shadows of that wonderful creation left an indelible imprint on my painter's brain.

Before my departure, the poet Jorge Cuesta tearfully confessed to me that he was in love with Lupe. I did not even pretend to be angry, but gave him leave to court her and wished him success. I warned him, however, that Lupe was dangerous to men who were not very tough. Cuesta gave no heed to my warning. Soon after I left for Russia, he married her, and she bore him a son. Cuesta became mentally ill and castrated himself and the baby boy. The following year he hanged himself.

Some years later, Lupe wrote a popular novel entitled *La Única*. In it, using very thin disguises, she described her life with me and with Cuesta.

As the train pulled out of the station on the first leg of my journey to the Soviet Union, Lupe's last words to me were, "Go to hell with your big-breasted girls!"

That's what she called the Russian women.

HITLER

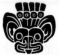 ON MY WAY, I stopped over in Berlin and did some interesting paintings there. My friend and host, Willi Muenzenberg, asked me many questions about my life and work, and my statements were incorporated in an excellent book by another friend, Lotte Schwartz. Entitled *Das Werk Diego Riveras*, this volume covered my career up to the murals I had just completed. It was published by the Neuer Deutscher Verlag headed by Muenzenberg.

In 1928, Germany was in the throes of a crisis that, in the next year, would become world wide. The big German cartels were slipping into bankruptcy, one after another. There was a wave of suicides among the bourgeoisie. Hugo Stinnes, head of the steel trust, Admiral von Tirpitz, a shipping magnate, and Dr. Scheidemann, boss of the chemical industry, all put revolvers to their heads and blew out their brains.

A contagion of lunacy was abroad in the land. I felt its presence on two separate, apparently unrelated occasions.

One night Muenzenberg, a few other friends, and I disguised ourselves and, with forged credentials, attended the most astounding ceremony I have ever witnessed. It took place in the forest of Grunewald near Berlin.

From behind a clump of trees in the middle of the forest, there appeared a strange cortege. The marching men and women wore white tunics and crowns of mistletoe, the Druidic ceremonial plant. In their hands, they held green branches. Their pace was slow and ritualistic. Behind them four men bore an archaic throne on which was seated a man representing the war god, Wotan. This man was

none other than the President of the Republic, Paul von Hinden-burg! Garbed in ancient raiment, von Hindenburg held aloft a lance on which supposedly magic runes were engraved. The audi-ence, Muenzenberg explained, took von Hindenburg for a reincar-nation of Wotan. Behind Hindenburg's appeared another throne occupied by Marshal Ludendorff, who represented the thunder god, Thor. Behind the "god" trooped an honorary train of wor-shippers composed of eminent chemists, mathematicians, biolo-gists, physicists, and philosophers. Every field of German "Kultur" was represented in the Grunewald that night.

The procession halted and the ceremony began. For several hours the elite of Berlin chanted and howled prayers and rites from out of Germany's barbaric past. Here was proof, if anyone needed it, of the failure of two thousand years of Roman, Greek, and Euro-pean civilization. I could hardly believe that what I saw was really taking place before my eyes.

Nobody among my German leftist friends could give me any sat-isfactory explanation of the bizarre proceedings. Instead, they tried to laugh them off, calling the participants "crazy." To this day, I am puzzled by their collective lack of perception. Recalling that orgy of dry drunkenness and delirium, I found it impossible to imagine the least sensitive spectator dismissing what I had witnessed as only a harmless masquerade.

A few days later I saw Adolf Hitler address a mass meeting in Berlin, on a square before a building so immense that it took up the whole block. This structure was the headquarters of the German Communist Party. A temporary united front was then in effect be-tween the Nazis and the Communists against the corrupt reformists and social democrats.

The square was literally jammed with twenty-five to thirty thou-sand Communist workers. Hitler arrived with an escort of nearly a thousand men. They crossed the square and halted below a window from which Communist Party leaders were watching. I was among them, having been invited by Muenzenberg, who was at my right. At my left stood Thaelmann, the Party's General Secretary. Muen-zenberg interpreted my comments for Thaelmann, and translated Hitler's speech for me.

My Communist friends made mocking remarks about the "funny little man" who was to address the meeting, and considered those who saw a threat in him timorous or foolish.

As he prepared to speak, Hitler drew himself rigidly erect, as if he expected to swell out and fill his oversized English officer's rain-coat and look like a giant. Then he made a motion for silence. Some

Communist workers booed him, but after a few minutes the entire crowd became perfectly silent.

As he warmed up, Hitler began screaming and waving his arms like an epileptic. Something about him must have stirred the deepest centers of his fellow Germans, for after awhile I sensed a weird magnetic current flowing between him and the crowd. So profound was it that, when he finished, after two hours of speaking, there was a second of complete silence. Not even the Communist youth groups, instructed to do so, whistled at him. Then the silence gave way to tremendous, ear-shattering applause from all over the square.

As he left, Hitler's followers closed ranks around him with every sign of devoted loyalty. Thaelmann and Muenzenberg laughed like schoolboys. As for me, I was as mystified and troubled now as when I had witnessed the decadent ritual a few days before in the Grunewald. I could see nothing to laugh at. I actually felt depressed.

Muenzenberg, glancing at me, asked, "Diego, what's the matter with you?"

The matter with me was, I informed him, that I was filled with forebodings. I had a premonition that, if the armed Communists here permitted Hitler to leave this place alive, he might live to cut off both of my comrades' heads in a few years.

Thaelmann and Muenzenberg only laughed louder. Muenzenberg complimented me on my artist's vivid imagination.

"You must be joking," he said. "Haven't you heard Hitler talk? Haven't you understood the stupidities I translated for you?"

I replied, "But these idiocies are also in the heads of his audience, maddened by hunger and fear. Hitler is promising them a change, economic, political, cultural, and scientific. Well, they want changes, and he may be able to do just what he says, since he has all the capitalist money behind him. With that he can give food to the hungry German workers and persuade them to go over to his side and turn on us. Let me shoot him, at least. I'll take the responsibility. He's still within range."

But this made my German comrades laugh still harder. After laughing himself out, Thaelmann said, "Of course it's best to have someone always ready to liquidate the clown. Don't worry, though. In a few months he'll be finished, and then we'll be in a position to take power."

This only depressed me more, and I reiterated my fears. By now, Muenzenberg wasn't smiling. He had been watching Hitler, then nearly at the other end of the square. He had noticed that the crowd was still applauding. Before leaving the square, Hitler turned and

gave the Nazi salute. Instead of boos, the applause swelled. It was clear that Hitler had won many followers among these left-wing workers. Muenzenberg suddenly turned pale and clutched my arm.

Thaelmann looked surprised at both of us. Then he smiled wanly and patted my head. In Russian, which sounded thick in his German accent, he said, "*Nitchevo, nitchevo.*"—"It's nothing, nothing at all."

My "crazy" artist's imagination was later bitterly substantiated. Both Thaelmann and my friend Muenzenberg were among the millions of human beings put to death by the "clown" we had watched in the square that day.

STALIN

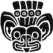 WHEN I LEFT BERLIN, it was as one of a large heterogeneous company. Railroad workers, rough and jolly. Miners, silent and strong, looking at the world with eyes accustomed to darkness. Textile workers, quiet, acute, funmakers with unbelievably dextrous fingers. Professional revolutionaries who stayed up to discuss Marxist theory while the rest of us slept. Writers, like the wonderful Theodore Dreiser and Henri Barbusse, were there. The four-foot-tall Moroccan rebel sultan, Abdel Krim, who spoke nearly every language in the world with amusing incoherence. North and South Americans of all ages. Beautiful Czechoslovak working girls, and always at my side, a former shoeshine boy who had been tutored by Lenin himself— Willi Muenzenberg.

The morning we arrived in the Moscow terminal, the ground was covered with ice. A high Soviet official, named Peskovsky, was at the station to welcome us. His face shone with friendliness and joy when we came into view. He greeted the Mexican delegation in the Mexican way, embracing each of us in turn.

My friend Guadalupe Rodríguez was dressed in a Mexican *charro* (cowboy) outfit, topped with a tall black sombrero. Impressed by his colorful manner and appearance, Peskovsky took him under his wing. All of us delegates paraded out of the terminal in a triumphal procession, led by Peskovsky and Rodríguez. The bystanders stared and smiled at Rodríguez.

At the exit we found ourselves at the high end of a long, steep ramp covered entirely by a smooth sheet of ice. Rodríguez stepped ahead, unaware of the hazard. Peskovsky paled and made a warning motion but too late. Without losing his hat, Rodríguez began to travel down the ramp on his posterior, his face calm and immobile. Somehow, he managed to maintain his dignity through all that long slide. At the end of the ramp, a couple of soldiers with blue ribbons in their hats tried to help him up. Motioning them aside, Rodríguez jumped up by himself as agilely as if he were dismounting a horse.

People must have thought this a proper way for a guest from a mythical country to enter Moscow, for they applauded heartily, shouting, "Hooray!"

Peskovsky regained his color then, his face even becoming red with pleasure over this happy ending, and he responded with a loud, "*Viva México!*" Thanks to the unique way the delegate guest from Mexico had chosen to arrive, international cordiality rose to a new height.

I shall never forget my first sight in Moscow of the organized marching and movement of people. An early morning snow was falling in the streets. The marching mass was dark, compact, rhythmically united, elastic. It had the floating motion of a snake, but it was more awesome than any serpent I could imagine. It flowed slowly from the narrow streets into the open squares without end. At the head of this winding, undulating creature mass was a group in the form of an enormous locomotive. A big red star and five picks were over the "cylinder" of the "boiler." The "headlight" was an enormous inscription between two red flags: THE UNIONS ARE THE LOCOMOTIVES MOVING THE TRAIN OF THE REVOLUTION. THE CORRECT REVOLUTIONARY THEORY IS THE STEEL TRACK.

During the three hours that I withstood the icy winds, watching this procession, I drew many sketches for water colors. About fifty of these were afterwards purchased by Mrs. John D. Rockefeller, Jr.

One night we delegates were instructed to get up at seven the next morning and assemble at the Central Committee building at a quarter to eight. An important meeting was to begin at eight.

When we appeared next morning at the Central Committee building, we were escorted into an enormous room. From one of its three huge glass windows, I could see the Kremlin in the foreground and the city spreading behind it. Moscow seemed as large as the sea, misty, with the forms of the buildings dissolving into the horizon. The colors were a wonderful scale of grays and browns with some deep, fine greens.

The delegates were seated at one long table, facing another long table at which the officials sat. At the stroke of eight, a door on the officials' side of the room opened. A man, neither tall nor short, stepped in. He gave an impression of tremendous but controlled strength, which seemed to permeate the entire room. He wore warm high boots and a green khaki uniform of coarse quality. The jacket, buttoned up to the neck, was old, the elbows worn down almost to holes, and the wristbands so threadbare that loose threads were plainly visible.

The man himself was dark and warm-colored, like a Mexican peasant. The skin of his face was pitted with smallpox. He had startling, vivid, but small eyes. Thick black mustache ends drooped along each side of his mouth. His hair was cropped short. He had a remarkably rugged physique which suggested great physical power.

He stopped before the officials' table and stood quietly before us; then he put his hands, which had been clenched tightly into fists, into his pockets.

Without any visible sign, everyone suddenly stood up; an eerie silence pervaded the room.

The chairman broke it. "Comrade Stalin," he said, "is going to have the floor."

We had been asked before to make no display. Nevertheless, three or four people started to applaud. I recall that they were dressed in the black suits of German professors. As soon as we heard them, we could not restrain ourselves from joining in. The applause rose to a resounding ovation.

Stalin leaned toward the center of the table, acknowledged the handclapping with a slight movement of his head, and placed his right hand on his breast. The moment the ovation was over, he put his hand back in his pocket and said, "I thank you, comrades. I accept your spirited greeting in the name of the revolutionary workers who participated in the October Revolution with successful achievement. I come here in their name and under their mandate. My purpose is to inform you what we have done since the Revolution, what we are doing at present, and what we propose to do next."

Stalin paused, acknowledging a new burst of applause. Making a friendly gesture for his admirers to stop, he continued, "I am going to tell you things that you can easily verify. Should you not approve what I say, I hope you will openly manifest your disapproval with the same spirit you have just displayed."

This drew an approving murmur from his listeners. Stalin's speech, in Russian, ended exactly at nine o'clock. Immediately, tea

was brought into the room. Stalin sat down to his glass, drained it, and lit and smoked his pipe while interpreters translated his words into the many languages spoken by the delegates.

The translations took another half hour. Then for the next ten minutes, free, informal discussions went on. At a quarter to ten the chairman rang a bell, and Stalin resumed speaking.

After a few minutes, a magnetic current arose which seemed to fuse the speaker with each member of his audience. Stalin used no oratorical devices. He phrased his words in the tone one uses in informal conversation with friends. Speaking slowly, he pronounced each word with care. Very few of his listeners understood Russian. Yet as I studied the faces around me, I could see in each an urgent desire for communication. Throughout the speech, not a single face showed fatigue or inattention.

When the speech was over, questions were called for. Stalin answered them with a clarity and power of logic the like of which I had only once before encountered, in Jaurès. His reasoning, though luminous, was mercilessly straightforward.

The last question asked was, "What do you intend doing if the minority opposition in the Party still persists, thereby violating the Party's final decision?"

The figure of Stalin appeared to grow taller as he gave his detailed answer, concluding with, "We are going to produce all available proofs that our decisions are correct. We will present these proofs to the opposition. If, then, they still refuse to return to the general party line, we shall be obliged either to suspend or expel them.

"I do not believe, however, that they will refuse to accept the will of the majority, since we have all the workers on our side. The opposition maintains that the workers oppose us and are discontented. This does not seem correct. You have all seen our workers voluntarily marching in ranks with readied, bayoneted guns and plenty of ammunition. If the workers are against us, why don't they shoot us down when they file past, especially when we are grouped together, as we were recently, when we paid tribute at the tomb of Lenin? We would have made a perfect target on that occasion."

His searching glance encompassed all of us, one after another. "Yes, why did they not shoot us?" he asked again. "Thousands passed before the tribune, and the fire of one well-trained man would have been enough to annihilate us all in a few seconds. Why didn't they, then? Simply because we express their united will. If the opposition, therefore, insists upon disrupting our unity and delivering divided armies to our enemies, we will be forced to turn to

the methods of the G.P.U." Saying which, Stalin smashed the table with his fist as if he were actually falling upon the opposition.

A hush followed this outburst. Stalin looked out upon the assembly, as if gauging its reaction, which began with scattered clapping and swelled into another ovation.

Stalin did not now acknowledge the applause but sat down calmly and lit his pipe, awaiting the completion of the translations and the reading of the agenda for the next meetings.

I was sitting directly opposite Stalin. Taking advantage of my position, I began making sketches of his face. He evidently noticed what I was doing. When I put down my pencil, he walked over and asked to see my pencil sketches. He examined all of them, selected one, and wrote on the back of it in blue pencil: "Greetings to the Mexican revolutionaries," and signed "Stalin." As he was inscribing, the chairman declared the meeting over. After Stalin left, we were given the signal to leave the room.

Moscow Sketches

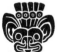 AT THE BEGINNING of my visit to Moscow, I was lodged in the Peasants' House. This building had formerly been an exclusive club of the Moscow magnates, surpassed in prestige only by the Noblemen's Club. Here the biggest landowners of Europe often came to meet the wealthy Russian merchants of wheat, flour, tea, furs, and caviar. It had not been as elegantly appointed as the Noblemen's Club, and its architecture had not been considered high style, but it had boasted an intimate theater in which could be seen the most beautiful naked women in nocturnal Europe. The most luxurious suites had been reserved for the rendezvous of the beauteous artistes and their moneyed admirers. Here the biggest diamonds, emeralds, and rubies in the world had changed ownership.

Billiard tables were still ranged in the salon, which was as huge as a railroad station waiting room. Most of the lavish halls were furnished with their original, old-fashioned Russian-style pieces, interspersed with other pieces in the most baroque and revolting modernism of the turn of the century.

This building, which formerly had served the revels of the upper bourgeoisie, now belonged to the peasants on whom they had fattened. In the burlesque theater and in other large halls, Russian farmers in colorful folk costumes could be seen dancing. They, too, were celebrating the tenth year of the new system in which they had become the owners as well as the workers of the land. The place rang with their healthy exuberance.

Many and varied cultural entertainments went on night and day. At all times, a rich table was set for the peasants, who had come from all corners of the world to meet with their comrades in this exciting land.

Wishing to broaden my acquaintance with the Russian people, I decided to move to a hotel where a large number of other delegates had taken up residence. I remained here for the period of the celebration and a little after.

When the festivals and meetings were over, I was asked by the manager of the hotel whether I intended to go elsewhere or stay on in Moscow. I replied that I might remain indefinitely. I had just received a request from the Commissar of Education to do a mural in the Red Army Club. If the public favored this work, I had been told, I would be allowed to paint the walls of a newly completed institute.

When I explained this to the manager, he declared, "That's fine, comrade. You're no longer a guest but one of our own citizens." Then he shook my hand in congratulation. That was the whole ceremony extended to me in recognition of my acceptance. I appreciated its beauty and simplicity. But I admired all of the social customs in Russia during my visit.

I recall one incident especially well. It occurred during a day in my travels through the countryside. I had just settled down in my train compartment when I saw a young man walk casually over to an attractive young woman in the compartment across from mine. The young man smiled but said not a word. Instead, he unhurriedly took out his health and identity cards and offered them for the girl's inspection. In a minute she was smiling back and offering him her credentials. What an ideal way to choose one's lovers!

A few days later, someone knocked at my hotel door early in the morning. I let in a skinny, gangly, sallow-looking adolescent boy. However, the lad presented himself to me in a manner that was respectful and self-assured. Introducing himself as the chief reporter for *Komsomolskaya Pravda*, he went on, "Comrade Rivera, we have learned that you're going to stay among us. Will you write an article for us? Our organization is not rich, most of us being stu-

dents. Here, however, is thirteen hundred rubles for your article. We would like to be the ones to give you your first job in the Soviet Union."

I was touched to have the Communist youth organization do me this honor. At the same time, I was surprised at the extreme youth of the reporter sent to represent his paper. I would have guessed his age at about thirteen. After further discussion, we agreed that I should do not one but a series of ten articles, to be delivered at fifteen-day intervals. I signed a three-line contract to that effect.

As the reporter was stowing away the contract in his briefcase, preparing to go, I asked, "How old are you, comrade? You look very young."

He seemed rather offended at my remark. Raising himself to his full height, he replied, "But not at all, comrade; I am seventeen years already."

I had to restrain myself from laughing, so odd to my Mexican ears seemed the boy's grown-up pride, and so typical of the new Russia, where youth, too, has its constructive place in society.

As soon as my young friend had left, I sat down to outline the subjects of my future articles. For the next few days, I was busy jotting down notes on Mexico's social situation, which was to be the subject of my opening piece. In the midst of it, I was interrupted by another visitor, a towering, bearded man in high boots and a green uniform. He held a black portfolio under his arm.

In beautiful French, he said, "Comrade Rivera, I'm Engineer So-and-So. I'm extremely interested in your paintings. We have all seen reproductions of your frescoes. I happen to be the director of one of the newest factories in Moscow and a technical labor inspector. In that capacity, I have come to offer you any materials you may need for the murals you're to do in Moscow."

But, alas, I was not to put so much as a dab of paint on any wall in Moscow. The reason is quite simple. Lunacharsky, my host, "requested" me to return to Mexico. I suspect that resentment on the part of certain Soviet artists brought about this unhappy turn.

Leaving Moscow, I had in my pocket a mandate to organize the peasants' and workers' electoral bloc in Mexico. I also carried several sketches for a Ministry of Education fresco, which I intended to complete at home, numerous water colors of the Red Army, cover designs for some Soviet magazines, and three or four sketch books recording my observations of the life of the Soviet people.

Epecially impressive among these was one in water colors depicting the May Day celebration. I had done a series portraying a Russian worker and his family from the time they prepared to attend

this event until its close, including the march into Red Square. I also took home some finished oils on the October anniversary celebration.

AN INSPIRATION

FROM MOSCOW I went to Hamburg, where I embarked for Mexico. On the second morning out of that port, I was surprised and delighted to meet my friend David Álfaro Siqueiros, with his first wife, Gracielo Amador. They had boarded the ship the night before from France. The three of us enjoyed a warm reunion.

Throughout this return crossing, the weather was ideal, and I took advantage of it to complete some canvases and water colors I had started in the Soviet Union.

Enroute, there occurred an incident of perhaps only a minute's duration which had a profound effect upon me. Gracielo, Siqueiros, and I were on deck watching a brilliant sunset. A glaring red ball suddenly bounded over the horizon of the sea and came to rest in a greenish-white bank of clouds. A few seconds afterwards another sphere shot into our view, then still another.

Siqueiros cried, "Look, Gracita! Look, Diego! Those things are really small balls. If we could get them in our hands, we could play with them. Real balls, I tell you!"

At that moment the conception of the National Palace stairway mural, which I had begun to plan in 1922, flashed to completion in my mind—so clearly that immediately upon my arrival in Mexico, I sketched it as easily as if I were copying paintings I had already done.

The National Palace stairway rises broadly and majestically from a wide inner court, then forks at the first flight to right and left. For the wall of the right staircase, I envisioned Mexico before the Conquest: its popular arts, crafts, and legends; its temples, palaces, sacrifices, and gods. On the great six-arched central wall, I would paint the entire history of Mexico from the Conquest through the Mexican Revolution. At the triangular base, I would represent the cruelties of Spanish rule, and above that, the many struggles of my people for independence, culminating in the outer arches, in the lost

war with the northern invaders, and the final victory over the French. The four central arches would show aspects of the Revolution against Díaz and its reverberations in the strife-torn years of Madero, Huerta, Carranza, Obregón, down to the ugly present of Plutarco Calles.

On the wall of the right staircase, I would paint the present and the future. Naturally, I was less certain of the course to which the present tended than of the past. I would consume much time circling backward to find the right point from which the future could be projected until, after six years, my preliminary perspectives would be sharpened by the destruction of my mural in Rockefeller Center.

During this third sea voyage to my homeland, I became sure of my future artistic medium. I also spent time clarifying my impressions of my sojourn in Russia. I began to understand the opposition of the Soviet painters toward me as a working painter in their country. And that helped me to understand better my place as a Mexican painter in mine.

H. P.

 SHORTLY AFTER MY RETURN HOME in 1928, I was given a rather unusual and enjoyable commission: to design the scenes, props, and costumes for a ballet titled "H. P." (the abbreviation for horse power). I had been recommended for the job by the composer Carlos Chávez, my association with whom was to have a ludicrous and unhappy ending several years later. My designs for "H. P." included a cocoanut tree, a bag of money, horse power, downtown New York, a girl and boy from Tijuana, a banana, an American girl, a pineapple, sailors, sugar cane, a captain, tobacco, and cotton—quite a lot, in fact. "H. P." was first performed in 1932 at the Philadelphia Academy of Music with Leopold Stokowski conducting. Afterwards I did an album of the costumes in color, which was purchased by Mrs. John D. Rockefeller, Jr., and donated by her to the Museum of Modern Art in New York.

THE ASSASSINATION OF JULIO MELLA

 TOWARD THE END OF 1928, the personal lawyer of President Calles paid me a visit in my home, No. 8 Tampico Street. He had come to urge me to end my ardent personal campaign on behalf of the revolutionary general and guerilla fighter Rodríguez Triana. Triana, a foe of Calles, was an outstanding contender for leadership of the peasants' and workers' bloc, sponsored by the Communist Party.

When Calles' representative had finished expounding his client's wishes, I told him quite calmly that I would support any political candidate I believed in.

"Think about it carefully, Diego," he said. "If you don't curtail your activities, the Old Man is likely to give the order to stretch your throat."

I answered, trying to conceal my anger, "All right, tell Calles I know he has plenty of ropes and lots of hangmen. But tell him also that he's mistaken if he thinks I can be frightened off. Don't forget to report what else I'm going to tell you, either. I shall continue to do what I wish until the Communist Party itself throws me out for using the Party to make myself dictator of Mexico. I mention this possibility because I long ago asked for the privilege of leading the first uprising against Calles."

I suppose my outright defiance was more than the poor man had expected. He made a hurried exit. I was not hanged; I am still living and painting.

As for Calles, he was later kicked out of power by my good friend Lázaro Cárdenas, recent President of Mexico. With appropriate civilian and military rites, he long ago descended into hell, where his smoldering body has an honor guard of reactionaries, his former enemies when he pretended to be a revolutionary.

Throughout the following year, I was intensely involved in Party activities, the most memorable of which was in connection with the defense of Tina Modotti, who was placed on trial for the murder of Julio Mella. During this hectic period, I nevertheless managed to paint some frescoes in the Ministry of Health building, about which I shall speak first.

These panels, done in the building's Assembly Hall and covering over 350 square feet of wall and ceiling, comprised six large female

nudes symbolizing Purity, Strength, Knowledge, Life, Moderation, and Health itself.

Purity sat on the ground near a stream of clear water flowing over her hand. On the ceiling above her, looking downward, flew Life. Strength rested on the ground, full-bosomed, with sturdy thighs and powerful hands. Knowledge sat with her feet doubled under her, dreamily gazing at an open blossom in her hand. Near her and almost touching her face, was a snake coiled around a tree. Health was a seated figure with hands raised. Moderation was a tall, big-boned woman lying down, her eyes closed. In her hand she gripped a snake below the head from which darted its forked tongue; its body was clasped between her knees.

Afterwards I designed four stained-glass windows for this same building. I tried, by blending the tints of colored glass, to create as plastic an effect as possible. To this end, I also used pieces of glass cut into curved segments to give the complete composition a symmetry of mobile lines.

Julio Mella was a Cuban revolutionary leader who had fled the dictatorship of President Gerardo Machado. Mella had come to Mexico seeking refuge, and here he had met Tina Modotti, an excellent painter and photographer. I had been friendly with Tina before my trip to Russia; in fact, this friendship had been the final cause of Lupe's divorcing me.

Long before my return to Mexico, Tina and Mella had become lovers.

In 1929, Julio Mella was assassinated, on President Machado's orders.

The Mexican government, however, chose not to see a political motive in the crime. It took the position that the murder was a crime of passion and indicted Tina, whose political views were offensive to the regime, as the murderess. The government's case was based solely on the fact that Tina had been Mella's most recent mistress. From this it deduced that Tina had tired of Mella, and had decided to bring their affair to an end by killing him.

Because the case was being used to give a bad name to the Communist Party, its leadership took up Tina's defense. It commissioned me to dig up the true facts behind Mella's murder. With the assistance of friends, I was able to establish that the assassin of Julio Mella had been a Cuban gunman in the pay of the Machado government, sent by the chief of its secret service explicitly to perform the crime. My evidence, presented in court, ripped apart the net of speculations in which the prosecution had hoped to entrap Tina. The detective in charge of the investigation was forced to resign. And the Cuban government's involvement in the intrigue was offi-

cially recognized in an order obliging the Cuban Ambassador to leave the country for one year.

This was my last Party assignment. Before the year was over, I was to be expelled from the Party.

I AM EXPELLED FROM THE PARTY

 As AN ARTIST I have always tried to be faithful to my vision of life, and I have frequently been in conflict with those who wanted me to paint not what I saw but what they wished me to see.

However, the immediate cause of my expulsion from the Communist Party was not a painting that I had done, but one I had failed to do.

Toward the end of 1929 I was at work on one of the central arches of the National Palace stairway. My original sketch had shown a figure representing the Revolutionary Fatherland, holding a peasant in one arm and a worker in the other. In the course of the actual painting, I altered certain details which, in turn, made my symbolic representation of Mexico seem not quite right. For the figure of the Fatherland, I substituted a portrait of Felipe Carrillo Puerto, a former Governor of Yucatán, who had proved himself a true man of the people.

Because of this change in my plan, charges were brought against me by a committee headed by Joseph Freeman. Of Freeman I will only say that when his time for clarification came, he also failed to satisfy the Party and was thrown out as, in fact, he had always deserved to be.

My alteration in my mural was, of course, only one of a list of points which the Party had collected in my disfavor. Another was my public disapproval of the Party's line regarding labor unions. The Party then favored dividing the unions into Communist and non-Communist ones, but I had maintained that this policy was unwise and that the working class should be kept united in unsegregated associations. A few years after my expulsion, the Party reversed itself and took the line I had been condemned for.

Still another point against me was a statement I had made to the effect that I trusted no one and nothing and never could. My accusers asserted that a good revolutionary must have trust in his fellow men in order to inspire their faith and good will.

However, I think that what brought me most in disfavor with the Party was a view I had aired which was in direct contradiction to an expressed belief of Stalin's. Stalin had asserted that the capitalist countries would not attack Russia but would themselves be converted to communism on realizing its inevitable triumph. I had declared that an attack would come.

Years later, after the Nazi invasion, Stalin realized how wrong he had been. He died, however, without forgiving me for having been right.

On these and other charges, I was declared unworthy of Party membership.

As time went on, my former comrades labeled me a Trotskyite—a political designation I found wryly amusing. For the Trotskyites had always reviled me as a Stalinist. Even after my expulsion from the Party, they regarded me as a secret agent of Stalin.

Their charges against me went back to World War I, during which, they declared, I had collected diseased lice from dying men and dispersed them among the Italians and Poles from paper bags. Before 1920, according to my Trotskyite biographers, I had been poor and obscure. Then, somehow, I had come into a fortune in gold—of which I made a gift to Stalin. I had once, said these authorities, been married to a distant cousin of Stalin's wife. Later, when I helped Trotsky come to Mexico, they declared it was in order to shadow him and report to Stalin everything Trotsky did.

After Trotsky's assassination, they spread a rumor that Trotsky had previously broken with me out of fear that I would kill him, but that he had made his move too late. All the details of Trotsky's death were so expertly interpreted into evidence against me that sometimes even I almost believed the lie.

For a Communist, there is only one way to relate to the Party—maintain the Party's line against everything and everybody, never for a moment doubting its correctness. To hold a personal opinion at variance with the Party's line means doubling one's burden. It means that, while continuing to fight the enemies of the revolution, one incurs the enmity of friends to whom the slightest difference of view appears as a betrayal.

This is no criticism of the Party. Had I stayed within the bounds of Party discipline, I would have voted for my own expulsion. Nevertheless, I differed in certain particulars with the Party and its leadership and could not be convinced that I was wrong. I de-

fended my views up to the very moment the Party ousted me. In revoking my membership, the Party was merely carrying out its duty.

I have always believed that one who has been expelled from the Party should be allowed to seek readmittance if he has reasonable grounds for re-entering. His expulsion from the Party does not necessarily mean a fundamental change in his thinking.

After 1929, I continued to regard myself as a Communist in spite of my expulsion. Three times I applied for reinstatement in the Party. The first time my application was ignored. The second time it was weighed, and I was advised to try again in another year. I was encouraged to reapply a third time, also, by an opinion voiced by certain Party members that I might be useful to the Party.

This third time I clearly set forth my attitude towards the Party in the documents of my application, which were published. I emphasized that my readmittance would encourage Party intellectuals who stood for free, progressive expression and attract new members to the Party who were opposed to excessive discipline. For a long time there was no answer—neither acceptance nor rejection. I kept on hoping that my application would finally be approved and at last, in 1955, I received word that it had been.

I believe that my readmittance into the Party was directly related to the new basis of leadership in the Communist Party in Russia. Now that absolute one-man leadership has been done away with, anyone sincerely interested in working for Communist objectives is welcomed. The personal prejudices of a head man no longer have weight. This is as it should be.

CUERNAVACA

 I WENT ON with my mural in the National Palace, and by the time I completed the arches, I judged it the finest thing I had ever done. I am still proud of this stairway mural. It is not for me, of course, to forecast the verdict of future times. Yet, like it or not, no one can deny that it represented a new approach to mural painting.

The murals before it had all set isolated figures and groups of figures against large and quiet backgrounds. In this mural, I borrowed the architectonic movement of the stairway itself and related

it to the dynamic upward ascent of the Revolution. Each personage in the mural was dialectically connected with his neighbors, in accordance with his role in history. Nothing was solitary; nothing was irrelevant. My National Palace mural is the only plastic poem I know of which embodies the whole history of a people in its composition.

It is also the work which has consumed most of my time. I might leave it to paint other murals, but I kept returning to it—the last time in 1955—to make additions and changes. Because all its details are organically related, there are few alterations I can make that do not affect neighboring details. To my friends it has become a joke to say, "Have you heard the news? Diego has finished painting the stairway."

In 1930, I was called away from my work in the National Palace by Dwight W. Morrow, United States Ambassador to Mexico, to paint a wall of the Palace of Cortés at Cuernavaca, in the State of Morelos. I was given complete freedom of choice as to subject matter and a fee of 30,000 pesos (about $12,000) from which, however, I had to pay my assistants and buy my own materials and equipment.

I chose to do scenes from the history of the region in sixteen consecutive panels, beginning with the Spanish conquest. The episodes included the seizure of Cuernavaca by the Spaniards, the building of the palace by the conqueror, and the establishment of the sugar refineries. The concluding episode was the peasant revolt led by Zapata. In the panels depicting the horrors of the Spanish conquest, I portrayed the inhuman role of the old, dictatorial Church. I took care to authenticate every detail by exact research, because I wanted to leave no opening for anyone to try to discredit the murals as a whole by the charge that any detail was a fabrication. In some of the panels my hero was a priest, the brave and incorruptible Miguel Hidalgo, who had not hesitated to defy the Church in his loyalty to the people and to truth.

The panels were done on all three walls of an outer colonnade. Under the main panels I experimented with a pseudo bas-relief trim. I gave myself the task of integrating the movement of the figures with the rhythm of the architecture, with the movement of history in time and space, and with the movement of the landscape ascending from the valleys to the mountains. I was very happy with the outcome.

My commission from Morrow had been arranged by my friend the American architect William Spratling. Spratling had come to live in Mexico and was seeking some way of earning his livelihood in my country. I expected him to accept the customary agent's commission but he would not. Aware of his needs, I used an indirect

means to make the payment. I asked him to buy me a house in Taxco, and then I signed the property over to him as a gift.

Of the 23,000 pesos remaining to me after the purchase of the house, I spent 8,000 on the restoration of the colonnade, which was literally falling down. That left me 15,000 pesos on which to live, pay my assistants, and buy supplies during the seven months it took to do the murals. When the work was finished, I was flat broke.

Frida Becomes My Wife

 Just before I went to Cuernavaca, there occurred one of the happiest events in my life. I was at work on one of the uppermost frescoes of the Ministry of Education building one day, when I heard a girl shouting up to me, "Diego, please come down from there! I have something important to discuss with you!"

I turned my head and looked down from my scaffold.

On the ground beneath me stood a girl of about eighteen. She had a fine nervous body, topped by a delicate face. Her hair was long; dark and thick eyebrows met above her nose. They seemed like the wings of a blackbird, their black arches framing two extraordinary brown eyes.

When I climbed down, she said, "I didn't come here for fun. I have to work to earn my livelihood. I have done some paintings which I want you to look over professionally. I want an absolutely straightforward opinion, because I cannot afford to go on just to appease my vanity. I want you to tell me whether you think I can become a good enough artist to make it worth my while to go on. I've brought three of my paintings here. Will you come and look at them?"

"Yes," I said, and followed her to a cubicle under a stairway where she had left her paintings. She turned each of them, leaning against the wall, to face me. They were all three portraits of women. As I looked at them, one by one, I was immediately impressed. The canvases revealed an unusual energy of expression, precise delineation of character, and true severity. They showed none of the tricks in the name of originality that usually mark the work of ambitious

beginners. They had a fundamental plastic honesty, and an artistic personality of their own. They communicated a vital sensuality, complemented by a merciless yet sensitive power of observation. It was obvious to me that this girl was an authentic artist.

She undoubtedly noticed the enthusiasm in my face, for before I could say anything, she admonished me in a harshly defensive tone, "I have not come to you looking for compliments. I want the criticism of a serious man. I'm neither an art lover nor an amateur. I'm simply a girl who must work for her living."

I felt deeply moved by admiration for this girl. I had to restrain myself from praising her as much as I wanted to. Yet I could not be completely insincere. I was puzzled by her attitude. Why, I asked her, didn't she trust my judgment? Hadn't she come herself to ask for it?

"The trouble is," she replied, "that some of your good friends have advised me not to put too much stock in what you say. They say that if it's a girl who asks your opinion and she's not an absolute horror, you are ready to gush all over her. Well, I want you to tell me only one thing. Do you actually believe that I should continue to paint, or should I turn to some other sort of work?"

"In my opinion, no matter how difficult it is for you, you must continue to paint," I answered at once.

"Then I'll follow your advice. Now I'd like to ask you one more favor. I've done other paintings which I'd like you to see. Since you don't work on Sundays, could you come to my place next Sunday to see them? I live in Coyoacán, Avenida Londres, 126. My name is Frida Kahlo."

The moment I heard her name, I remembered that my friend Lombardo Toledano, while Director of the National Preparatory School, had complained to me about the intractability of a girl of that name. She was the leader, he said, of a band of juvenile delinquents who raised such uproars in the school that Toledano had considered quitting his job on account of them. I recalled him once pointing her out to me after depositing her in the principal's office for a reprimand. Then another image popped into my mind, that of the twelve-year-old girl who had defied Lupe, seven years before, in the auditorium of the school where I had been painting murals.

I said, "But you are . . ."

She stopped me quickly, almost putting her hand on my mouth in her anxiety. Her eyes acquired a devilish brilliancy.

Threateningly, she said, "Yes, so what? I was the girl in the auditorium, but that has absolutely nothing to do with now. You still want to come Sunday?"

I had great difficulty not answering, "More than ever!" But if I showed my excitement she might not let me come at all. So I only answered, "Yes."

Then, after refusing my help in carrying her paintings, Frida departed, the big canvases jiggling under her arms.

Next Sunday found me in Coyoacán looking for Avenida Londres, 126. When I knocked on the door, I heard someone over my head, whistling "The International." In the top of a high tree, I saw Frida in overalls, starting to climb down. Laughing gaily, she took my hand and ushered me through the house, which seemed to be empty, and into her room. Then she paraded all her paintings before me. These, her room, her sparkling presence, filled me with a wonderful joy.

I did not know it then, but Frida had already become the most important fact in my life. And she would continue to be, up to the moment she died, twenty-seven years later.

A few days after this visit to Frida's home, I kissed her for the first time. When I had completed my work in the Education building, I began courting her in earnest. Although she was but eighteen and I more than twice her age, neither of us felt the least bit awkward. Her family, too, seemed to accept what was happening.

One day her father, Don Guillermo Kahlo, who was an excellent photographer, took me aside.

"I see you're interested in my daughter, eh?" he said.

"Yes," I replied. "Otherwise I would not be coming all the way out to Coyoacán to see her."

"She is a devil," he said.

"I know it."

"Well, I've warned you," he said, and he left.

Soon after, we were married in a civil ceremony. The wedding was performed in the town's ancient city hall by the Mayor of Coyoacán, a prominent *pulque* dealer. At first the mayor wanted to marry us in the meeting room of the Municipal Council. "This merger is an historical event," he argued. The Kahlos, however, persuaded him that a legislative chamber was not a fitting place for a wedding.

Our witnesses were Panchito, a hairdresser, Dr. Coronado, a homeopathic doctor (who examined and dispensed medicines to the wealthy for one peso and charged poor patients nothing), and old Judge Mondragón of Coyoacán. The judge, a heavy, bearded man, had been a schoolmate of mine in the Fine Arts School.

In the middle of the service, Don Guillermo Kahlo got up and declared, "Gentlemen, is it not true that we're play-acting?" Frida's father found our marriage very amusing.

At the wedding party afterwards, Lupe turned up as one of the guests. Jealous as always, she made a scene, berated Frida, and then stamped out of the house.

Years later, Lupe came to know Frida and to like her very much.

A BID TO PAINT IN THE
SAN FRANCISCO STOCK EXCHANGE

IN 1926, through the American sculptor Ralph Stackpole, whom I had known in Paris and Mexico City, I received an invitation from William Gerstle, President of the San Francisco Art Commission, to paint a wall in the California School of Fine Arts. At that time I was so immersed in my work in the Education building and in the chapel of the Agricultural College at Chapingo, that I could not so much as think of painting anywhere else.

Now, however, Stackpole secured for me a second commission (the first had never been revoked) to do a mural in the new San Francisco Stock Exchange, which he and other artists were decorating under the supervision of its architect, Timothy Pflueger. Pflueger offered me $2,500 which, together with $1,500 that Gerstle had promised for my work in the Fine Arts School, came to $4,000—the most munificent sum I had ever been offered to paint walls.

I was enormously excited. This would be a crucial test of my mural techniques. Unlike Mexico, the United States was a truly industrial country such as I had originally envisioned as the ideal place for modern mural art.

When I applied for admission into the United States, I ran into considerable difficulty because of my political affiliations. However, mainly through the unflagging efforts of Albert Bender, a prominent San Francisco art patron and collector, I finally obtained a visa, and in November, 1930, Frida and I embarked for the United States.

Some time before our journey, in fact, even before we were married, Frida told me she had dreamed for years about going to San Francisco. On the night before Pflueger's invitation arrived, Frida

dreamed that she was waving good-bye to her family, on her way to this "City of the World," as she called San Francisco.

Frida and I, already engaged, were strolling in the twilight as she told me about this dream. We paused momentarily on a street corner just as the electric street lights of Coyoacán began to pop on. On a sudden impulse, I stooped to kiss her. As our lips touched the light nearest us went off and came on again when our lips parted. I was amused but said nothing to Frida. We walked on. A few minutes later I stooped under another light and a second kiss put out the second light. This time Frida noticed what had happened, remarked about it, and became a little uneasy. Then, self-consciously, we repeated the experiment three times more with the same mysterious result.

Many months later, after we had returned from the United States and we were no longer thought of as newlyweds, we recalled the phenomenon. We happened to be in the very room where Frida had been born. Half joking, half in earnest, we started to close all the windows and doors. Feeling experimentally gay, we turned on one electric light. Then, standing directly below the blazing bulb, we enjoyed a long kiss. Uncannily, the bulb blinked on and off five times. We looked at each other, simultaneously bursting into hilarious laughter.

Enroute to San Francisco, Frida surprised me with a gift of a portrait of herself which she had recently completed. Its background was an unfamiliar city skyline. Frida made no attempt to explain the painting. When we arrived in San Francisco, I was almost frightened to realize that her imagined city was the very one we were now seeing for the first time.

We were welcomed magnificently by the people of San Francisco and were feted at parties, dinners, and receptions. I received assignments to lecture at handsome fees. Stackpole put his studio at my disposal, and from the beginning, I worked on my plans with vigor and spontaneity.

Pflueger's Stock Exchange Building was in the tradition of all such establishments in the United States—that embodied in the Federal Reserve Building. Yet, within this limitation, he had done his job in a clean, modern manner. What was most original in his concept, however, was the use of associated arts. He had pressed for and been granted permission to call in the foremost contemporary artists and sculptors to collaborate with him. The group he gathered about him achieved a remarkable success in expressing their individual vision of American society, in a harmony which included the architectonics of the building.

The wall I was to cover flanked an interior staircase connecting the two stories of the Exchange's Luncheon Club. It was thirty feet high. In the central portion of the mural, I painted a colossal figure of a woman representing California. The almost classically beautiful tennis champion Helen Wills Moody served as my model. In portraying her, I made no attempt to formalize her features but left them recognizably hers. Soon a cry was heard: California was an abstraction and should not be an identifiable likeness of anybody. To this I replied that California was known abroad mainly because of Helen Wills Moody; that she seemed to represent California better than anyone I knew—she was intelligent, young, energetic, and beautiful; and that, finally, if I thought her the best model, I had the right to use her. While the protest spent itself, I painted around her figure the rich and varied resources of the state: on her left, the lush agriculture, its workers and heroes; on her right, industry, its buildings and machines, and representative working men and women. As a symbol of the future I showed a young California boy facing the sky with a model airplane in his hands.

On the ceiling above the wall, I painted a female nude in billowing clouds, symbolizing the fertility of the earth as well as the natural interconnection of agriculture and industry.

I worked on this mural with such complete absorption that when I was finished I was literally exhausted. I accepted an invitation from Mrs. Sigmund Stern, an art patron who lived in Atherton, to rest in her home, and there Frida and I stayed for a time. To keep in practice, I painted a pastoral mural on our hostess' living-room wall.

Back in San Francisco, I found letters from the President of Mexico, Ortiz Rubio, demanding that I return at once to continue work in the National Palace as required by my government contract. Rubio, a former engineer and general, who had recently replaced the Provisional President, Emilio Portes Gil, had a passion for precision and order. William Gerstle, however, who had waited so long for me to execute my mural in the California School of Fine Arts, was equally anxious not to have me suddenly plucked out of his hands. There were visits to officials, exchanges of cables, and in the end, Gerstle received permission for me to stay for as long as was required to carry out the commission.

The wall offered me at the School of Fine Arts was a small one of only 120 square feet, not at all suitable to my purpose, which was to present a dynamic concerto of construction—technicians, planners, and artists working together to create a modern building. Taking advantage of the vague stipulation as to the length of time I might

remain in San Francisco, I chose another wall, ten times as big. It was here that I showed how a mural is actually painted: the tiered scaffold, the assistants plastering, sketching, and painting; myself resting at midpoint; and the actual mural subject, a worker whose hand is turning a valve so placed as to seem part of a mechanism of the building.

Since I was facing and leaning toward my work, the portrait of myself was a rear view with my buttocks protruding over the edge of the scaffold. Some persons took this as a deliberate expression of contempt for my American hosts and raised a clamor. However, I insisted that the painting meant nothing else than what it pictured. I would never think of insulting the people of a city I had come to love and in which I had been continuously happy. Moreover, I asked for not a cent more for painting this wall, measuring ten times the space, than for the wall specified in the original contract.[*]

While working in California, I met William Valentiner and Edgar Richardson of the Detroit Institute of Arts. I mentioned a desire which I had to paint a series of murals about the industries of the United States, a series that would constitute a new kind of plastic poem, depicting in color and form the story of each industry and its division of labor. Dr. Valentiner was keenly interested, considering my idea a potential base for a new school of modern art in America, as related to the social structure of American life as the art of the Middle Ages had been related to medieval society.

The longer Valentiner and I talked, the more our mutual enthusiasm grew. But Valentiner was not in a position to make any offers on his own. And it was on a note of suspended exhilaration that we parted when he returned to Detroit.

Before my stay in San Francisco was over, however, I received a happy letter from him telling me that my artistic dream was to become a reality in Detroit. The city's Art Commission, of which Edsel Ford was chairman, had agreed to let me paint subjects of my own choosing on the walls of the inner garden courtyard of the Detroit Institute of Arts.

[*]This mural was subsequently covered over by a false wall, which was removed, and the mural rededicated, after Rivera's death.—G.M.

ONE-MAN SHOW IN THE
MUSEUM OF MODERN ART

 WHILE I WAS AWAY in San Francisco, I had left two of my assistants, the American painter Ione Robinson and the Russian painter Arnautov, to continue my work in the National Palace. They had painted several of the arches in the central stairway, and also the sky in a panel adjacent to one I had completed before my departure. They had imitated my style, yet their work looked so different to me from what I did with my own hands, that I could not let it stand. I was obliged to scratch out every stroke of their painting.

Where I had expected to find a gain, I met with a loss. But having been out of the country for about a year, the return to Mexico again had a revitalizing effect upon me. I started painting with the same unbounded exuberance I had felt while working on the Ministry of Education murals. Sometimes I kept going for twenty-four hours without a break. I was sustained by an ethereal drunkenness, a pure joy which the act of painting gave me. All my materials having previously been prepared, I did the entire central panel, sixty-five feet in width and forty feet high, in three and a half months!

One day, while at work on my scaffold, I was visited by the New York art dealer Frances Flynn Paine. As a Director of the newly formed Mexican Arts Association, she had come to offer me a one-man show in the New York Museum of Modern Art. To every modern artist, this is the pinnacle of professional success. As soon as I had completed the work presently required in the National Palace, I began to prepare for this show. At the same time, with the money I had earned in California, I started building my house in San Ángel.

Accompanied by Mrs. Paine, Frida and I sailed for New York on the *Morro Castle* early in November, 1931. The captain graciously provided me with temporary studio facilities enroute; and, upon our arrival, Mrs. Paine secured for me a spacious studio gallery right in the Museum building, where I began at once to prepare seven movable frescoes—movable because the Museum was then in temporary quarters, a floor of the Heckscher Building. Four of these panels were adaptations of details from my Mexican murals.

The remaining three were representations of subjects I observed in the city.

"Electric Welding" showed a group of workers welding a big boiler in one of the power and light plants of the General Electric Company. "Pneumatic Drilling" depicted laborers drilling through the rock ledge of Manhattan preparatory to the construction of Rockefeller Center. The most ambitious of these frescoes represented various strata of life in New York during the Great Depression. At the top loomed skyscrapers like mausoleums reaching up into the cold night. Underneath them were people going home, miserably crushed together in the subway trains. In the center was a wharf used by homeless unemployed as their dormitory, with a muscular cop standing guard. In the lower part of the panel, I showed another side of this society: a steel-grilled safety deposit vault in which a lady was depositing her jewels while other persons waited their turn to enter the sanctum. At the bottom of the panel were networks of subway tunnels, water pipes, electric conduits, and sewage pipes. A journalist who came to report the show, which opened on December 23rd, baptized this fresco "Frozen Assets," a name which Mrs. Paine, now my agent, at once adopted for it.

The show consisted of 150 pieces, including oils, pastels, water colors, and black and whites, in addition to the seven frescoes. It represented all my periods. Although there was embarrassment in some quarters about the frankness with which I represented the current economic crisis in "Frozen Assets," my exhibition was well received.

It failed, however, to fulfill one of my hopes for the show—to give American museum directors and architects a grasp of the character and value of mural painting. A true appreciation of the mural may be long in coming to the United States, the chief obstacle being the essentially temporary character of its architecture, combined with the North American preference for commodities of easy manipulation, which results in the creation of expensive screen-printed wallpaper rather than wall painting of real artistic value. The movable panels which I did for the show gave a fairly good idea of my technique but not of the true uses of the medium.

A Visit with Henry Ford

EARLY IN 1932 Frida and I went by train to Detroit. We were met at the depot by a small welcoming party consisting officially of Dr. Valentiner and Mr. Burroughs, the Head Curator and Secretary of the Arts Institute. The reception was swelled by an unexpected contingent of Mexicans living in Detroit, led by the Mexican Consul. These well-wishers escorted Frida and me to lodgings reserved for us in the Brevoort Hotel, facing the Institute. After getting settled, we were introduced to Edsel Ford and the other members of the Art Commission.

Ford set only one condition: that in representing the industry of Detroit, I should not limit myself to steel and automobiles but take in chemicals and pharmaceuticals, which were also important in the economy of the city. He wanted to have a full tableau of the industrial life of Detroit. He said good-humoredly that he wished to avoid any impression of partiality toward the industry served by his father and himself.

After a comprehensive survey of the city's plants and factories, I made preliminary sketches which I showed to Edsel Ford. Then I asked him for a concession. My commission called for frescoes on two walls, each fifty square yards, which I was to paint for the sum of $10,000. I could not possibly carry out my designs in this space. I therefore requested the space of all the four walls of the garden. Ford, who was taken with my preliminary sketches, not only acceded to my wish but raised my fee to $25,000.

I spent the two and one-half months between my meeting with the Art Commission and the beginning of my actual mural work in soaking up impressions of the productive activities of the city. I studied industrial scenes by night as well as by day, making literally thousands of sketches of towering blast furnaces, serpentine conveyor belts, impressive scientific laboratories, busy assembling rooms; also of precision instruments, some of them massive yet delicate; and of the men who worked them all. I walked for miles through the immense workshops of the Ford, Chrysler, Edison, Michigan Alkali, and Parke-Davis plants. I was afire with enthusiasm. My childhood passion for mechanical toys had been transmuted to a delight in machinery for its own sake and for its

111

meaning to man—his self-fulfillment and liberation from drudgery and poverty. That is why now I placed the collective hero, man-and-machine, higher than the old traditional heroes of art and legend. I felt that in the society of the future as already, to some extent, that of the present, man-and-machine would be as important as air, water, and the light of the sun.

This was the "philosophy," the state of mind in which I undertook my Detroit frescoes.

Not long after coming to Detroit, I heard of a museum of machinery in Dearborn which had been set up by Henry Ford but which, at that time, had not acquired its present popularity. The well-to-do people of fashionable Grosse Pointe and the Detroit workers as well ignored Greenfield Village, as this museum area was called. Almost nobody had any use for it, and I found out about it only through hearing people laugh at "old man Ford" for "wasting" millions on his "pile of scrap iron." These gibes excited my curiosity, and I asked my friends how I could arrange a visit and what was the earliest time I might go.

"Any time you like," they answered, not troubling to conceal their disdain.

I arrived at Greenfield Village six o'clock the following morning, and spent an hour walking around it. At precisely seven o'clock, a marvelous mechanical clock, equipped with a figure hammering on bells, sent peals of music into the bright morning air. An old-fashioned wagon, drawn by three pairs of mules, an apparition out of the eighteenth century, crossed the road where the automobile I had come in was parked. I was startled by this sudden juxtaposition of the past and present. I asked my assistant, Clifford Wight, who had come with me, and our tour guide, to let me visit the museum by myself, if that was permitted. Cliff seemed surprised and may even have taken offense at my request.

The guide, however, answered, "We've been told, sir, to do absolutely everything you wish." With that, he returned to the car with the puzzled Clifford.

The first thing I encountered on entering the museum was the earliest steam engine built in England. As I walked on, marveling at each successive mechanical wonder, I realized that I was witnessing the history of machinery, as if on parade, from its primitive beginnings to the present day, in all its complex and astounding elaborations.

Henry Ford's so-called "pile of scrap iron" was organized not only with scientific clarity but with impeccable, unpretentious good taste. Relics of the times associated with each machine were displayed beside it. To me, Greenfield Village, inside and out, was a visual feast.

While I was inside the model of an early American cabin, a strange thing occurred. I was looking at the furniture, tools, clothing, and yellowed ballad sheets affixed to the walls when suddenly the light began to fade. In a few seconds, I was in total darkness.

As I felt my way along a wall in an attempt to get out, I heard a man's voice say, "Don't you want some light?"

"Yes, certainly I do!" I answered. The light came on at once, but no human being was visible. As I hunted for the source of the voice, I heard it again. "What do you think of my electrical system?"

"Marvelous," I replied, continuing to look about me for the man who had spoken.

"That's fine," the voice said, and then there was silence. Shrugging my shoulders, I continued on my tour, which lasted hours and hours.

At last I began to feel weak. It occurred to me that it was already night, and I probably needed food. I found the car at an exit waiting for me. Alongside it stood a man who introduced himself to me as Henry Ford's secretary. Mr. Ford, he said, realized that I, no less than he, was a very busy man. Nevertheless, he begged me to set aside time the following day to lunch with him in his home. I accepted this invitation warmly. The secretary pointed out Mr. Ford's house to me. It was not far from where we were standing. I was surprised to see that it was much like the homes of the engineers and skilled workers living in Dearborn. There was nothing to set it apart from the other houses in the neighborhood.

I had already begun working in the Arts Institute. And early the following morning, I found a motion-picture cameraman, with all his paraphernalia, waiting for me on the scaffold.

He said, "Mr. Ford instructed me to come here every day while you're working on your murals and take pictures of you in action. I must have each day's shooting ready to be shown to him in his home by evening. He is eager to watch you paint, and since he can't spare the time during the day, he thought of this idea. It will make him feel as if he were actually here."

I told the photographer I was delighted with Mr. Ford's personal interest in my work, and he was welcome to take pictures of me at any time.

Later that day, I kept my luncheon appointment with Henry Ford, whom I found a most charming man, old in years but in other ways very young. Discarding formalities, Ford greeted me with a hearty handshake and then began one of the most intelligent, clever, and lively conversations I have ever enjoyed. This amiable genius radiated a kind of luminous atmosphere.

After a while, he said, "Since you like mechanics so much, I'd like to show you something. Please follow me."

He led me into an amazing kitchen, so highly mechanized there was almost nothing in it to be done by hand. He explained that he believed human sensitivity and intelligence should be reserved for the full enjoyment of food, rather than wasted in its preparation. Standing in Ford's kitchen, I had the odd sensation of being surrounded by a mechanical orchestra.

At table, Ford described the electrical systems in Greenfield Village. Suddenly a bell rang in my head and I looked at him inquiringly. Smiling, he said, "Yes, Diego, that voice you heard yesterday in the cabin was mine. I couldn't resist playing the prank on you, since you seemed to be as fond as I am of those piles of scrap iron. Am I right, boy?" Chuckling, he slapped me good-naturedly on the shoulder.

"From seven in the morning until half past one the next morning—that's quite a record time for a visitor to stay at a museum," he continued. "It proves that you may be even more interested in mechanics than I am. And you almost have to be a fanatic to compete with me. That's certainly something!" he exclaimed, grinning broad approval of our common bond.

Having eaten lunch, I got up to return to my job. Ford shook hands with me again and said warmly, "Good-bye, Diego, thank you for coming. I can't tell you how much I've enjoyed our meeting."

"Good-bye and thank you too, Henry," I responded with equal warmth.

As I rode back to Detroit, a vision of Henry Ford's industrial empire kept passing before my eyes. In my ears, I heard the wonderful symphony which came from his factories where metals were shaped into tools for men's service. It was a new music, waiting for the composer with genius enough to give it communicable form.

I thought of the millions of different men by whose combined labor and thought automobiles were produced, from the miners who dug the iron ore out of the earth to the railroad men and teamsters who brought the finished machines to the consumer, so that man, space, and time might be conquered, and ever-expanding victories be won against death.

And then I recalled, as clearly as if they were now flowing into my ears, the words I had heard spoken by a Russian worker. On a visit to his home I had noticed, hanging on a wall, three separate portraits above a fourth, of Stalin. The first portrait was of Karl Marx, the center one of Lenin, and the third, a likeness of my esteemed new friend, Henry Ford. As my face showed astonishment at this unique ensemble, the worker had explained, "Those three make the establishment of socialism a real possibility. Karl Marx produced the indispensable theory. Lenin applied the theory with his

sense of large-scale social organization. And Henry Ford made the work of the socialist state possible. None of their contributions would have meant anything, however, without the political genius of Stalin."

Recalling these words now, I regretted that Henry Ford was a capitalist and one of the richest men on earth. I did not feel free to praise him as long and as loudly as I wanted to, since that would put me under the suspicion of sycophancy, of flattering the rich. Otherwise, I should have attempted to write a book presenting Henry Ford as I saw him, a true poet and artist, one of the greatest in the world.

Some time later Frida and I were invited by Ford to a party where the guests danced early American dances. Frida, looking lovely in her Mexican costume, soon became the center of attraction. Ford danced with her several times.

When the party was over, beckoning me to follow, Ford escorted Frida outside, where a car was waiting. It was a new Lincoln, a chauffeur at the wheel. Ford told Frida that the chauffeur had already been paid and that both he and the car were at Frida's disposal for the time she remained in Detroit.

I was embarrassed for us both and thanked Ford but declared that neither Frida nor I could possibly accept such a lavish gift. This car, I said, was too rich for our blood.

Ford took my refusal with gracious understanding. Then, without our knowledge, he got his son Edsel to design a special small Ford car, which he presented to Frida a short time later.

THE BATTLE OF DETROIT

WORKING AT THE ARTS INSTITUTE now absorbed me completely. Despite the fact that I was on a rigorous meat-free and debilitating thyroid-supplemented diet to lose weight, I averaged fifteen hours a day on the scaffold, seven days a week. When I started painting, I weighed a good deal more than three hundred pounds; when I was done, I had worked and dieted off more than one hundred pounds.

Frida was also working. She had developed her own style and was beginning to paint real masterpieces. When we had been in Detroit

for about six months, however, her mother fell fatally ill, and Frida
had to return to Coyoacán. I remained in Detroit, laboring harder
than ever.

In my previous murals, I had tried to achieve a harmony in my
painting with the architecture of the building. But to attempt such a
harmony in the garden of the Institute would have defeated my
purposes. For the walls here were of an intricate Italian baroque
style, with little windows, heads of satyrs, doorways, and sculptur-
esque mouldings. It was within such a frame that I was to represent
the life of an age which had nothing to do with baroque refine-
ments—a new life which was characterized by masses, machines,
and naked mechanical power. So I set to work consciously to over-
power the ornamentation of the room.

My subject matter lent itself, both historically and pictorially,
to this conflict. And to strengthen and integrate it plastically I
decided, throughout its whole, to establish a rhythm more elemen-
tal, more powerful than any other in the garden. I chose one of
the dominant rhythms in the life process—the wave. My Detroit
Institute mural consists of twenty-seven panels divided roughly
into three levels; at the base, inset scenes depict events in the work-
ers' day; at the main level, from the base mouldings to the tops of
the columns, the major area of the composition, are shown ma-
chines in motion; on the upper level, the painting represents the
physiography of the region, its soil, its minerals and fossils, its
lake and river transport, and finally, directly under the rafters, its
civilian and military aviation and the races of man. In panel after
panel, the undulating wave reappears—in the giant steel con-
veyor belts, in the tubes and piping, and in the strata of the sub-
soil.

Thoroughly immersed in my labors though I was, I became con-
scious after a time, that whispers were beginning to circulate
through the city concerning certain subjects of my frescoes. On the
upper level of one wall, I had painted hands breaking through the
surface of the earth to bring up pieces of minerals and metals.
Above this portrayal, I had painted two reclining female nudes: one
black, representing coal; one red, representing iron. On the wall
directly opposite, I had shown hands taking limestone, sand, sul-
phur, and other light-colored substances from the earth, and di-
rectly above, had again represented their human analogues in
white and yellow female nudes.

The females, who also represented the races of man, were au-
tochthonous types, hardly "pretty." The gossip spread that I was
painting a poem to ugliness, that this was what the figures symbol-
ized, standing above the roar and glint of steel machinery. I, who

knew better, merely worked on. What I did not understand was that certain people in Detroit were looking for a pretext to attack me and my mural.

In a pharmacological panel, they found it at last. In front of three men at work in a modern biochemical plant, I had pictured a child, in the arms of a nurse, being vaccinated by a white-gowned physician. Directly before them stood a horse, a cow, and some sheep—animals from whose tissues many vaccines are prepared. The panel was intended to celebrate the noble work of men of science fighting against disease. To some people, the panel seemed to be a portrayal of the Holy Family in modern dress, the three laboratory workers standing for the three kings, and the animals the animals of the manger. To my enemies, because it had sprung from my conception, the painting was sacrilegious.

One day, from my scaffold, I observed a peculiar-looking man studying my panels. He was introduced to me as a painter of stained-glass windows for churches. Completely bald on top, he had a round, rosy-cheeked face framed in long gray hair which fell to his shoulders in curls. On greeting me, his thin lips widened into a weak smile. His blue-gray eyes were cast down as if he had lost something essential and was looking for it.

His gray suit was unusually shabby and dirty for someone living in the United States. He was shod in black canvas slippers in the style of Saint Antoine, who became a church janitor.

As he spoke, he joined his fingers in a handclasp, like a schoolgirl. He was, this odd creature told me, of French descent, and he had devoted all his life to religious art. Taking one last, sweeping look around the room, he congratulated me on my work with obvious insincerity and hurriedly departed. I didn't understand his purpose until several days later.

The following day another visitor, presented to me as a columnist for one of the big Detroit newspapers, came to see me at work. This visitor was even more unpleasant-looking than the religious painter. He wore his hat pulled down over his eyes, which, when he lifted his head, were obscured by lenses as thick as bottle glass.

After watching me for a time, he shouted up, "Don't you think the perspective is wrong?"

I peered down, and suddenly I found the sight of this terribly myopic, hat-blinded man so amusing that I could not control myself and burst out laughing.

The columnist squinted back at me in an uncomprehending and embarrassed manner. Finally, he asked where the lavatory was. Between gasps for breath, I gave him directions. Needless to say, he did not return.

But the following day he officially opened the campaign against me in his column. The basis of his condemnation was the alleged immorality of my frescoes. How, in such a beautiful museum, he asked, could I be permitted to paint such filth! He had been informed, he said, by trustworthy authorities, that I was dishonoring the walls of the Institute with pornographic paintings. If I was not stopped now. . . .

But he was only the first of the crackpots who now set upon me.

An even more deranged—and dangerous—foe of my mural was a priest who lived in a suburb of Detroit. His name was Father Charles Coughlin. This clergyman had built a handsome church with the liberal contributions of his poor and ignorant followers. The building was lavishly decorated with stained-glass windows done, as it happened, by my queer visitor, the religious painter. In addition to his pulpit, Father Coughlin had at his disposal, for the dissemination of his lunacies, his own radio station. He used it to broadcast the most vicious reactionary propaganda imaginable, without any interference at all. The day after the appearance of the column denouncing my work, Father Coughlin began to honor me daily with long diatribes condemning the Institute frescoes as immoral, blasphemous, antireligious, obscene, materialistic, and communistic. As a result, the whole city of Detroit began to argue about what I was doing. A city councilman assailed my murals as "a travesty on the spirit of Detroit" and urged his fellow councilmen to order that they be washed from the walls. Soon the whole region entered into the melee. As for myself, I calmly continued to paint.

In the midst of the storm, Frida returned to Detroit. She had been watching her mother die, and was spent with grief. Added to this, she was horrified by my appearance. At first she could not recognize me. In her absence, I had dieted and worked so hard that I had lost a great deal of weight. I was also wearing an unfamiliar-looking suit belonging to Clifford Wight, because none of my own clothes now fitted me.

The moment I saw her, I called out, "It's me." Finally acknowledging my identity, she embraced me and began to cry. I looked hideous, my pale flesh hung loosely in elephantine folds. I tried to console her by telling her that, in compensation for my loss of weight, I had gained a new quickness of movement which enabled me to work with remarkable agility. As a result of my diet and thyroid treatment, I would be able to finish my work sooner than I had expected. But Frida refused to be pacified, and remained apprehensive until the last dab of paint on the last panel was dry.

Three days before the reopening of the museum to the general public, there was a private showing of my frescoes for the art patrons of Detroit, of whom there seemed to be very many.

Their condemnation was unanimous. Beautiful, well-dressed ladies complained about the loss of their peaceful, lovely garden, which had been like an oasis in the industrial desert of Detroit. Thanks to me, their charming sanctum was now an epitome of everything that made noise and smoke and dust. It seemed true enough to me that my paintings distracted attention from their gorgeous gowns.

Into the ears of the French architect of the garden, they whispered their dismay.

I stood apart, observing their reactions. Then I was approached by a group of society women with whom I had previously become acquainted. They asked me how I felt about the prevailing attitude toward my frescoes. I asked these ladies to report back to their friends that the growth and wealth of the city of Detroit which they enjoyed came from the subjects and substances to which they were objecting. Furthermore, I said, many of them owed their personal riches to steel, which I had been so assiduous in representing and which I happened to love, though it was certainly a hard and cold metal. What I had represented on their garden walls was reality.

Why had I not chosen something pleasanter to paint instead, such as concerts, sports, open-air festivals, or art expositions? I explained, as politely as I could, that I found any factory more significant and beautiful than any of the subjects they suggested.

They took offense at my reply and told me that they could not possibly believe I had made this statement in good faith. How, they wondered, coming from Mexico, a land of romance, and then trained in sophisticated Paris, could I voice such an opinion, if not to mock and belittle them? My attitude was unfair. They were not responsible for the merciless expansion of Detroit's industry. They were not guilty of imposing the mechanical ugliness of its factories upon the city's original stately elegance.

The morning after this sombre reception, a group of men whose bearing made it clear that they had no connection whatsoever with the previous night's visitors, arrived at the museum. More than sixty in number, they walked into the garden in almost military formation behind a man who acted as their spokesman. His card, presented to Clifford Wight, identified him as the chief engineer of the Chrysler automobile factory. All the others in his party, he told Cliff, were also engineers. Cliff could speak French as well as English, of which I knew little, and when he had made the introductions, I asked him to be our interpreter.

Cliff immediately began to explain to the group that my frescoes were the work of painters, not engineers. The spokesman interrupted him, almost rudely, with a motion of his hand. "I should like to talk to Diego Rivera."

Cliff looked at me questioningly, and I in turn conveyed to the speaker that he had my full attention.

"Each of these men," he began, "is an engineer in one of the important steel or automobile factories in Detroit. They wanted me to talk to you, first because I am their leader, and secondly, because you, my good fellow with your damned frescoes, have caused me to fail to report to my job on nineteen separate occasions. Never before you came here had I so much as set a foot inside this place. I am not interested in the usual cultural stuff. I pass this building every day to and from work. I stopped in the first time merely to see what the asses in the newspapers were braying at.

"Since that first visit, I have had the urge to return here again and again. I have already spent more than fifty hours in this place. I've brought these other men with me today to share my enjoyment. I waited until today, because I wanted to be sure that all those fashionable women, those salon parrots, were out of the way. But that is not the point. What I wish to say for myself and these men with me, is that had we been commissioned to do the job you were asked to do, we would, technically speaking, have done exactly what you did."

Then turning to Cliff Wight, "You may wish to correct me by reminding me that Rivera is not an engineer by profession. All right. But this fellow has fused together, in a few feet, sequences of operations which are actually performed in a distance of at least two miles, and every inch of his work is technically correct. That's what is so amazing!"

With that, and with all of his fellows following suit, he shook hands with Cliff and me in a deeply sincere congratulatory manner. Bidding us good-bye, the delegation of engineers then walked out as they had entered.

For the first time in my life, I felt not only content but elated and proud on account of this unique demonstration of approval of my work.

In the afternoon of the same day, I received an even more gratifying ovation. It was of a kind which made me feel that none of my efforts—even those I had believed wasted—had been in vain.

Again it began with a mass of men marching in to see me, but now there were not sixty but more than two hundred. This group also had a spokesman. However, he showed no credentials. As soon as he appeared, he shouted in a deep resonant voice, striding into the center of the garden, "We want Diego Rivera to come here!"

I stopped what I was doing and glanced around at the crowd below. At once, I descended from the scaffold and walked right up to the big, muscular speaker.

Waiving all ordinary social preliminaries, he acknowledged my presence with a nod of his head. "We are Detroit workers from different factories and belonging to different political parties. Some of us are Communists, some are Trotskyites, others are plain Democrats and Republicans, and still others belong to no party at all.

"You're said to be a man of the left opposition, though not a Trotskyite. In any case, you're reported to have said that, as long as the working class does not hold power, a proletarian art is impossible. You have further qualified this by saying that a proletarian art is feasible only so long as the class in power imposes such an art upon the general population. So you have implied that only in a revolutionary society can a true revolutionary art exist. All right! But can you show me, in all these paintings of yours, a square inch of surface which does not contain a proletarian character, subject, or feeling? If you can do this, I will immediately join the left opposition myself. If you cannot, you must admit before all these men, that here stands a classic example of proletarian art created exclusively by you for the pleasure of the workers of this city."

I looked around at the work I had done, and I conceded that the speaker was entirely right.

As soon as I had made my reply, a crippled man advanced toward me from the throng.

He said, "We discussed what might happen today. And we decided that a man such as you would certainly admit your error, being faced with indisputable proof of it. For our part, we must declare formally and in public, that in his art Maestro Diego Rivera is a man of great integrity and honesty."

I was deeply touched by this tribute from a representative of the working class of the industrial city I wanted so much to impress.

Pleased by my evident delight, he went on, smiling warmly, "While I have the floor, I'll take the opportunity to tell you what we think about your frescoes. We've discovered one thing only lacking from your excellent portrayal of our life, and that is the factory whistle. I say this in jest, but you know the whistle does mark the beginning and the end of our working day.

"Seriously, and most important of all, we wish to inform you of what we have done to express a fraction of our appreciation for the paintings you have given us.

"The Constitution of the State of Michigan permits its citizens to band together in the event that a group of individuals intends to destroy a part of the state's common wealth. In such a case, the citizens have the right to use any weapons at their disposal. As you well know, there has been much talk against your frescoes, and there have been rumors that hoodlums may come here to destroy them.

We have therefore organized a guard to protect your work. Eight thousand men have already volunteered. To legalize our action, in accordance with the Constitution, we have already sent a document describing our purposes to the Governor of Michigan."

The following Sunday, my frescoes were put on view for the general public. The men guarding the entrance to the Institute asked identification of every visitor by having him write his name and address in a register. Despite this unusual precautionary step, the museum authorities were obliged to keep the doors open until half past one on Monday morning. At closing time, the register bulged with the names and addresses of eighty-six thousand citizens of Detroit. For the next several months, there was a continuous stream of people coming to the Institute to view my work.

The battle of Detroit, however, continued a long time afterward. Father Coughlin, many Jesuits, and quite a few politicians—some as far away from the frescoes as New York—continued to rant against what I had done. Yet, among writers, men of science, university professors, and ordinary working people, I found defenders. I was gratified that Edsel Ford stood by me loyally. And until all the sound and fury had passed, my army of eight thousand, working in shifts, guarded my work from destruction.

My satisfaction was indeed complete. Years before, in Paris, I had abandoned a profitable career in cubism because I had envisioned the mural as the art form of the industrial society of the future. The overwhelming approval of my paintings by the workers of Detroit not only endorsed my belief but seemed to be the beginning of the realization of my life's dream. For, already, two other important commissions awaited me: one, to paint a mural for the Rockefellers in their R.C.A. Building in Rockefeller Center; the other, to do a mural on the theme of American industry in the General Motors Building for the forthcoming Chicago World's Fair.

FRIDA'S TRAGEDY

ONE INCIDENT will always cloud my happy memories of Detroit. It concerned Frida; she was the chief sufferer. Three years before, in Mexico, Frida had been one of the victims in a horrible traffic accident. A bus in which she was riding had collided with a trolley car. Only five passengers in the vehicle had escaped with their lives. Frida was carried from the scene literally in pieces. Her vertebral column, her pelvis, and her left arm were fractured. Her right leg was broken in eleven places. Still worse, an iron rod had pierced her body from one side to the other, severing her matrix.

The doctors were unable to understand how she had survived. But she had not only survived, she became her lively self again. However, as a result of the accident, she would never be able to carry a baby, and the doctors warned her not to attempt to conceive.

For Frida this was a terrible psychological blow. Since the age of twelve, as a wild and precocious schoolgirl, she had been obsessed with the idea of having my baby. When asked her greatest ambition, she would announce to her flustered teachers and schoolmates, "To have a baby by Diego Rivera just as soon as I can convince him to co-operate."

Frida was not deterred by the doctors' warnings. While we were in Detroit, she became pregnant.

Her pregnancy was painful. The many women with whom Frida had made friends in Detroit, who had come to love her, did everything in their power to help her have the child. With the best of care, however, she suffered a torturous miscarriage. She became so ill that I forbade her ever to conceive again.

Nevertheless, Frida's desire to have a baby was so strong that she again risked her life by becoming pregnant three other times. Each pregnancy ended in a painful loss. But none was as acutely distressful as this first one in Detroit.

Frida's tragedy—for such she felt her experience to be—inspired her to paint a canvas depicting a miscarriage and expressing the sensations and emotions it gives rise to. She also painted a picture representing her own birth. Immediately thereafter, she began work on a series of masterpieces which had no precedent in the history of art—paintings which exalted the feminine qualities of en-

durance to truth, reality, cruelty, and suffering. Never before had a woman put such agonized poetry on canvas as Frida did at this time in Detroit.

During Frida's period of recovery, I occupied the greater part of my time in attempting to help migratory Mexicans, of whom several hundred then lived in Detroit, in constant dread of being deported. Native Americans were voicing resentment at these foreigners receiving welfare checks from the city. Their own needy, they said, were a heavy enough burden to carry during this time of universal bankruptcy.

There were some among my former countrymen who thought that conditions were better back in Mexico. Nostalgically, they dreamed of establishing agricultural colonies south of the Rio Grande. The task I set myself was to convince them, through a series of lectures, that a return to Mexico would not solve their problems, that having established roots in the United States, they must act with all other Americans to achieve a betterment of their economic situation.

Unfortunately, I failed in my purpose. So that they would not think I was exaggerating the difficulties of colonization in order to avoid helping them, I gave them most of the money I had earned painting the Arts Institute frescoes. With that subsidy, they returned to Mexico and established three colonies. Only one, established near Acapulco, survived. A few years later its members repaid my kindness in a unique way.

HOLOCAUST IN ROCKEFELLER CENTER

WHEN NELSON ROCKEFELLER DECIDED to decorate the main floor of his new R.C.A. Building in Radio City with murals, he also decided to get the best artists for the job. His choices were Picasso, Matisse, and myself. But he set about securing our services in the worst possible way. Through the architect of the building, Raymond Hood, he asked us to submit sample murals. Now, there are few indignities that can be thrown in the face of an established painter greater than to offer him a commission on terms which imply any doubts as to his abilities. But the invitations went further, they specified how the sample murals were

to be done. Picasso flatly refused. As for Matisse, he politely but firmly replied that the specifications did not accord with his style of painting. I answered Hood that I was frankly baffled by this unorthodox way of dealing with me and could only say no.

Having thus quickly lost Picasso and Matisse, Rockefeller determined that at the very least he would have me. In May, 1932, he entered into the negotiations directly since, on many matters, Hood and I could not see eye to eye. Hood's idea of a mural was typically American; a mural was a mere accessory, an ornament. He could not understand that its function was to extend the dimensions of the architecture. Hood wanted me to work in a funereal black, white and gray rather than in color, and on canvas rather than in fresco. Our differences piled up when I heard that two inferior painters, Frank Brangwyn and José María Sert, had been given the walls previously offered to Picasso and Matisse, walls that flanked the one offered me. Amid this difference and tension, Rockefeller moved with the calm of the practiced politician. He refused to be ruffled. By the fall of the year, he had persuaded Hood to let me work in fresco and in color, and we had agreed on the terms. For the sum of $21,000 for myself and my assistants, I was to cover slightly more than one thousand square feet of wall. The theme offered me was an exciting one: "Man at the Crossroads Looking with Hope and High Vision to the Choosing of a New and Better Future." After the complicated preliminaries, I entered into my assignment with enthusiasm. By the beginning of November, I had completed my preliminary sketches, submitted them, and received prompt and unqualified approval from Rockefeller. In March of 1933, Frida and I arrived in New York from Detroit, greeted by the icy blasts of the New York winter.

I set to work immediately. My wall, standing high above the elevators which faced the main entrance of the building, had already been prepared by my assistants, the scaffold erected, the full-scale sketches traced and stenciled on the wet surface, the colors ground. I painted rapidly and easily. Everything was going smoothly—perhaps too smoothly. Rockefeller had not yet seen me or my work, but in the beginning of April, he wrote me that he had seen a photograph of the fresco in one of the newspapers and was enthusiastic about what I was doing. He hoped that I would be finished by the first of May, when the building was to be officially opened to the public.

The center of my mural showed a worker at the controls of a large machine. In front of him, emerging from space, was a large hand holding a globe on which the dynamics of chemistry and biology, the recombination of atoms, and the division of a cell, were rep-

resented schematically. Two elongated ellipses crossed and met in the figure of the worker: one showing the wonders of the telescope and its revelations of bodies in space; the other showing the microscope and its discoveries—cells, germs, bacteria, and delicate tissues. Above the germinating soil at the bottom, I projected two visions of civilization. On the left of the crossed ellipses, I showed a night-club scene of the debauched rich, a battlefield with men in the holocaust of war, and unemployed workers in a demonstration being clubbed by the police. On the right, I painted corresponding scenes of life in a socialist country: a May Day demonstration of marching, singing workers; an athletic stadium filled with girls exercising their bodies; and a figure of Lenin, symbolically clasping the hands of a black American and a white Russian soldier and worker, as allies of the future.

A newspaper reporter for a New York afternoon paper came to interview me about my work, then nearing completion. He was particularly struck by this last scene and asked me for an explanation. I said that, as long as the Soviet Union was in existence, Nazi fascism could never be sure of its survival. Therefore, the Soviet Union must expect to be attacked by this reactionary enemy. If the United States wished to preserve its democratic forms, it would ally itself with Russia against fascism. Since Lenin was the pre-eminent founder of the Soviet Union and also the first and most altruistic theorist of modern communism, I used him as the center of the inevitable alliance between the Russian and the American. In doing this, I said, I was quite aware that I was going against public opinion.

Having heard me out, the reporter, smiling politely, remarked that, apart from being a remarkable painter, I was also an excellent humorist.

The following day the reporter's story appeared in his paper, *The World Telegram*. It told what should have surprised nobody, least of all Nelson Rockefeller, who was fully acquainted not only with my past and my political ideas but with my actual plans and sketches: that I was painting a revolutionary mural. However, the story suggested that I had hoaxed my patron, Rockefeller, which was, of course, not true. Thus the storm broke. I, who had become inured to storms, only painted on with greater speed. The first of May had passed, and I was nearly finished when I received a letter from Nelson Rockefeller requesting me to paint out the face of Lenin and substitute the face of an unknown man. Reasonable. However, one change might lead to demands for others. And hadn't every artist the right to use whatever models he wished in his painting?

I gave the problem the most careful consideration. My assistants were all for a flat denial of the request and threatened to strike if I yielded. The reply I sent Rockefeller, two days after receiving his letter was, however, conciliatory in tone. To explain my refusal to paint out the head of Lenin, I pointed out that a figure of Lenin had appeared in my earliest sketches submitted to Raymond Hood. If anyone now objected to the appearance of this dead great man in my mural, such a person would, very likely, object to my entire concept. "Therefore," I wrote, never expecting that a presumably cultured man like Rockefeller would act upon my words so literally and so savagely, "rather than mutilate the conception, I should prefer the physical destruction of the conception in its entirety, but preserving, at least, its integrity."

I suggested as a compromise that I replace the contrasting nightclub scene in the left half of the mural with the figure of Abraham Lincoln (symbolizing the reunification of the American states and the abolition of slavery), surrounded by John Brown, Nat Turner, William Lloyd Garrison, Wendell Phillips, and Harriet Beecher Stowe, or with a scientific figure like Cyrus McCormick, whose reaping machine had contributed to the victory of the Union forces by facilitating the harvesting of wheat in the fields depleted of men.

As I awaited Rockefeller's response, the hours ticked by in silence. I was seized by a premonition that no further word would come, but that something terrible, instead, was about to happen. I summoned a photographer to take pictures of the almost finished mural, but the guards, who had been ordered to admit no photographers, barred him. At last, one of my assistants, Lucienne Bloch, smuggled in a Leica, concealed in her bosom. Mounting the scaffold, she surreptitiously snapped as many pictures as she could without getting caught.

On the day in the second week in May when Rockefeller finally made his move, the private police force of Radio City, reinforced the week before, was doubled. My assistants and I, aware that we were watched, that forces were being deployed as if for a military operation, worked on, pretending to ourselves that nothing was happening, or nothing as bad as we feared. But at dinnertime, when our numbers were at their smallest, three files of men surrounded my scaffold. Behind them appeared a representative of the firm of Todd, Robertson and Todd, managing agents for John D. Rockefeller, Jr. Like a victorious commander, he asked me to come down for a parley. My assistants present at this dark moment, Ben Shahn, Hideo Noda, Lou Bloch, Lucienne Bloch, Sánchez Flores, and Arthur Niedendorff, looked at me helplessly. Helplessly, I

let myself be ushered into the working shack, the telephone of which had been cut off, acknowledged the order to stop work, and received my check.

Other men, meanwhile, removed my scaffold and replaced it with smaller ones, from which they affixed canvas frames covering the entire wall. Other men closed off the entrance with thick curtaining. As I left the building, I heard airplanes roaring overhead. Mounted policemen patrolled the streets. And then one of the very scenes I had depicted in my mural materialized before my eyes. A demonstration of workers began to form; the policemen charged, the workers dispersed; and the back of a seven-year-old girl, whose little legs could not carry her to safety in time, was injured by the blow of a club.

One last thing remained. In February of 1934, after I had returned to Mexico, my Radio City mural was smashed to pieces from the wall. Thus was a great victory won over a portrait of Lenin; thus was free expression honored in America.

One result of the fracas was the cancellation of my General Motors assignment, and I was cut off from commissions to paint in the United States for a long time. Rockefeller, wishing to avoid further bad publicity or the nuisance of a court action, had paid me my entire fee. Out of the $21,000, however, $6,300 went to Mrs. Paine as her agent's commission; about $8,000 covered the cost of materials and the wages of assistants; and I was left with somewhat less than $7,000. Considering the loss of present and future commissions, I was advised by my attorney to sue Rockefeller for $250,000 for damages and indemnification. However, I did not sue; a legal action would have tended to nullify my position.

Rockefeller's action in covering the mural—with canvas frames and later with strips of sheath paper—became a cause célèbre. Sides were drawn. A group of conservative artists calling themselves the Advance American Art Commission exploited the occasion to condemn the hiring of foreign painters in the United States. In contrast to these chauvinistic second-raters, who would have substituted a national-origin standard for that of artistic excellence, and who applauded Rockefeller's act of vandalism, another group of artists, writers, and intellectuals, including Walter Pach, George Biddle, Bruce Bliven, Robert L. Cantwell, Lewis Gannett, Rockwell Kent, H. L. Mencken, Lewis Mumford, Waldo Pierce, and Boardman Robinson, besought Rockefeller to reconsider what he had done. It was largely because of such protests that Rockefeller waited nearly a year before he destroyed my mural. Two days after it had been covered over, Raymond Hood announced that it would receive "very careful handling." At the worst, two possibilities were

suggested as its fate: that it might temporarily be screened with a canvas mural; or that it might be removed, plaster and all, for preservation elsewhere.

Oddly enough Communist leaders such as Robert Minor, Sidney Bloomfield, and my old friend Joe Freeman, editor of the *New Masses*, denounced the work as "reactionary" and "counterrevolutionary" and condemned me for having betrayed the masses by painting in capitalistic buildings!

In the spring of 1933, I aired my views over a small radio station in New York: "The case of Diego Rivera is a small matter. I want to explain more clearly the principles involved. Let us take, as an example, an American millionaire who buys the Sistine Chapel, which contains the work of Michelangelo. . . . Would that millionaire have the right to destroy the Sistine Chapel?

"Let us suppose that another millionaire should buy the unpublished manuscripts in which a scientist like Einstein had left the key to his mathematical theories. Would that millionaire have the right to burn those manuscripts? . . . In human creation there is something which belongs to humanity at large, and . . . no individual owner has the right to destroy it or keep it solely for his own enjoyment."

Reconstruction

 I STILL HAD HOPES of reconstructing the mural (from Lucienne's photographs) somewhere in the United States. Walls enough were offered to me, but either they were of the wrong dimensions or the buildings in which they stood were unsuitable to the projection of my theme. At last I hit upon the New Workers School, then located on West 14th Street, and maintained by a communist group in opposition to the Communist Party. Its auditorium wall seemed almost adequate. But the building was only rented, and might therefore pass into the hands of other occupants. Besides, it was so old that it was likely soon to fall to the wreckers. Rockefeller would then have the satisfaction of seeing my mural destroyed twice. So I abandoned the idea of reconstructing the Radio City fresco there. But the future pleasure I

might have in spending the last of Rockefeller's money to decorate a workers' school struck me as too attractive to forgo.

I decided to paint a series of movable panels, which the school could transport when it moved to another building. My theme was to be a "Portrait of America," in which, through representative figures of each period, I would create a dynamic history of the United States from the colonial era to 1933, illuminating the continuous struggle between the privileged and the dispossessed. To insure the historical accuracy of my portrayals, the faculty and student body of the school labored as one to supply me with contemporary documents of the successive periods, including newspapers, photographs, woodcuts, caricatures, prints, and reproductions of oils. I did twenty-one panels in all, representing such objects as the American Revolution, Shays' Rebellion, the westward expansion, the antislavery movement, the Civil War, Reconstruction, the I.W.W. and the Syndicalist Movement, modern industry, World War I, the new liberties, imperialism, the Depression, and the New Deal. Each panel was filled with masses of people at work or in conflict, but individuals stood out as leaders and spokesmen. So it was that I painted portrait interpretations of Benjamin Franklin, Thomas Paine, Thomas Jefferson, Samuel Adams, Ralph Waldo Emerson, Walt Whitman, Henry D. Thoreau, Abraham Lincoln, John Brown, and other figures of importance in American history and thought.

When the New Workers School moved from 14th to 33rd Street, the panels, each weighing about 300 pounds, were carried out of the auditorium, loaded into vans, and shipped to the new plant. Here they remained until the school was disbanded. The International Ladies' Garment Workers Union then acquired them, and they are now on permanent display at Unity House, a vacation resort operated for members of the union and their families in Forest Park, Pennsylvania.

It was not in the United States but in Mexico, to which I returned later the same year, that I finally reconstructed the "Rockefeller" mural.

Orozco and I were commissioned to do two large panels in the Palace of Fine Arts. Although the dimensions of the surface were not quite right, I decided that this was the place where I would bring the murdered painting back to life. I made certain changes. In the extra space of the Palace wall, I added a few figures not in the Radio City fresco. The most important of the additions was a portrait of John D. Rockefeller, Jr., which I inserted into the night-club scene, his head but a short distance away from the venereal disease germs pictured in the ellipse of the microscope.

THE NAZIS LEARN HOW TO DEAL WITH ME

 BEFORE ENGAGING in this project, I had returned to the National Palace stairway. My vision now crystallized in the acid of my recent bitter experience, I began to paint Mexico today and tomorrow. I depicted the betrayal of the Revolution by self-seeking demagogues. In contrast with their millennial promises, I painted the reality of Mexico today: strikes being crushed; farmers and workers being shot or sent off to the penal colony of Islas Marías. At the top of the stairs, I portrayed Karl Marx exhorting the suffering workers to break their chains, and pointing to a vision of a future industrialized and socialized land of peace and plenty.

While working on the second Rockefeller mural, I contracted a severe eye ailment which forced me, for a time, to leave the scaffold. Because of this disability I had to give up several commissions, among them a mural for the new Medical School in Mexico. I confined myself, for the time being, to easel painting.

At this period, the German Ambassador to Mexico resided in a house near mine. Always attired in a formal morning suit, he would stroll each day up and down the street before my studio. People in the neighborhood, amused by his rigid manner and sombre attire, called him "the undertaker." I had recently done a highly uncomplimentary painting of Hitler and other Nazi officials, and I knew that I was not in favor with this gentleman.

On three separate occasions, two typical SS men had visited my dealer, Alberto Misrachi, subtly "advising" him to remove the painting from his display window. Misrachi warned them that if they approached him again, he would have them arrested. When he told me of his experiences, I became terribly enraged. I declared that if his visitors bothered him again, he should tell them to deal with me personally.

A few days later two shots were fired into my workroom. They were aimed at a typist sitting in a chair in which Frida usually sat conversing with me as I painted. The typist was Frida's sister, Christine, who was several inches shorter than she. The bullets passed just over her head.

Afterwards, it occurred to me that the would-be assassins had thought that by killing Frida they could hurt me infinitely more than if they struck at me. In this respect, they were absolutely right.

Hot with rage as soon as she realized what had happened, Christine searched for and found my gun. Clutching it in her hand, she leapt into her car, drove at breakneck speed, and caught up with the Germans. She shot one of them in the leg and forced the other, at gunpoint, to surrender. Then she brought them both to the police station.

A few days afterward they "escaped" from jail. Nobody had any idea where they had fled to until I received a message from Acapulco. The message, sent by one of the migrant Mexican workers whom I had subsidized in Detroit to set up a colony near the famous resort city, simply stated that two men, one with a limp, had been found hanged in the vicinity. I knew at once that my charity had been repaid.

When the news of the hangings became known, the Minister of the Interior summoned me to his office. As we were friends, he asked me directly whether I had been responsible for the execution of the two Germans. I replied that, unfortunately, I had not been, but while envious, I was not unhappy that others had taken the task upon themselves.

While we were talking, the German Ambassador dropped in to see the Minister. The Ambassador said he hoped no animosity would arise between the nations of Mexico and Germany over the incident. The dead men, he said, were merely soldiers who had fallen in the line of duty. He desired that the inquiry into the deaths be halted at once lest this trifling episode be magnified into an international incident.

When he had done speaking, the Minister of the Interior introduced me to him. The Ambassador clicked his heels, Prussian fashion, and bowed from the waist.

I said, "I see you're not using an intellectual approach in dealing with Mexicans."

The Nazi, unable to look me straight in the eye, falteringly answered, "*Ja, ja*," and left immediately.

The next day a stunningly beautiful woman, who introduced herself as the chief secretary of the German Embassy, called at my studio. She said she had always adored my work and wanted to buy everything I had on hand. She wouldn't think of returning from Mexico to her Fatherland without a goodly collection of my paintings. Of course I was flattered that so beautiful a woman should show so much interest, and we became very good friends.

Shortly before she was to leave for Germany, I asked her to report back to the German Ambassador that I thought this the best way to deal with Mexicans. And when I again chanced to meet him, the Ambassador remarked that my message had been completely in order. He, too, preferred to be dealt with as I had been.

PANI LOSES AN EYE

 WITH TIME OUT to take care of my eye ailment, I completed my fresco at the Palace of Fine Arts in the spring of 1936, nineteen months after I had begun working on it. My old friend, Alberto Pani, who had helped subsidize my journey to Italy, now offered me a commission to paint four panels for the large dining room in the Hotel Reforma, which he was in the process of building.

The fee Pani agreed to was 4,000 pesos, or about $1,000. In keeping with the decor of the room, I decided to use carnival themes. As my plans developed, I was led to give my paintings of present-day subjects touches of a satirical nature. Aware from my still recent experience in New York that these embellishments might provoke controversy, I made the panels movable, so that if Pani decided to play Rockefeller, there would be no excuse to destroy them. In this, as will be seen, I showed considerable foresight.

Of the four panels, two depicted traditional Mexican festivals: one centering about the ancient Yautepec god of war, Huichilobos; the other honoring the bandit hero Augustín Lorenzo, who fought against the French and once unsuccessfully attempted to kidnap the Empress Carlotta. Of the remaining two panels, dedicated to more contemporary themes, one burlesqued the Mexico of the tourists and lady folklorists—desiccated urban types whose imbecile pretensions were satirized by asses' ears sprouting from their heads.

The other depicted the carnival which is Mexican life today. Here men in symbolic uniforms, with mask-like faces, charged upon straw scarecrows as the street crowds obediently blew their noise-makers. Among them, a pig-faced general danced with a woman symbolizing Mexico; his hand surreptitiously reached over her shoulder to steal fruit from the basket on her back. A man with sheep's features, symbolizing the hireling intellectual, broadcast an official account of the festivities, holding aloft a dry bone. Over his shoulder peeped a grinning cleric. Behind an enormous, out-of-scale figure was the head of a Mexican capitalist. The ugly, grinning giant who obscured him and dominated the panel bore features of Hitler, Mussolini, Franklin D. Roosevelt, and the Mikado. A flag which he held in his right hand was a composite of the colors of Germany, Italy, the United States, and Japan.

My old friend Pani watched the progress of my panels with affable smiles. If he had any objections to any of the details, he never declared them to my face. Instead, when I had completed my work, he secretly sent his brother Arturo to make the changes he desired. Arturo painted out the American portion of the giant's flag; he also removed the thieving hand of General Pig from Miss Mexico's basket; and he altered the features of a dancing tiger who resembled Calles. Informed of these "improvements" a few nights afterward, I charged into the hotel. Guns were drawn, the police arrived, and I was taken to jail to spend the night. The following day the building trades union called a sympathy strike.

Apparently desirous of ending all of Pani's legal troubles in one swoop, the Attorney General of the Republic summoned me, the workers' legal representative, and Pani's attorney to a hearing at his office. After the formal preliminaries, the Attorney General cited an old law which held that anyone who altered a work of art, while preserving the signature of its original creator, was guilty of forgery. Since my agreement with Pani contained no provision permitting alterations, the Attorney General ruled Pani guilty of that offense. He ordered Pani to pay not only the stipulated fee but a heavy fine for ordering the act of forgery, and full compensation to the workers for wages lost while out on strike. I knew that this judgment would infuriate Pani, and I remarked to Frida that we must expect some act of retaliation from him.

Pani fought the judgment in the courts and lost; and while the case remained alive, the strike continued. One day, accompanied by a labor inspector, Frida and I arrived outside the hotel in the capacity of supplementary guards for the workers. Upon seeing us, Pani immediately dispatched his brother Arturo to summon help from the police station. Arturo offered the police lieutenant a bribe of two hundred pesos to throw us in jail. The officer indignantly refused and accused Arturo of attempted corruption.

Before the charge could be legally presented, however, Arturo somehow managed to have Frida whisked off to the police station. Enraged near to madness by this, I warned Arturo that as soon as I got Frida out, I would deal with him in my own way. Arturo was frightened by my show of anger; he whined that he should not be held responsible, that he had only followed brother Alberto's orders. If I wanted satisfaction, I should deal with Alberto.

In blind rage I answered him with the first threat which entered my mind. "Very well, Arturo, crawl back to your brother and tell him that this dirty little trick is going to cost him one of his eyes."

Gambler's luck was with me. My random threat soon came true, though through no action of mine. At a bullfight not long after-

wards, an excited, drunken army captain threw an empty bottle into the air. It lit on Pani's skull and put out one of his eyes.

The panels were finally removed from the hotel and replaced by mirrors. Pani kept them in storage for a time and then sold them to Misrachi, who stored them in the warehouse of his Central Art Galleries in Mexico City.

An Invitation from Mussolini

 In the same year, 1936, I was invited to paint in Italy. The offer came from Mussolini himself, through a most unique envoy, Margherita Sarfatti, an acquaintance of my Paris days, who had been Mussolini's mistress.

In 1908, when I first met Margherita, she was a member of the "salon set," also frequented by Angelica Balabanova. Around these two beautiful young women clustered such men as Modigliani, Riccioto Canudo, the brothers Garibaldi, and Margherita's lover of the time, Valentine de Saint Point. One activity of the group was the publication of a magazine which was regarded as an organ of the French imperialists.

The one member of the group who differed politically from the others was Angelica. She was, in fact, a personal friend of Lenin and one of the most eminent social revolutionaries in Paris. During this period Mussolini, then an Italian Socialist leader, became Angelica's lover. Soon he was the puppet of the fiery Angelica, echoing her every word and thought; for a time in fact, Angelica was Mussolini's brain. Then one day, at the home of Saint Point, Mussolini met and fell in love with Margherita, deserted Angelica, and took Margherita as his mistress. Assuming Angelica's old role, Margherita turned his thinking completely about, nurturing the germ of fascism which had always lain dormant in *Il Duce*'s mind.

My telephone rang at one o'clock in the morning. I picked up the receiver and heard Misrachi at the other end of the line. Apologizing for disturbing me at this late hour, he jubilantly informed me that a very lovely European lady had purchased every painting of mine in his gallery and was going to take them all back with her to Europe. Before she left, however, she wanted to speak to me personally. Misrachi urged me to grant her this favor. I had no idea

then who she might be, but when I heard her voice on the telephone, I immediately recognized it as Margherita's.

She said, "Diego, you old fool, I've been thrown over by the Old Man and now even you refuse to talk to your old Parisian friend. I wanted to speak to you, not for personal reasons, but because I have a message from him which I must give you before I leave Mexico. Mussolini instructed me to tell you how much your work is appreciated in Italy, and that anytime you wish to come to Italy, you're welcome. You can paint whatever you like, and everything you need will be at your disposal. He also said this: if you ever feel there's no safe place left in the world for you to plant your feet, you'll always find a haven in Italy."

I answered Margherita politely—my politeness based solely upon my former acquaintance with Mussolini and herself: "Thank you for your message, Margherita, and thank Mussolini for his invitation. But tell Mussolini that I am quite certain he'll have dire need for a safe place to put his feet much sooner than I."

It was my year to be prophetic. As in the case of Pani, my chance remark proved to be an augury. Ten years later my old fellow Parisian, Mussolini, was strung up with his feet high in the air.

FRIDA: TRIUMPH AND ANGUISH

 FOLLOWING THE AFFAIR of the Hotel Reforma, poor health kept me from painting murals for several years. In his biography of me (*Diego Rivera: His Life and Times*, New York, 1939), Bertram Wolfe dramatizes this period of languishment as a kind of artistic exile which I incurred because of my political beliefs, but his interpretation is not in accord with the facts.

The Medical School fresco which I had contracted to paint was not done because of my eye ailment; the commission was never revoked. Another commission I had, to do a series of frescoes in the corridors of the National Palace, was also postponed but never invalidated; and, in 1942, I actually began the work. During these years of bad health, I became passionately absorbed by a less exacting artistic activity—making spot sketches of aspects of Mexican life. Many of these sketches evolved into drawings and water colors.

More important, they stimulated me to observe more closely than ever before the life of my countrymen. I am still making use, both in terms of subject matter and technique, of the experiments I then engaged in.

It was about this time that Frida, beyond all doubt, proved her love for me. We were having lunch one day at the Acapulco Restaurant in Mexico City, when four hired assassins of the reactionary General Saturnino Cedillo walked up to our table. Cedillo had ordered the execution of all revolutionary partisans of General Cárdenas. When the assassins calmly drew their guns and aimed them at me, I was sure my end had come.

Quick as an arrow, Frida leaped out of her chair in front of me. She screamed at the gunmen to shoot her first if they dared. To provoke them, she called them cowards and practically every foul name in her ample vocabulary. Her hysterical shouting roused everyone in the dining room.

The four killers, shocked into immobility, stood frozen, guns in hand, like statues of themselves. Finally, awakened to reality by the swelling hubbub around them, they wheeled and ran into the street. Some days later, while trying to escape across the northern border into the United States, all four were shot down.

However, when the reaction to this narrow escape set in afterwards, Frida became very ill and nervous and ran a high fever. When she recovered, she resumed her painting, now with grave intensity, for she was preparing for her first New York show, only a few months off.

Before she left for New York, taking with her the best of her recent work, I gave her, among other letters of introduction, one to Clare Boothe Luce, wife of the magazine tycoon and recently American Ambassador to Italy. I had imagined that Frida would find Mrs. Luce an interesting person to know, but she didn't take to her at all. She found her cold, brittle, and impenetrably defensive.

Nevertheless, Mrs. Luce asked Frida to do one painting for her, and Frida complied. Apparently, Mrs. Luce disliked the work, for she returned it to Frida only a few weeks after she had received it.

But Mrs. Luce's coldness was not shared by the art critics, and Frida's New York show was warmly acclaimed. I suggested that, instead of returning to Mexico, she proceed to Paris and complete her triumph. Frida was reluctant and afraid. To persuade her, I argued that one should take every opportunity that contains the promise of fulfillment or pleasure. I was quite certain she would be well received in Paris.

So, in 1939, Frida sailed for Paris and conquered it. The more rigorous the critics, the greater their enthusiasm.

The praise of two men in particular gilded the aureole of Frida's happiness. One was Vasily Kandinsky, probably the greatest pioneer in modern abstractionism; the other was Marcel Duchamp, one of the masters of abstract expressionism [*sic*]. Kandinsky was so moved by Frida's paintings that, right before everyone in the exhibition room, he lifted her in his arms, and kissed her cheeks and brow while tears of sheer emotion ran down his face. Even Picasso, the difficult of difficults, sang the praises of Frida's artistic and personal qualities. From the moment he met her until the day she left for home, Picasso was under her spell.

In mere weeks, Frida won over the Parisian world of art more completely than more famous painters had after years of struggle. Her triumph spilled over into the world of fashion. That season Schiaparelli introduced La Robe Madame Rivera, a Parisian interpretation of Frida's beautiful style of Mexican dress. And the most widely-read high-fashion magazine appeared on the stands with a cover photograph of Frida's right hand, together with an elegant jewel box containing four of her favorite gems. Amid all this concern for novel, suddenly modish trinkets, it was hard to believe Europe was tottering on the brink of another world war.

But then the bad luck that always stalked poor Frida struck again. She suddenly fell ill and had to be taken to a hospital. Though her many new friends pampered her, she was in an agony to get home, and as soon as she was well enough to travel, she changed her convalescent's bed for a ship berth. She arrived in Mexico miserably sick, suffering the recurrent pain of her old accident.

I never was—the reader may be bored with my repeating it—a faithful husband, even with Frida. As with Angeline and Lupe, I indulged my caprices and had affairs. Now, moved by the extremity of Frida's condition, I began taking stock of myself as a marriage partner. I found very little which could be said in my favor. And yet I knew I could not change.

Once, on discovering that I was having an affair with her best friend, Frida had left me, only to return with somewhat diminished pride but undiminished love. I loved her too much to want to cause her suffering, and to spare her further torments, I decided to separate from her.

In the beginning, I only hinted at the idea of a divorce, but when the hints brought no response, I made the suggestion openly. Frida, who had by now recovered her health, responded calmly that she would prefer to endure anything rather than lose me completely.

The situation between us grew worse and worse. One evening, entirely on impulse, I telephoned her to plead for her consent to a divorce, and in my anxiety, fabricated a stupid and vulgar pretext. I

dreaded a long, heart-wrenching discussion so much that I impulsively seized on the quickest way to my end.

It worked. Frida declared that she too wanted an immediate divorce. My "victory" quickly changed to gall in my heart. We had been married now for thirteen years. We still loved each other. I simply wanted to be free to carry on with any woman who caught my fancy. Yet Frida did not object to my infidelity as such. What she could not understand was my choosing women who were either unworthy of me or inferior to her. She took it as a personal humiliation to be abandoned for sluts. To let her draw any line, however, was this not to circumscribe my freedom? Or was I simply the depraved victim of my own appetites? And wasn't it merely a consoling lie to think that a divorce would put an end to Frida's suffering? Wouldn't Frida suffer even more?

During the two years we lived apart, Frida turned out some of her best work, sublimating her anguish in her painting . . . and then, because of certain events which involved her, although indirectly, she became weak and sick again. I shall now relate these events exactly, if not always in the sequence in which they occurred.

TROTSKY

 ON MAY 24, 1940, twenty men disguised as policemen burst into the Mexican home of Leon Trotsky and his wife and sprayed his bedroom with Thompson submachine guns. The Trotskys saved themselves by dropping flat on the floor while their beds were riddled by about three hundred rounds. Questioned by the police as to the identity of his would-be assassins, Trotsky suggested that it might prove enlightening to investigate a station wagon belonging to a well-known local painter which had been seen in the neighborhood at the time of the attack.

One night, several days later, a platoon of policemen, moving silently through the street, cordoned off my studio in San Ángel. I knew nothing of this action until I received a telephone call from the movie actress Paulette Goddard, whose portrait I had recently begun painting. Paulette was staying at an inn just across from my

studio. Chancing to look outside her window, she saw what was happening and immediately rang me up.

"Diego," she said, her voice trembling with excitement, "if I know anything about gangster movies, brother, you're on the spot. The cops are swarming around your studio. And they look like they mean business."

Visiting my studio at the time was the Hungarian-American painter Irene Bohus. Despite the fact that I had no notion what the police wanted with me, I recognized trouble and decided to get away. Irene agreed to help me, and I quickly worked out a plan. Irene left the studio, carrying as many canvases as she could under her arms. She descended very slowly by the outside stairway, bidding me a long, loud *adieu* in English. After responding to Irene's first words, I left the door wide open and ran back to put on all the lights in my studio. This was to give the impression that I had resumed my work. However, I immediately ran down the inside stairway to Irene's car, safely concealed in the inner courtyard. By the time Irene, who had meanwhile been pretending to bombard me with chatter, entered the car, I was lying flat on the floor inside. She piled all the canvases she had taken on top of me, concealing me completely. Then she swung the car out of the courtyard and into the road, whisking me out from under the very noses of Police Colonel de la Rosa and all thirty of his men, alertly waiting to move in on me with drawn revolvers.

When the police finally entered my house and found me gone, they proceeded to search it for evidence. Probably angered over being outwitted, they broke some items of my valuable archeological collection. My watch and certain other personal belongings also disappeared.

They stayed the whole night, awaiting my return. By next morning, realizing that I was not going to oblige them, they appropriated my station wagon and arrested my two chauffeurs. They kept the chauffeurs in custody for two weeks, subjecting them to all the devices used by police to extort confessions, but to no avail. Meanwhile, the police laboratory had made a thorough analysis of my station wagon, but since I had had no connection with the attack, they found nothing, and their efforts to implicate me remained fruitless.

During all this time I stayed in hiding. For, in spite of my innocence, I did not want to become involved in any way in the intrigues which had come to surround Trotsky. My refuge was never discovered by the police. Paulette, enjoying her role in this real-life drama, brought me delicacies and the finest of wines on her fre-

quent visits. Her lovely presence alone was enough to make my retreat a delight. In the meanwhile, my portrait of Paulette, as well as all of Irene's paintings, were removed from the studio and put in the custody of a good friend, American Vice-Consul MacGregor. Since both Paulette and Irene were American citizens, he was merely acting to protect their property.

What were the reasons behind Trotsky's suspicion of me and behind the eagerness of the police to act for him against a citizen of Mexico? It was I who had been instrumental in securing Trotsky's admittance into Mexico after every country in the world had closed its doors to him. I had acted only after many pleas by his supporters to use my influence. In yielding to them, I had been swayed by two considerations: my belief that a man persecuted for political reasons in his own country was entitled to refuge in another; and the fact that having been expelled from the Communist Party in 1929, I would not be betraying it.

At the same time I was aware that, if Soviet justice, having condemned Trotsky for treason, decided to impose its usual penalty for that crime, nothing that Trotsky could do would prevent its being carried out. But that was Trotsky's concern. Belonging then to a political group allied to Trotsky's Fourth International, I accepted the whole responsibility of promoting a legal asylum for Trotsky in Mexico. To this purpose I asked for an audience with the President of the Republic, Lázaro Cárdenas. Cárdenas received me cordially, listened to, and granted my appeal. Thus Trotsky obtained his visa.

At the time of Trotsky's arrival in Mexico in December, 1936, I was ill, and I asked Frida to welcome him and Madame Trotsky at the dock. Frida detested Trotsky's politics but, desiring to please me, she not only greeted the Trotskys as they landed, but invited them to stay at her family's house in Coyoacán, a forty-five-minute drive from my studio in San Ángel, where Frida and I were living.

In appreciation, Trotsky wrote an article, published in the August-September, 1938 number of the *Partisan Review*, which contained the highest kind of praise for my work.

"Do you wish to see with your own eyes the hidden springs of the social revolution?" Trotsky wrote. "Look at the frescoes of Rivera. Do you wish to know what revolutionary art is like? Look at the frescoes of Rivera.

"Come a little closer and you will see, clearly enough, gashes and spots made by the vandals. . . . These cuts and gashes give even greater life to the frescoes. You have before you, not simply a 'painting,' an object of esthetic contemplation, but a living part of the class struggle. And it is at the same time a masterpiece!"

Trotsky went on to condemn the Stalin regime for having me expelled from the Mexican Communist Party and for having refused to let me paint frescoes on the walls of Soviet buildings.

By 1940, however, the political differences between Trotsky and myself had made any amicable relationship impossible. At our last meeting that year, Trotsky became so infuriated with me that he ordered me out of his house. Immediately before, he had remarked that he could not understand, judging by my politics, why I was not one of Stalin's best friends. In saying this, he implied that he suspected me of being a secret henchman of Stalin. The police followed the same line of reasoning in their attempt to implicate me in the attack on Trotsky's home.

The Mexican authorities had their own reasons for wishing to pin something on me. Not long before I had embarrassed them by an exposé of apparent collusion with the Nazis. Late in 1939, a German liner, the *Columbus*, flanked by two smaller vessels, had dropped anchor in Mexican waters. Having learned that the *Columbus* was being used as a ship of war, I published a demand that I be allowed to search it, accompanied by representatives from the Mexican Army, the marines, and the police, as well as the British and French legations (the United States was not yet at war with Germany). I declared my readiness to go to jail and stand trial on whatever charges might be brought against me if my information was disproved.

My information, I wrote, had come from a trustworthy man of authority who had assured me that his facts were entirely accurate, and I had decided to risk personal danger to do what I felt was my civic obligation.

According to my informant, the swimming pool of the liner was being used as a fuel tank and cargo hold for servicing submarines. Beneath the pool was an apparatus by which the submarines could take on the supplies while submerged, thus minimizing the possibility of detection. Four eight-inch guns were concealed along the shaft of the propeller together with the equipment required to mount them. The *Columbus* could thus be converted into an auxiliary cruiser on short notice. Within the bulkhead walls, along the sides of the ship, were ammunition stores ample for a four-month campaign. Of the two smaller vessels, one was stocked with fuel and lubricants, the other with food and medical supplies.

In conclusion, I declared that, if the government did not authorize the search I requested, it could reasonably be assumed to be permitting Germany to use a Mexican port as a submarine base.

My article was printed in *Hoy* in mid-December, 1939. On the same day the magazine came out, the newspapers *Novedades, El*

Gráphico, and *La Prensa* summarized my charges. I waited at my studio all day to see what might happen, but nobody showed up.

At four o'clock that afternoon, the *Columbus*, without being challenged by any Mexican authority, suddenly weighed anchor and, with its two satellite vessels, headed out to sea. About forty-eight hours later, on December 19, 1939, all three ships were blown up by their crews to avoid capture by alerted British destroyers which had sighted them in Bahaman waters.

Soon after the war began, the pro-Nazi, anti-Semitic elements in Mexico, disguised, as was then fashionable, in the garb of nationalism, began to attack me. Infuriated by my action in the *Columbus* affair, these vermin now organized a full-scale campaign of character assassination. They even printed leaflets calling me a traitor and an agent of the Jews. One of these, following Gestapo models, contributed two rabbis to my geneaology, a grandfather from Poland and a great-grandfather from Russia. This handout was being circulated at the time the police occupied my studio.

During my self-imposed exile, I prepared statements explaining why, although I was not guilty of the attack on Trotsky's house, I refused to present myself to the police. My reasons were those I have given above. Instead of helping my situation, however, my statements so aggravated it that two loyal friends of mine, high officials in the Cárdenas government, came to Frida and told her that it was vital to my safety that they see me. Convinced that they were speaking the truth, Frida, who, besides Paulette, was the only person who knew its location, led them to my hideout. There they informed me of measures that were being taken against me and then presented me with a passport already prepared for entry into the United States. I realized that they had devoted much time and effort, at great personal risk, to arrange for my escape. Accepting their advice and the passport, I quietly slipped out of Mexico and headed for San Francisco.

THE ENORMOUS NECKTIE

 SAN FRANCISCO was a city which I knew and liked. As it happened, I had recently been invited by my old friend Timothy Pflueger to participate in an "Art in Action" exhibit at the Golden Gate International Exposition on Treasure Island in the spring of 1940. Pflueger, the chief architect of the exposition, had arranged that the mural I painted there should afterwards be placed in the new City College of San Francisco, which he had also designed.

Shortly before the Trotsky attack, Pflueger had made a quick trip to Mexico to discuss the mural with me, and we had decided upon the theme of Pan-American unity, in which I have always believed with all my heart.

I arrived in San Francisco by plane and was met at the airport by Pflueger and Albert Bender. They drove me to a hotel located high up on Russian Hill.

Along the way Pflueger told me about the marvelous location of this hotel, another of his creations. From its roof garden, one had a view of the bay, the Golden Gate Bridge, and much of the changing landscape of Marin County. I could not help but find inspiration, he said, in that marvelous vista.

On reaching the hotel, we were greeted by the manager, who personally accompanied us to my rooms, a gesture signifying his participation in my welcome. If he had stayed with us, we might have been spared what followed. But he left, and Pflueger, Bender, and I made ready to see the roof garden. As soon as we entered the elevator, however, we found ourselves in an impasse. The elevator boy refused to take us up because, as he politely explained, I wasn't wearing a necktie. After an absence of ten years, I had forgotten about the American urban mentality. Pflueger protested violently: he was the architect of the building and therefore due special consideration. But nothing availed. To every argument and appeal, the dutiful elevator boy answered that he had been given strict orders that no one, regardless of who he was, was to be allowed to enter the roof garden without a necktie.

Bender now took over the argument. After trying diplomacy and failing, he summoned up all his authority. The elevator boy conceded Bender's right to classify himself as one of the most influen-

144

tial men of the city. But instructions were instructions. Nothing could break through the battlements of the operator's little mind. I hope, when war was declared, he was given the rank of at least brigadier general.

Finally admitting defeat, we returned to my room. I rummaged through all my belongings without finding a single tie. My hurried departure from Mexico had not permitted thought of sartorial niceties. The more we talked about it, the more tired I felt of the whole silly business. Seeking to put an end to it, I asked Pflueger whether we couldn't leave this scenic palace of his and go to some other place where my open-necked shirt wouldn't offend. Bender, however, refused to give up. He summoned the manager, who in turn notified the director and two other hotel executives. All four solemnly filed into my room, anxious to have me forget the unpleasantness. They explained that they had issued the directive against tielessness primarily to keep the roof garden from being invaded by an undesirable younger set of open-collared youths and their half-clad dates whose behavior, as well as dress, did not accord with the amenities traditional to San Francisco.

The executive suggested that they all personally escort us to the roof garden, and to propitiate me, they offered to fire the elevator boy. I, however, knowing that he had merely been following the instructions of his superiors in order to keep his job, defended him. The upshot of the matter was that we dispensed with the wonderful view from the roof garden. Shortly afterward, I left the hotel.

A few days later, comfortably settled in a place more congenial to me, a small apartment on Telegraph Hill, I received a gift-wrapped package from Bender. Inside was a large assortment of neckties—appreciated, but arrived too late to undo what had happened. I kept the ties, however, and used them for "formal" occasions, which I have never been able entirely to avoid.

A VISIT WITH CHARLIE CHAPLIN

FOR THE WEEKEND of this first week in San Francisco, I was invited to Los Angeles, to the home of the Charlie Chaplins. My hostess was my old friend, then Chaplin's wife, Paulette Goddard. I was elated not only to see Paulette again but to meet Charlie, of whose work I had been a fanatical admirer for years.

I had seen Chaplin's earliest films in Paris. On first watching them flicker across the screen, I had felt that I was beholding not only one of the world's greatest actors but also one of the greatest writers of tragicomedy since Shakespeare. In Chaplin's work, however, the acting and writing arts were so completely fused that the wordless poetry would have been meaningless without his sublimely eloquent presentation.

Many artists and writers of Paris were as enthusiastic about Chaplin as I. Ilya Ehrenburg, Guillaume Apollinaire, Max Jacob, and André Breton, to name a few, had belonged to the Chaplin claque. With the master of masters, Picasso, at our head, we had formed a club called The Admirers of Charlie Chaplin. Charlie was greatly pleased when I told him, for the first time, of this tribute from the leading painters and poets of Paris.

On the day I arrived, Chaplin and I talked together all morning and all through lunch. As I had expected, I found him an intelligent, sincere, and knowledgeable artist. In the afternoon, other guests arrived, including some of the leading lights of the film world. Among them were Aldous Huxley and my old friends Dolores Del Rio and Orson Welles.

Later I met Dolores and Orson at a party given in their honor as Hollywood's romantic couple of the year. According to a Hollywood custom, they were asked to tell what had made them fall in love with each other. Orson went into a long, impromptu rhapsody about the virtues and qualities of Dolores, but Dolores was reluctant to answer. After much coaxing, she admitted that she had fallen in love with Orson mainly because he so closely resembled me when I was his age.

Amusingly, before Dolores' confession, Orson had expressed a high regard for my work. Immediately after that, he lost all interest in my paintings and became an ardent champion of Siqueiros instead. Dolores and I laugh whenever we recall this story.

A Salute by the U. S. Navy

 When I returned to San Francisco, I immediately began work on my mural in the exposition building called the Palace of Fine Arts. One day I was invited to a reception on the exposition grounds sponsored by the United States Navy. To my surprise, I found that I was the guest of honor.

In addition to many high-ranking officers, an official representative from the Navy Department in Washington and George Creel, personal friend and political advisor to President Roosevelt, were present.

The crew of the German liner *Columbus* had just been picked up and taken into custody by the United States Coast Guard. Although the United States was not yet a belligerent, my action in the *Columbus* affair had caused me to be singled out as an example.

At the reception, Creel showed me a letter he had received from President Roosevelt, referring to the German submarine menace in American waters and commending my action which had led to the destruction of the *Columbus*. He called for similar acts of co-operation and common defense throughout the Pan-American continent and expressed the hope that I might be persuaded to further this aim by making a radio broadcast about the Nazi terror on the seas.

I readily agreed and made the broadcast with great pride and pleasure. I was convinced that the Axis powers would soon initiate hostilities against the United States, and I felt that telling my story might shake some sense into the people who were still pacifists and isolationists.

TROTSKY AGAIN—DEAD

 ONE DAY, soon after this broadcast, while I was at work, I received a long-distance phone call from Mexico. An unfamiliar voice gruffly announced that Trotsky had been killed an hour before. The caller rang off before I had a chance to say anything. I stood there, absentmindedly holding the receiver, wondering who it was that had called, whether the news was true, and who the assassin might have been. About half an hour later, I received another call from Mexico. It was Frida. She verified the report of Trotsky's death and gave me some of the details.

Because she had met the assassin while in Paris and, furthermore, had twice invited him to her house to dine, Frida was under suspicion. Though she was again ill, the police picked her up and grilled her for twelve hours, using third-degree methods. My rage on hearing this almost wiped out of my mind the fact of Trotsky's assassination.

Returning home late that evening, I was met by a newspaperman who asked me for an interview. I consented and invited him up to my apartment. There he flashed credentials identifying him as a representative of International News Service and the United Press.

It was midsummer, and the day had been hot. Feeling tired and dirty from working since early in the morning, I asked my guest to please wait a few minutes while I cooled off under a shower.

Refreshed and in clean clothes, I rejoined him. He dived straight into the Trotsky affair, interrogating me about my relationship with and attitude toward the dead revolutionist. How was it that I had known about the killing ten minutes after it had occurred and before any news service had got wind of it? He put his questions to me in a droll and casual way but searching my face with evident concentration. His features became so puckered in his efforts to penetrate my thought that I found it difficult to keep from laughing, and I could not help giving him an inkling of my reactions.

At the end of the interview, he asked me what I intended doing after he departed. I detected no hidden meaning in his question so I answered with the simple truth, "Go to bed, I guess. I'm tired."

On hearing this, however, his scrutiny of my face became still more intense. What was he after, I wondered. Then he reiterated an earlier question—"for its special news value," as he put it. Was it

true that I had been suspected of the first attack on Trotsky and was my dear friend Siqueiros the real leader behind the attack?

I answered frankly that I had absolutely no idea about Siqueiros' possible connection with the first attack; but I could certainly say for myself, that I had had none. I had been persecuted by the police as a suspect, and I had been obliged to go into hiding. But Trotsky himself, I added, in a public declaration had cleared me of any suspicion on his part. This had substantiated my original belief that the police had acted on the vague circumstantial evidence of my quarrel with Trotsky, while their real motive was anger over the *Columbus* exposé.

On the day after the interview, a long, well-written, and dramatic article appeared in the newspapers. It ended with this flourish:

"Bukharin, one of Lenin's comrades, later executed by Stalin, once said that, while conversing with Stalin one day, he had asked Stalin what one thing pleased him more than anything else.

"To this Stalin had replied, 'To hear the news of the death of an enemy, quietly smoke my pipe, and go to bed.'

"Mr. Rivera doesn't smoke at all, but upon hearing confirmation of the death of Leon Trotsky, he took a shower, smiled valiantly, tried not to laugh, and then quietly went to sleep."

An amusing consequence of this article was that many Communists came to believe that Stalin never punished me for my criticism of him because of my presumed connection with the death of Trotsky.

A Second Time with Frida

 I HAD LITTLE TIME to think about the article because that very afternoon I received the bad news that Frida was extremely sick. Everything else flew out of my mind and I hastened to seek the advice of our good friend Dr. Leo Eloesser. Dr. Eloesser was very well known in California, both for his great professional skill and for the free service he gave to the poor. He advised me to arrange for Frida to come to San Francisco. He even telephoned her himself, informing her that he disapproved of the medical treatment she was receiving in Mexico.

When Frida arrived in San Francisco, she was suffering such severe pain that she could hardly move. Dr. Eloesser immediately placed her in St. Luke's Hospital where, thanks to his ministrations, Frida rapidly gained. When she was up again, Dr. Eloesser advised a change of scene as the next step in therapy. He endorsed her choice of a visit to New York, which held many pleasant associations for her and where she had many friends. The excitement of New York kept her from dwelling on her unhappiness, and when she returned to San Francisco, she seemed her old self again.

Now I asked Dr. Eloesser what he thought had been making her ill and what could be done to help her stay well. The stresses and strains of the past months had borne on her heavily, but they were gone now, except for one—the fact of our separation. Dr. Eloesser explained to me that our separation had affected her gravely and might again weigh on her with bad results.

On hearing this, I resolved to try and persuade Frida to marry me again. Because of my love for her, I had already begged her several times to remarry me, but without success. Now Dr. Eloesser came to my aid. Our separation, he said truthfully, was having a bad effect upon both of us.

In fairness to Frida, he warned her, that though I loved her more than ever and while I ardently wanted her back, she should realize that I was an incorrigible philanderer and in that respect would never change. Some men, he explained, were simply incapable of sexual fidelity and from his medical knowledge of me, he could definitely say that I was one of these men.

Dr. Eloesser's candor somewhat complicated my task of regaining Frida. But when she finally consented, it was with a clear appreciation of what she could expect. For her part, she asked for certain conditions: that she would provide for herself financially from the proceeds of her own work; that I would pay one half of our household expenses—nothing more; and that we would have no sexual intercourse. In explaining this last stipulation, she said that, with the images of all my other women flashing through her mind, she couldn't possibly make love with me, for a psychological barrier would spring up as soon as I made advances.

I was so happy to have Frida back that I assented to everything, and on my fifty-fourth birthday, December 8, 1940, Frida and I were married for the second time.

MORE POPULAR THAN WENDELL WILLKIE

 AFTER THE WEDDING, I returned to my work on Treasure Island and completed the mural three months after the exposition closed. A special day was set aside to present the work to the public.

Thirty-two thousand automobiles crossed the span of the Bay Bridge to Treasure Island that day. At an average of three occupants per car, a possible total of 100,000 people came to the opening of this one-man exposition. I distinctly recall the comment of the Mayor of San Francisco as he looked over the surrounding sea of heads: "This Rivera is more popular than Wendell Willkie."

Entitled "Marriage of the Artistic Expression of the North and South on This Continent," the mural measured no less than eighteen hundred square feet. It was spatially my biggest work. Even so, I had originally intended to cover several times this amount of space so that the composition would encircle three walls of the City College Library, which Pflueger had designed with the idea of having me decorate it.

In this mural I projected the idea of the fusion of the genius of the South (Mexico), with its religious ardor and its gift for plastic expression, and the genius of the North (the United States), with its gift for creative mechanical expression. Symbolizing this union— and focal point of the whole composition—was a colossal Goddess of Life, half Indian, half machine. She would be to the American civilization of my vision what Quetzalcóatl, the great mother [*sic*] of Mexico, was to the Aztec people.

I depicted the South in the period before Cortés. The outstanding physical landmarks were the massive and beautiful snow-crowned Popocatépetl and Ixtaccíhuatl. Nearby were the temples of Náhuatl [*sic*] and Quetzalcóatl and the temple of the plumed serpent. Also portrayed were the Yaqui Deer Dancers, pottery makers, and Netzahualcóyotl, the Aztec poet-king of Texcoco who designed a flying machine.

The conquest of time and space was symbolized by a woman diving and the Golden Gate Bridge spanning San Francisco Bay. A Quetzalcóatl figure personified the continuity of Mexico's ancient culture. This idea was elsewhere expressed in a portrait of Dudley Carter, an engineer who returned to a pure expression of plastics,

using only primitive materials and implements, such as a hand axe. I also painted a portrait of my wife Frida, a Mexican artist of European extraction, looking to the native traditions for her inspiration. Frida represented the vitality of these traditions in the South as Carter represented their penetration into the North.

The kinship of the Mexican and American traditions was further represented by an old Mexican planting a tree in the presence of a Mexican girl, as an American boy looked on. Nearby I painted a portrait of Paulette Goddard, holding in her hands what she called in a press release, "the tree of life and love." Representing American girlhood, she was shown in friendly contact with a Mexican man.

Just as the plastic tradition of the South penetrated into the North, the creative mechanical power of the North enriched life in the South. I depicted the greatness of the North in such engineering achievements as Shasta Dam, oil derricks, bridges set near the American peaks of Mount Shasta and Mount Lassen, and in portraits of such geniuses as Ford, Morse, and Fulton, the last two of whom were artists as well as inventors. The creative force of the United States and the emancipation of women were symbolized by a woman artist, a woman architect, and a sculptress.

In the lower part of this panel, I represented two scenes from that typical art form of the North, the movies. One was from Charlie Chaplin's film *The Great Dictator*, showing in a tragicomic grouping Hitler, Mussolini, and Stalin; the other from the Edward G. Robinson film *Confessions of a Nazi Spy*. Both works dramatized the fight between the democracies and the totalitarian powers. A hand rose up out of a machine as if to ward off the forces of aggression, symbolizing the American conscience reacting to the threat against freedom, in the love of which the history of Mexico and the United States were united. This concept was amplified in portraits of the great liberators—Washington, Jefferson, Hidalgo, Morelos, Bolívar, Lincoln, and John Brown.

Soon after the showing of this mural, a storm arose over the scene from *The Great Dictator*. As most people will recall, this movie was detested by reactionaries. The ladies of the Century Club, many of whom belonged to influential German-American families, publicly denounced the composition; and to insure my knowing their opinion, they sent a delegation of their oldest and most respectable members to berate me personally.

The local Junior Leaguers also held discussions of my mural, but they decided to approve it. They sent me a delegation of their loveliest and brightest young ladies to communicate their unanimous approval. Naturally, this group offset the ill effects of the previous

one. It gave me considerable pleasure to hear one of the prettiest Junior Leaguers tell me, "We can't understand how anyone can say that your concept in this painting is anti-American. We doubt if those who object to it have ever seen it. As anyone can plainly see, it's as American as 'The Star-Spangled Banner.' "*

Before leaving California to return to Mexico, I painted two portraits, one in San Francisco and one in Santa Barbara. These were the last of my commissions in the United States up to the present time.

PIN-UPS, SALOON STYLE

 HOME AGAIN, I immediately began preparations for additional panels in the National Palace corridor, complementing the big fresco on the stairway. The theme of these new paintings was to be the history of Mexican agriculture from before the Conquest through the colonial era, and then from Mexico's Independence from Spain to the present.

The research and documentation this entailed was so enormous that, to keep in practice, I did some easel paintings. The most interesting of these was a series of nineteen small oils, each depicting a separate movement in one dance by the wonderful-bodied American Negro dancer Modelle Boss. In addition to several newly commissioned portraits, I also completed my painting of Paulette Goddard, which had been interrupted by my forced vacation from Mexico.

I now began the actual labor on the National Palace mural, soon completing two whole panels. At the same time I managed to find

*Despite this judgment and the architect's plans, the mural was never mounted in the library for which it was intended. Instead it was stored in a shed. Rivera's death on November 24, 1957, ended the controversy which continued to hang over it. On November 28th, Dr. Harold Spears, San Francisco's Superintendent of Schools, announced a meeting of the Board of Education to decide the fate of the mural. On December 17th of that year, the board voted 5 to 1 to place the mural in the lobby of a new theater to be built on the City College campus.—G.M.

time, after my day's work, to do two other big frescoes in the new Cardiology Institute, with the history of cardiology as my subject.

On these panels, I used a scale of tones higher and brighter than any I had used before in fresco. The panel on the east wall represented cardiological knowledge in ancient times; the one on the west wall, modern developments in this science.

In both paintings, located in the main lobby of the Institute, I combined portraits of great cardiologists with notable events in the history of the study of the heart. Starting from ancient Greek, African, Chinese, and Aztec medicine, I projected a vision of future aspects of cardiology.

Another commission of these wartime years was a most unusual one: to paint a series of panels for the new Ciro's night club in the Hotel Reforma. So that these paintings would harmonize with the atmospheric qualities of the room, I developed what I call my "saloon style," a style expressing a mood of sexual freedom and exhilaration, through ensembles of form and color which marked a unique innovation in my career as a painter.

The subject matter of the Ciro's panels consisted of isolated nudes of the kind then called "pin-up" girls which, however, I painted trying to retain the old plastic traditions. Pin-ups were to be found in many amusement places where the nouveau riche made merry on war profits. They were also hung on the walls and lockers of soldiers' barracks, where women-starved boys prepared themselves for slaughter while the vulturous profiteers schemed to make more money out of their blood.

The simple meaning of these paintings has not yet been really understood, certainly not by the critics who made solemn—and to me, amusing—judgments on them. I did these paintings with a feeling of simple, sensuous joy. The women I portrayed at Ciro's were to be appreciated as pin-ups—nothing more.

My models were not professional artists' models. On the contrary, they belonged to the wealthiest families in Mexico. And they all confessed to the same reason for wanting to be painted nude on a barroom wall—a desire to be eternally naked in an excitingly lit room where men would uninhibitedly lust for them. Conscious of the passion her body aroused, each would always feel desirable, despite the changes and finally, the ravages of age. In my oils, she would remain forever youthful.

After completing this assignment, I was offered a job as art consultant by a big Mexican movie company. Despite the temptingly large salary, I rejected the offer, sensing that the job would contribute nothing to my growth as an artist.

A HOME FOR MY IDOLS

 IN 1945 I began to feel that I was nearing the end of my life's adventure. My father had died at seventy-two, my mother at sixty-two, both of cancer. If, as I believed, heredity determined one's life span, I must die of cancer soon, for I was nearing sixty. Fortunately, my theory proved mistaken.

My mind was preoccupied with two things which I wanted to do before the end. One was to paint Tenochtitlán, the ancient capital of Mexico, as it had originally been before the barbaric Spanish invaders destroyed its beauty. After a year and a half of preparation, I carried out this dream. One could not love a subject so deeply without painting it well, and I regard my painted vision of the ancient site as one of my masterpieces.

The second dream, one of thirty-five years' standing, was renewed by the destruction wreaked everywhere by the war. It was to build a home for my anthropological collection, which I had started to assemble on my first return to Mexico in 1910.

So while the bombs menaced our very lives and made painting seem a thing of insignificance, Frida and I started a strange kind of ranch. Here we planned to raise our own food staples, milk, honey, and vegetables, while we prepared to build our museum. In the first weeks, we erected a stable for our animals.

The site we chose was near Coyoacán, right on top of a lava bed. Cactus sprang up profusely from the crevices in the stones. Nature had landscaped the area as if for our purpose, and I decided that our house should be in harmony with her work. Accordingly, we cut our stone from the basalt indigenous to the region. The structure would rise from the earth like an extension of its natural surface.

I designed the building in a composite of Aztec, Mayan, and "Rivera Traditional" styles. The squarely built exterior resembles an ancient Mexican pyramid of the pre-Cortés period.

The main floor is the museum where my sculptures of this period are displayed. The rooms here wind and open into each other like those of a labyrinth. Walled in unfaced stone, they are gray and dank. On the ceilings are white stone mosaics, mainly abstract in form. One of the mosaics, however, is of the rain god, Tlaloc, whose face I represented as a formation of two wriggling snakes.

155

The upper section is still to be completed. I intended it as my studio, where I could create my own sculptures to adorn the outside walls. But lack of time and money have so far prevented me from carrying out this part of my plan.

Surmounting all is a tower representing the god of air and open on all sides to the raw, cool drafts of mountain air. The cool and stony aspect of the place gives one the impression of being in an underground temple.

During the war, this building was "home" for Frida and me. After the war, it was converted exclusively into a home for my idols. Guided by Dr. Alfonso Caso, Mexico's leading anthropologist, I passed many wonderful hours placing my statues in chronological order in the different rooms of the building. Dr. Caso and his associates were enthusiastic about my collection, declaring that while my dating of some pieces might be in error, I had shown an uncanny instinct for what was authentic and important. They rated the collection among the best in the world.

This venture, however, has almost impoverished me. The cost of maintaining the museum has been about $125 a week. With this outlay added to the $300 a month I gave Frida for household expenses for our home in Coyoacán and the forty dollars a month I paid for my daughter Ruth's college tuition, I was left with hardly enough change to buy the daily newspaper.

People are under the impression that I am wealthy because I have sometimes paid as much as $250 for a single idol. But when I have made such a purchase, I have often, as a result, had to scrimp on necessities. Frida used to scold me sometimes for not keeping enough money to buy such prosaic things as underwear. But my idols have more than compensated me for their expense. Whenever I feel disgusted with some painting I have done, I have only to look at them and suddenly I feel good again.

By now, I have already spent more than fifty thousand dollars on the museum and still it is not complete. Most visitors are astonished to hear this low figure. However, I did so much myself: the architectural designs, the engineering, and even the overseeing of the actual work, thus cutting the cost of construction considerably.

Since beginning the project, I have put into it literally every penny I have earned above modest living expenses. Work on the museum halted during Frida's illnesses, when the heavy medical and hospital bills virtually bankrupted me. However, when Frida was well and earning money from her own paintings, she would refuse to accept any money from me, and I would go on idol-buying sprees. All in all I have spent about one hundred thousand dollars on my collection—apart from the building itself.

I calculate that another forty thousand dollars will be required to complete the building. My plan is to give the museum to the state, provided it appropriates the money needed to finish it. My only other stipulation will be that I be allowed to supervise the final construction. If I cannot arrange a mutually satisfactory agreement with the authorities, I shall dynamite the building with my own hands rather than have it put to some stupid use at odds with the purpose for which I designed it.

A Sunday in Alameda Park

 In 1947 I was commissioned to do a mural in the main dining room of the new Hotel del Prado. The theme I chose was "A Sunday in Alameda Park." In the painting, I attempted to combine my own childhood experiences in the park with scenes and personages associated with its history.

Though a public park, the Alameda, during my childhood in the regime of the dictator Díaz, was actually restricted to the "better classes." The poor were kept out by the police. I had more than once seen these unfortunates being hustled past the gate, and these scenes, which had incited my first anti-Díaz feelings, remained vivid in my memory. I had gone to the Alameda with my family and listened to the band concerts on the pleasant green. Chairs could be rented at twenty-five and fifty centavos, prices which my father, himself not a poor man, found exorbitant.

Under the rule of Cortés, in the very earliest colonial days, the monastery of San Diego had stood at the west end of the park. The structure included a crematorium where victims of the Inquisition were burned alive. But the stench of decomposing human flesh became intolerable to the residents of the surrounding fashionable streets, and the Church had been obliged to move its holy incinerator elsewhere. In 1848, the victorious United States army had camped in the park after the treacherous General Santa Ana, sabotaging the Mexican defense plan, had handed over the country to the invaders on a silver platter. Alameda Park had also been the scene of historical political demonstrations, among them the one organized by Ignacio Ramírez, later a minister in the Juárez gov-

ernment, to rouse the Mexican people to arms against the French invaders seeking to install Maximilian as a puppet emperor in 1862.

"Sunday Dream," as my mural was called, utilized such personal and national memories. In the center stood I, a boy of ten, a frog and a snake peering out of my jacket pockets. Beside me, a skeleton in woman's dress held my hand, and my boyhood master, José Guadalupe Posada, famous for his drawings of skeletons, held her other hand under his arm. Frida, as a grown woman, stood behind me, her hand on my shoulder. On the right side of the mural, I also painted Lupe Marín beside our two adult daughters. Above them were portraits of historical figures representing the social classes of Mexico.

One of the key scenes in my "Dream" was a portrait of Madero triumphantly proclaiming the success of the revolution against Díaz and speaking out against the corruption of the new bourgeoisie to a crowd in the park. On one side of the mural, I painted Cortés, his hands dripping with blood, beside figures representing the Inquisition at its work of torture and death; the traitor Santa Ana, surrendering the keys of Texas; and above him, the people's hero, Benito Juárez, holding up the liberating constitution of 1857.

Another of my portrayals was an average President of the Republic, with a composite executive face in which some saw the features of Calles, some recognized those of Ávila Camacho and others, including that gentleman himself, those of Miguel Alemán. The partisans of these politicos, feeling that I had caricatured the physiognomies of their heroes, vilified the mural.

But the chief target of its antagonists was a brief quotation from a recorded statement by Ignacio Ramírez, which I reproduced on a scrap of paper held in his hand. It occupied a space no more than two inches high and read: "God does not exist."

The statement was not my own, as many people thought, but had actually been made by Ramírez when a student before an assembly of students and faculty at the Academy of Letrán, located at the south side of the park. The academy was then headed by Father Lacunza, later Archbishop of all Mexico. Ramírez had taken the position that mankind could progress only through mutual aid, and this rendered the idea of supernatural aid an absurdity.

The faculty of the academy, most of them priests, had sought to prevent Ramírez from speaking. But Father Lacunza had overruled them in the interest of freedom of thought and expression. He had allowed Ramírez to deliver his address, which caused wild excitement in the audience.

Father Lacunza had gone further. He called for a unanimous vote to enroll Ramírez as a regular member of the academy, main-

taining that Ramírez deserved this honor for the brilliant logic and scientific knowledge he had displayed. "Besides," he said, "God himself has permitted the birth and growth of a creature endowed with such a superior mentality. All-powerful God, if he wished, could have confounded the boy's dialectical prowess."

Ramírez had delivered the lecture, Father Lacunza informed the audience, from notes made on scraps of paper, because he had been too poor to afford fresh paper. Consequently, the torn scrap Ramírez held in his hand in my mural, as well as the declaration itself, had historical authority.

If certain people had not been deliberately seeking to provoke a scandal, this detail would have aroused little notice. It had been on the wall in the preliminary charcoal sketch for over six months without any objection being raised.

The chief agitator in the attack on "Sunday Dream" was Torres Rivas, Manager of the del Prado Hotel. Like Pani before him, he dreamed of becoming a Mexican Rockefeller. Scion of a formerly wealthy family which had lost its money with the downfall of Díaz, Rivas sought a way of cashing in on his pretentious but otherwise worthless titles, which were almost his sole possessions.

Rivas did not wield enough power to achieve his dream alone, but he found a powerful ally in Rogerio de la Selva, President Alemán's personal secretary and commander of Alemán's private guard. Selva discerned his employer's features in my composite presidential portrait, and acted, he said, to protect the President's dignity. He was aided by corrupt journalists whom he used as his mouthpieces.

On his authority as Alemán's secretary, Selva mobilized a private civilian army of the student sons of the nouveau riche. These privileged hoodlums entered his service as a means of advancing in their political careers. In varying disguises, including the regalia of Jesuits and Knights of Columbus, they organized demonstrations against my painting and me, chanting through the streets:

"Does He exist?"

"Long live Jesus Christ!"

"Death to Diego Rivera!"

Some went so far as to throw stones through the windows of my studio in San Ángel and my home in Coyoacán.

Taking advantage of the uproar, Rivas used this occasion to ask the Archbishop of Mexico to confer his benediction upon the new hotel building and upon my mural. As Rivas anticipated, the Archbishop refused and Rivas added this fact to his argument.

A nephew of Rivas, seeking a thrill and who knows what favors from his uncle, plotted more direct action. With three schoolmates

belonging to *Los Conejos*, a secret fraternity of clerical and reaction-
ary students, he stole into the hotel dining room and scratched out
Ramírez's provocative quotation.

At the time, friends of mine and I were attending a banquet given
to honor Frances Toor for her excellent writings on Mexican folk-
lore, and Fernando Gamboa, head of the city's Plastic Arts Depart-
ment, for his work in collecting valuable Mexican paintings.

When news of the vandalism was brought to me at the banquet, I
got up at once to protect my mural. My friends, feeling that the best
answer to the act was a protest demonstration right in the Prado,
followed me into the street.

Señor Rivas' nephew's action constituted more than an attack
upon my artistic property rights. At that time, together with Orozco
and Siqueiros, I was an executive director of the board of the Fine
Arts Department. An important part of the board's responsibility
was to protect painters and their works from unwarranted attacks.
Consequently, this wanton defacement of my mural was symboli-
cally an outrage against the rights of every artist.

The cream of Mexico's intellectuals, young and old, marched into
the Prado in a picturesque protest demonstration. While I set to
work restoring Ramírez's quotation, Orozco, Siqueiros, and the bit-
terly eloquent popular writer Revueltas harangued the startled ho-
tel guests.

The uniformed police did not dare to intervene, but some plain-
clothesmen were sent over to watch us. They remained motionless,
probably having been instructed to do nothing unless there was vi-
olence.

"Operation Schoolboy" having failed, a government-employed
carpenter was called upon a few days later to repeat the mutilation.
This poor devil was given the alternative of carrying out the un-
pleasant assignment or losing his job. As he was instructed, he
scratched out not only the offending quotation but also my face in
the painting.

Again I repaired the damage.

In the final analysis, every official concerned in this affair failed
in his obligation not only to enforce the established laws applying to
the protection of artistic property and freedom of expression, but
in maintaining official dignity and authority. The two separate acts
of vandalism directly challenged the Fine Arts Department, the
Ministry of Public Education, the Attorney General, and the Presi-
dent of the Republic. Yet not a single public official showed the
courage to act as his duty required. Instead there were apologies
and pretexts, and a few officials tried to buy me off with well-paying
commissions to paint portraits of the wives of prominent Mexicans.

An architect who held an important office in the Ministry of Public Health proposed that I change Ramírez's "God does not exist" to the single word "Confidence." I refused to permit this ridiculous and craven travesty upon historical truth.

For a long time after the two assaults, the newspapers filled columns with scurrilous attacks upon me. The fact that I wasn't lynched by an overstimulated mob was assuredly no fault of theirs. They tried their best.

The hotel owners, balked in their vandalism, finally hit upon a safe, typically hypocritical "moderate" solution; they covered my mural with a movable screen. Made of white nylon, the screen could be pulled aside for any distinguished guests who desired to see the notorious painting. And, as it turned out, these guests invariably gave large tips to the hotel guides—a boon to employer-employee relations.

CARDINAL DOUGHERTY DEFENDS

 A FEW MONTHS after this "solution" has been effected, Dennis Cardinal Dougherty, Archbishop of Philadelphia, came to Mexico City, accompanied by about forty other distinguished Catholics who were making a pilgrimage to honor the Virgin of Guadalupe. Cardinal Dougherty took lodgings in the Hotel del Prado. One of his first requests, after checking into his room, was to see my mural. He apparently liked it so much that he returned to look at it fourteen times afterwards.

Upon learning of the Cardinal's repeated visits to my mural, the stockholders of the hotel began to feel extremely uneasy. Meeting together to discuss this unforeseen development, they decided to ask the Cardinal to join them in viewing the mural once more. What this was supposed to accomplish, I never could figure out.

The Cardinal replied that he would be happy to see the work again.

My esteemed friend Carlos Obregón, architect of the Prado, witnessed what transpired between the Cardinal and the owners in the hotel's dining room that day. I first heard the story from Carlos Chávez, General Director of the Fine Arts Department, who had heard it from Obregón. Afterwards Obregón himself confirmed

what Chávez had told me. In addition, two participants, a hotel executive and one of the stockholders, recounted their observations to me. Each of these reports agreed with the others.

After the screen was removed, the Cardinal turned to his hosts and thanked them for the opportunity to study my mural once more. "I like this Rivera painting very much," he said. "I have always had a special taste for mural paintings. Why? Before the Good Lord graced me with the inspiration to become His servant, I had dreamed of becoming a mural painter myself. After having attained my priesthood, I usually spent my vacations in travel, seeking out, studying, and enjoying murals. Therefore it is no wonder that I am familiar with the work of Rivera both here and in the United States, and I must tell you how much I have always appreciated and revered his art.

"I would also like to say that not only do I consider this mural the best Rivera has done but that it is also one of my favorites among all murals. In fact, I think it is as good as any mural I have ever seen anywhere in the world. I also happen to know the writings of Señor Ramírez and have admired the truly Catholic mind of Father Lacunza, head of the old Academy of Letrán. He was not only a beacon of the Mexican Church but of the entire world of Catholicism where 'Catholic' retains its meanings of 'universal' and 'tolerant.' "

At this, panic and consternation showed in the faces of the stockholders and especially on that of the Prado's manager, Torres Rivas, who saw his prestige plummeting. In a desperate effort to rehabilitate himself, he risked interrupting the Cardinal.

"But Your Eminence, His Eminence, the illustrious Archbishop of Mexico, had denied his benediction to the hotel because of the blasphemous phrase painted by Rivera into his mural."

The Cardinal stopped Rivas with a motion of his hand. "In the first place, the sentence quoted by Señor Rivera is a historical quotation and entirely unrelated to the Church itself. In the second, it alludes to an incident which only proves how open the mind of a fine man of the Mexican Church was as long ago as 1836; of course I refer to Father Lacunza. The defamatory acts and attitudes shown in the recent attacks upon this work of art, created by a man receiving his talent directly from God Himself, are in my opinion not only a violation of the most important concepts of the Catholic Church, but in opposition to the policies laid down by His Holiness, the Pope.

"You perhaps know that in augmentation of my position as a Catholic Archbishop, under the guiding jurisdiction of His Holiness, I have also been appointed by the College of Cardinals as Chief Director of the *Santo Oficio*, the supreme theological body of

the Church. You can easily understand that I am well versed in many matters concerning the Church and its ministers. The situation which followed upon Rivera's execution of this work is deplorable. In my opinion, the Archbishop of Mexico allowed himself to be used in a plot, just as the devil tempted Our Lord Jesus Christ centuries ago.

"I am also aware, Señor Rivas, of the part you personally played in this ill-conceived affair, bringing not only yourself but many other Catholics of good faith to act in a manner which departs from the meritorious standards ordained by His Holiness, the Pope. Those who co-operated with you in desecrating a worthy work of art do not deserve the right to call themselves Catholics, and the blame falls upon you. You have also instigated people outside the realm of the Catholic Church to commit the same desecration.

"For these reasons, Señor Rivas, despite your publicized protestations that you are a good Catholic, I must inform you that absolution for your act requires much penance on your part. What you have done not only maligns the good name of the Catholic Church but is disruptive of civilized life in general."

When the Cardinal had done speaking, Torres Rivas was in tears. He sat down quietly in a chair, his head bowed, covering his face with trembling hands.

Before leaving, the Cardinal turned briefly to the other men in the group. "Gentlemen, I refuse to offer any opinion regarding the matter of the benediction of this building simply because I have great respect for the Archbishop of Mexico. In my country, however, no priest of Christ has ever given his benediction to any commercial building or enterprise."

Whereupon Cardinal Dougherty nodded, signifying his intention to depart. His hosts, shocked into speechlessness, silently followed him out of the room.

One thing more. Many Mexican newspapers and magazines were given this story but not one dared to publish it, probably because it might place me in a favorable light. United States press correspondents in Mexico similarly failed to consider it "news."

AFTERMATHS

As a curious aftermath of the Prado affair, a Mexican representative of a well-known American private detective agency, mainly employed in guarding the lives and property of millionaires from the States, laid a unique proposition before me. He approached me indirectly through my dear friend Dr. Arenal (sister-in-law of Siqueiros), who relayed the offer. This gentleman declared that his firm would give me five years of complete protection for myself, my paintings, and my property, in return for permitting my name to be listed as one of his company's clients.

To Dr. Arenal, he explained that he was making his proposal through her because his organization had ascertained that between her and myself there existed a high degree of mutual felicity. Its reports about our relations, in fact, indicated that no one else at the time was dearer to me than she. Calmly ignoring this last, Dr. Arenal refused to broach the matter with me unless she learned the true motives for the company's generosity.

Her visitor then replied, "We have estimated that the publicity received by the del Prado Hotel through Señor Rivera's mural was worth $3,230,000 at prevailing space rates. This is about half the value of the entire plant together with all its furnishings. We are convinced that to have Rivera as one of our clients would be a publicity asset. We have asked you to be our intermediary as a way of proving to Señor Rivera that we are accurately informed about his private life. Thus," the man concluded smugly, "he will have a free demonstration of our efficiency."

When Dr. Arenal relayed the offer to me, I rejected it at once. The relationship between Dr. Arenal and myself by which he "proved" his agency's merit was simply nonexistent. I wish it had been otherwise. Dr. Arenal is an intelligent, charming, and beautiful woman, but alas, she has never been to me what her "well-informed" visitor declared.

The Fine Arts Institute, which had done nothing to protect my rights in the fracas over "Sunday Dream," meanwhile organized a retrospective exhibit of the work I had done in the last fifty years. The idea was hit upon, I am sure, as a means of pacifying and compensating me. The directors of the Institute may also have expected

that, because of changing art trends, the show would prove a flop. If so, they must have been very much disappointed. From the evening of the première to its close, a continuous stream of enthusiastic viewers literally jammed the Palace of Fine Arts, which housed the show.

While I was preparing for the exhibition, I gave Frida another bad time. I had fallen in love with the movie actress María Félix. I not only planned to center my show around a life-sized portrait I had painted of her, but I took steps toward a second divorce. Frida suffered deeply. And needlessly, as it turned out. For María not only refused to marry me, but for reasons of her own, having nothing to do with our personal relations, refused to lend me her portrait for the exhibit.

So I was left with my injured feelings, one blank wall, and a wife who was miserable and hurt. Within a short space of time, however, everything was well again. I got over my rejection by María. Frida was happy to have me back, and I was grateful to be married to her still. And the painting I used in place of María's portrait attracted far more attention than the latter would have. It was a tremendous, provocative, life-size nude of the poetess Pita Amor.

In all respects, the show which opened in the summer of 1949 was a huge success. Collectors from all over the world loaned their Riveras, including, oddly enough, Nelson Rockefeller and Mrs. John D. Rockefeller, Jr. It was gratifying to think that in spite of our past differences, the echoes of which had reverberated around the globe, the Rockefellers still considered me an artist worthy of attention.

Ironically, the President Alemán of my heretofore objectionable composite portrait was swayed by the overwhelming public ovation to declare over the radio that I was a true artistic genius! I found this evaluation by Mexico's chief executive most amusing—a farcical dénouement of the upheaval which had preceded it. Shortly afterward, the Mexican Government presented me with the National Prize for Plastic Art.

As for my "blasphemous" mural, its status, until recently, remained quo. It stood in its original place on the wall of the Prado dining room screened off from the general public every day except Sunday, when it was permitted to be viewed from 10:30 A.M. until noon. Then, and only then, those who wished could study the work at their leisure. Perhaps the rule obtains; I do not know.

In 1956, of my own free will, I decided to change Ramírez's objectionable phrase, as a minor contribution to the cause of international and national unity (97 per cent of my countrymen are Catholic). I ordered "God does not exist" be replaced with the phrase,

"Conference of Letrán, 1836." I felt that in the intervening eight years' time I had proved my position. I posted my wishes in the matter from the Soviet Union during my second visit to that country.

UNDERWATER

 EARLY IN 1951 I received the most fascinating commission of my career—to paint not only my usual type of mural but one which would also endure though submerged under clear water. Unfortunately, I did not succeed in developing paints that would resist the action of water.

At the bottom of a large reservoir, I painted varieties of protoplasmic life. These evolve, on the lower portion of the perpendicular walls, into more complex forms, culminating in a nude man and woman, the final creations of "Water, Origin of Life." As part of this mural, I represented the workers, architects, and engineers who built the new Lerma Water Supply System, which included this reservoir. I was very proud of this creation. But in the spring of 1956, the project engineer noted that the colors were deteriorating. I don't know how long it will be before sediment and flowing water obliterate the mural completely. I feel unhappy over the prospect of its fading away.

As another part of the decoration of these waterworks, I did a vast horizontal mural in relief of an ancient Aztec god emerging from the slime. I was so pleased with this combination of painting and sculpture that I used the technique again in my decorations for the stadium in University City. The chief figures in this relief mural were a man and a woman racing with a white dove to a child, symbolizing the development of the physique for the purposes of peace.

ANOTHER STORM

 IN THE LATTER PART of 1951, a new storm broke around one of my paintings. In order for it to be understood at all, I have to sketch the prevailing political and personal landscape.

At the beginning of the administration of President Alemán, the composer Carlos Chávez, Director of the Fine Arts Institute, made plans for an exhibition of Mexican art in Europe. Chávez had the typical Mexican sense of inferiority in matters artistic, and corresponding awe toward the culture of the Old World. His hope was to impress the Old World with what the New World could produce and thus establish an international reputation for himself as well.

Chávez's associate in this undertaking was Fernando Gamboa of the Plastic Arts Department. Gamboa expected to gain recognition for himself as a promoter of the Mexican plastic movement in international art. He also had a more immediate purpose from which he hoped to gain—to publicize the good name of Alemán.

Alemán was at this time ambitious to receive the Nobel Peace Prize. He also fostered hopes of ultimately succeeding Trygve Lie as Secretary General of the United Nations.

The instigator of these dreams was the Swedish millionaire Axel Wenner-Gren. Through a stock transfer during World War II, Wenner-Gren had turned over control of Swedish steel production to the Nazis. His claim was that he had done this to save his country from invasion. The brothers Maximino and Manuel Ávila Camacho, the latter President of Mexico, had, however, overlooked this questionable episode in the millionaire's career because of his willingness to invest in Mexican industries, and welcomed him to Mexico. When Alemán took over the Presidency from Ávila Camacho, he also inherited the friendship of Wenner-Gren, who promised to promote Alemán at the Swedish Academy and in the United Nations, in both of which he claimed to have influence.

The exhibition of Mexican art planned by Chávez to be held in Stockholm would provide a marvelous backdrop for the scene of Alemán receiving the Peace Prize. And, of course, Chávez and his assistant, Gamboa, would bask in the reflected glory. They could see themselves receiving titles and decorations, not to mention money. But there was one feature of the plan which they and

Alemán overlooked—Wenner-Gren was disliked by most of the decent people in Sweden.

Also, unfortunately for them, at the moment when votes were taken for the Peace Prize, dozens of people were killed in the streets of Mexico by machine guns manned by the mounted police comprising Alemán's personal military guard. The sound of the chattering weapons and the cries of the innocents could be heard even above Alemán's call for peace in Korea. No wonder he was balloted out of the running, despite the fact that his was the only name which had been officially submitted.

Chávez's plan for the art exhibition, however, did not die with Alemán's personal hopes. Its locus was shifted to Paris. And when the time came, Señor Gamboa and his tall, lovely American wife were dispatched there with vast treasures of Mexican art to court the approval of Mother Europe.

As to my involvement in all this: I was requested to paint a movable mural which, after being shown in the exhibition, was to be mounted in Mexico City's Palace of Fine Arts alongside my second "Rockefeller" mural.

When I received this commission from the Fine Arts Institute, I was told that I had complete freedom of choice in style and subject matter. Pleased by this expression of confidence, I planned to show my gratitude by authorizing the work to be displayed not only in Paris but wherever else it might be welcome. I began to organize a collection of some of my other paintings with this in mind.

However, I soon came to suspect that all was not as it should be. The commission allowed me only thirty-five days to work on the mural before it was sent out. Had anyone hoped to give me insufficient time to complete it, he need not have waited much longer. Examining my contract, I found none of the standard clauses regarding the failure of either party to carry out its commitments.

Nevertheless, I went ahead with my part of the bargain. My subject matter would complement and carry forward that of the Rockefeller mural. In the latter, I had portrayed my premonitions concerning the second World War, most uncannily as it turned out, in an actual battlefield scene and in a prophecy of atomic fission. In the new fresco, against a background of hangings, burnings, shootings, and an atomic explosion, I meant to show the movement for peace which could end the threat of a third World War.

On the very first of the thirty-five days, Chávez came to see me to set the exact dimension of my mural. As I outlined my theme, Chávez expressed his pleasure at being able to show an example of my type of painting together with such contrasting types as Tamayo's abstractions and Siqueiros' historical allegories.

In the foreground of my mural, I explained to Chávez, I would portray those friends of mine who had been most active in collecting signatures for the peace petition. In addition, I said, I would include monumental portraits of Stalin and Mao Tse-tung proffering pen and peace treaty to John Bull, Uncle Sam, and Belle Marianne. I explained that in these representations of the Russian and Chinese leaders, I hoped to create symbolic figures to correspond with those of Great Britain, the United States, and France.

Chávez was all honey and congratulations on this initial visit. But after I had worked steadily on my mural night and day for several days, I sensed a growing coolness on Chávez's part. He began to express doubt about how the painting would be received in Europe.

It was not, however, until the mural was nearly finished that Chávez interposed the question of whether the French government itself might not take offense and cancel the entire exhibition. For that reason, Chávez explained, it was necessary for him to confer with the Minister of Education.

Chávez reported the minister's decision to me. My work would not be sent to Paris but exhibited only in the Palace of Fine Arts. I insisted upon the fulfillment of my contract, particularly the clauses guaranteeing me freedom of expression.

Chávez did not answer my protest; instead he initiated a debate in the press concerning the "unwise" point of view represented in my mural. As a result, the Minister of Education adjudged my painting not only unsuitable to be shown abroad but also unacceptable for display in the Fine Arts Palace, on the ground that my subject matter would probably offend some of the big countries with which Mexico maintained amicable relations.

I sent out an inquiry to determine whether the ambassadors of these presumably sensitive nations—Great Britain, the United States, and France—had voiced any protest thus far, but received no satisfactory reply. This left me with no recourse but to secure the individual reactions of these personages personally. The French Ambassador told me his wife had seen the mural and found nothing objectionable in it; as representative of his government, he was certain that it would take the same view. I called upon the British Ambassador and, through the first secretary of the British embassy, who had seen my painting several times, I was given a similar favorable reply.

This left only William O'Dwyer, the American Ambassador, to be heard from. It happened that at this time I was invited to a tea party given by the wife of President Alemán. Among the guests were the American Ambassador and his wife, Sloan Simpson, as well as my old friend Carlos Chávez.

In time the conversation lighted on my mural. Mrs. O'Dwyer rhetorically asked whether my depiction of an atomic explosion in the background wasn't too realistic and whether I had represented American soldiers in it with sufficient sympathy. She felt my painting judged her country too harshly.

When the party was over, Chávez, who had heretofore treated me more like a brother than a friend, relayed Mrs. O'Dwyer's doubts to the Minister of Education, who in turn went to see Alemán, already prejudiced against my mural by his wife. Alemán, however, tossed the matter back into the laps of the Minister of Education and Chávez, who now began playing an absurd game, using me as the ball.

Chávez came to tell me that my mural might easily ruin the entire exhibition. However, he would insist that it be shown in the Fine Arts Palace or hand in his resignation.

The bitterness of my retort offended Chávez grievously. He reopened the controversy in the newspapers, hoping, I am sure, that the harassment would keep me from finishing my mural on schedule. But I worked harder than ever and was actually done even before the deadline. I then immediately held a public showing of the work, so that if anything wrong were seen in it, I could revise.

Never before had a painting of mine been so enthusiastically received by the Mexican people, and particularly by the workers and peasants. Despite the fact that there was little publicity, a crowd of more than three thousand came to look at the mural between 7:00 P.M. and midnight of that first evening. Many diplomats from Latin American countries were among the visitors.

During the showing I had the honor to receive the ambassador of the Soviet Union and the ministers of Poland and Czechoslovakia. They all congratulated me warmly, as did the President of the Mexican Peace Committee and numerous other intellectuals and politicians. Neither Chávez nor any other official of either the Fine Arts Institute or the Ministry of Public Education put in an appearance.

However, when the show was over, some friends of mine overheard Chávez and several of his cronies plotting in a restaurant to dismantle my painting and to ask Alemán for assistance in their scheme. These friends relayed the information to partisans of mine who were guarding the painting in the Fine Arts Palace. The following day thirty troopers of Alemán's personal security force moved into the room adjoining the one where my painting was on display.

Frida and some of my friends, sensing trouble, urged me to leave the palace. I was terribly tired, for I had been painting for three days and nights without stopping to sleep or rest. My dear friend

Dr. Ignacio Millán told me that if I didn't let up I would certainly have a nervous breakdown. Yet I was reluctant to leave; I knew that as long as I remained at my post, it would be difficult to carry out any action against my mural.

But Frida, who had left the hospital in a wheelchair, finally persuaded me to come away with her. She feared that violence would be used and, with the odds against me, that my life was in jeopardy. I could offer no counterarguments. Many ruthless and inhuman crimes had been effected by the people who were now ranged against me. The murders they had committed were explained away either as gangster attacks or as fatalities resulting from the victims resisting the police.

So I went home and to bed. In the following week, I was so sick and depressed that everyone thought I would die. But thanks to Frida, I rallied and little by little regained my will to live.

When Chávez learned that I had left the Palace, he hastened to it and ordered the police commander to have his men cut the painting down from its stretcher. Upon the latter's refusal to commit such a felony, even at the risk of losing his job, Chávez, the famous composer and official conservator of Mexican art, heroic Chávez, with the *Stalingrad Symphony* or possibly the *Eroica* ringing in his ears, himself took knife in hand and attacked my painting. Not wanting to appear less courageous than Chávez, one of my helpers, in hopes of delaying the vandalism as long as possible, cried out that while Señor Chávez might be very expert in directing an orchestra, he wasn't the best man to dismantle a painting. This only encouraged Chávez's lieutenant, Fernando Gamboa, to offer his own talented hands in aid of his superior, the genius composer. As soon as the painting had been cut down, Chávez gave the order to roll it up. This done, he commanded that none of the people working in the Palace of Fine Arts follow him. He personally escorted the rolled-up canvas, borne by a pair of troopers, out of the building. Only Gamboa, his equal in courage, was permitted to go along. The canvas was taken to the basement, where it was stored in a secret place. The business was carried out as if it were of the most tremendous import—as if my painting of an atomic explosion were the atom bomb itself.

The next day, before sunrise, Gamboa left Mexico City incognito, heading in the direction of an archeological center of pre-Hispanic ruins. Chávez, too, left the scene of his doughty deed and, certain he would receive unending favors from his master Alemán, hurried to his home in Acapulco.

Anticipating an inquiry, Maestro Chávez had already concocted a story for the press, which must rank among the worst Hollywood

movies and the trashiest crime novels. According to this tale, fifteen masked men had invaded the palace late at night, cowed the night watchman into silence with machine guns, and then cut down my painting and run off with it.

Poor Miss Llach, Chávez's secretary and chief of the administrative department of the Institute, brought this "news" to me in my house in Coyoacán together with a check for 30,000 pesos, which represented the balance due me of the stipulated fee of 50,000 pesos. Naturally I refused to accept the check. I also refused to permit her to leave the house before my lawyer, Alejandro Gómez Arias, could come to make an official record of the "facts" as she had stated them. Arias, a distinguished orator and man of letters, took down Miss Llach's recitation. At the end of it, he declared that in his opinion, not only had my rights under the contract and my artistic rights in general been violated, but that I could claim damages for the theft of my painting as soon as the criminals were found.

Furthermore, Arias declared, the case would have to be put in the hands of the Attorney General, since the Institute was no longer responsible, the robbers evidently having had no connection with its authorities. Whereupon Miss Llach declared that she herself felt a bit dubious about Chávez's version of the crime. She personally refused to assume any responsibility in connection with it.

Arias then summoned a notary public to make these last statements of hers official, and then presented the case to the Attorney General. This gentleman immediately assigned two of his agents to study the matter further. He advised Miss Llach not to leave her office in the Fine Arts Palace until after the investigation had been completed.

Two hours later I was summoned to the Attorney General's office. Some policeman and a notary public were in attendance.

Meanwhile, Miss Llach may have succeeded in communicating with Chávez and he, his feet chilling, had advised her to tell the truth. Perhaps, good woman that she really was, she had decided that she had had enough of dissimulation.

In any case, in the presence of a representative of the Attorney General, the policemen, and me, Miss Llach retracted her original story—Chávez's story. Instead she told the truth, that the painting had been cut down from its stretcher, rolled up, and hidden somewhere in the palace. She said that the act had been performed on orders received from the highest authorities of the Institute. Who precisely had issued these orders? The Minister of Education? Miss Llach answered in the negative. Señor Chávez? The answer was again "No." There was only one highest authority left, the President of the Republic. But at this point, Miss Llach broke down and, in

tears, declared that she had been commanded by Chávez not to name names under any circumstances. To this extent the matter was clarified and the entire shameful responsibility for the act placed with the Institute of Fine Arts.

After leaving the Attorney General's office late in the afternoon, I arranged a meeting with other painters who had been greatly agitated by my experience. It was decided that we convene a press conference the following morning at eleven o'clock in the home of Siqueiros' sister-in-law. Representatives of all the daily papers and reviews, and many foreign correspondents, came and were given the whole story. They sent out their dispatches right from the house, and their accounts made headlines in the afternoon papers. *Excelsior* even brought out an extra edition.

Two hours after the conference, Chávez, back by plane from Acapulco, telephoned my lawyer to ask for a gentlemen's agreement with me. I was to withdraw my accusations and give back my advance and, in return, receive my mural, stretchers, and all other materials mentioned in my contract.

The agreement was accepted. At exactly five o'clock that same day, Chávez, having "found" my purloined painting, accompanied me to the door of the Fine Arts Palace. He shook my hand, declaring the incident closed, and asked for a renewal of our friendship.

"I declare the incident closed," I responded, "and also, I declare as ended your status as a decent human being. Further, I declare as being completely terminated our former friendship. Good-bye."

On the opening day of the Mexican art exhibition in Paris, 2,500,000 copies of *Humanité*, journal of the French workers, put reproductions of my banned mural into as many hands and told the whole story concerning it. Reproductions were also sold at the door of the exhibition by young men and women belonging to progressive peace organizations. Many more such reproductions were sold all over the world, especially in the United States and China. The government of China finally acquired the original work.

In short, my painting turned out to be more successful for having been withdrawn than it would have been if quietly shown to the art-going public in Paris. Chávez, Gamboa, and company succeeded in making themselves notorious before the entire world as futile suppressors of the right of freedom of expression—a most ignoble and unenviable distinction.

CANCER

 IN 1952 I began to be bothered by pain in the penis, the swelling of that organ, and the retention of urine. After making the usual tests, my physician diagnosed my illness as cancer of the penis. He advised amputating my penis and testicles to prevent the spread of the malignancy.

I objected to this horrifying proposal and asked the doctor to try to arrest the cancer with X-ray therapy instead. "If you cannot," I said, "I want everything to remain as it is. I will be completely responsible. I refuse to allow the amputation of those organs which have given me the finest pleasure I know."

My doctor acceded to the request, and I underwent X-ray treatments. After a few months my symptoms disappeared. The doctor then performed a biopsy, which showed the malignancy to have been arrested. Reports of my rapid and amazing recovery were made known to medical groups all over the world. Cancer of the penis is so rare in this hemisphere as to evoke much curiosity. One of the foremost radiologists of the United States flew to Mexico just to study my case.

After this frightening experience, I altered my diet in order to keep my body in the best of condition. Bearing in mind my doctor's maxim that, for every two pounds of weight I lost, I would live another year, I cut down on fats and starches and proportionally increased my intake of proteins. For the next few years my lunch, my main meal, consisted of two eggs, meat, two slices of black bread, yogurt, a cooked dessert, six different fruits, and a tall thermos of unsweetened black coffee. This was packed for me at home in a laborer's lunchbox which I carried with me onto the scaffold, eating when one of my helpers reminded me it was mealtime.

While I was undergoing treatment, I passed through a deep personal depression, dominated by the feeling that my life was practically over. It happened that during this time I was working on a wall of the new Hospital de la Raza. My subject was the history of medicine in Mexico. On the left side of the mural, I painted a giant, phallic, yellow-green Tree of Life. Suddenly I was stopped by a painful idea flashing through my mind. Gazing wistfully at my creation, I thought, "No more for me. Physical love exists for me no longer. I am an old man, too old and too sick to enjoy that wonderful ecstasy."

174

As my health returned I became restless. I yearned to go back to Europe and paint there again. It seemed to me that despite all the work I had been doing in the past few years, I had been asleep and not even dreaming. In 1946 I had passed up a second invitation to paint in Italy, extended by the administration of Alcide de Gasperi.

Now I decided to take advantage of the opportunity provided by the Vienna World Peace Conference to travel on the continent which had been my second home. Accompanied by my younger daughter Ruth, I left Mexico for Austria in January of 1953, planning to stop on the way back in Chile, where another peace conference was scheduled some weeks later.

Vienna, it seemed to me, had not yet shaken off the effects of the recent war. The despair of the people, which I observed during the conference, was reflected in the incomplete restoration of the city. Vienna was like a gravely wounded man who has experienced everything, and in the recesses of his heart, yearns only for order and peace.

When the conference was over I made a short junket to Czechoslovakia. Here, by contrast, I observed a remarkable recovery from the war. It was as if I were in another world. I was surprised and delighted. The people were happy and busy, and their activity showed a deep and positive sense of purpose. As I wandered through the towns and cities, I came upon murals noteworthy not only for their technical maturity but for the enjoyment and enthusiasm for life they expressed. Even the industrial murals had a deeply poetic quality.

When I got back to Mexico, I felt renewed again. The trip had admirably served its purpose as a tonic. Some time in the future I would like to commemorate it in a painting of the Vienna World Peace Conference from sketches which I made at the time—a mural if possible, but if not, a large canvas, depicting the final session as I remember it.

YET ANOTHER STORM

 TOWARD THE END of February, 1953, I was commissioned to do a mural on an outside wall of the new Teatro de los Insurgentes. Designed by the brothers Julio and Alejandro Prieto, this motion-picture house belonged to the master politician and composer of songs José María Dávila and his vivacious and attractive wife, Queta. It was Señora Dávila, chiefly, who was responsible for my being offered this interesting commission.

The space I was given comprised the whole main façade of the theatre, facing the busy Avenida de los Insurgentes. The plastic problem here was extremely challenging. For the surface was curved at the top and convex, and most of the people who would see the mural would be passing it quickly in cars and buses.

To establish immediately the theme of the mural and the purpose of the building, I painted a large masked head with two female hands in delicately laced evening gloves in the lower central portion. I covered the remaining surface with scenes from plays reflecting the history of Mexico from pre-Colonial times to the present, and converging in the upper center in a portrait of Cantinflas, the Mexican genius of popular farce, asking for money from the rich people and giving it to the poor, as he actually does.

It was this scene which precipitated the storm. When only the first charcoal sketch had been done, someone noticed that Cantinflas was wearing a medal of the Virgin of Guadalupe. Immediately there arose a hue and cry. It was blasphemous to connect a low comedy figure with something as sacred as the Virgin.

Interviewed by reporters, Cantinflas said that if I had actually blasphemed against the Virgin of Guadalupe in my mural, he would never permit any of his films to be shown in the theater. But my representation could be simply literal, for he always wore the medal in real life. Nobody, Cantinflas said, could either take it away from him or mock his reverence and love.

When Cantinflas saw my sketch, he was perfectly satisfied. He even posed with me for pictures on the scaffold beside the place where I had drawn the Virgin. He stood next to me, proudly showing his medal for the public to see in the photographers' prints.

Having Cantinflas' endorsement, the press came over to my side, pointing out that there was nothing contradictory between Cantinflas and the Virgin of Guadalupe. Cantinflas was an artist who symbolized the people of Mexico, and the Virgin was the banner of their faith.

A majority of the public subscribed to this interpretation. But the agitation against my painting was not allowed to die away. In fact, it was organized by a gangster syndicate led by professional extortioners, posing as staunch supporters of the Faith.

The gangsters' purpose was to shake down the Dávilas for a percentage of the profits of the theater—their price for tranquility. Not only the Dávilas, but even Cantinflas began to be frightened by the situation, and finally, I myself ceased to find it amusing. So when I got to that portion of the mural where the Virgin had been sketched, I did not paint her in at all, outwitting both friends and enemies, false and true. Executing this unexpected turnabout, I must admit, gave me not a little pleasure.

FRIDA DIES

FOR ME, the most thrilling event of 1953 was Frida's one-man show in Mexico City during the month of April. Anyone who attended it could not but marvel at her great talent. Even I was impressed when I saw all her work together. The arrangements had been made by her many friends as their personal tribute to her.

At the time Frida was bedridden—a few months later one of her legs was to be amputated—and she arrived in an ambulance, like a heroine, in the midst of admirers and friends.

Frida sat in the room quietly and happily, pleased at the numbers of people who were honoring her so warmly. She said practically nothing, but I thought afterwards that she must have realized she was bidding good-bye to life.

The following August she re-entered the hospital to have her leg cut off at the knee. The nerves had died and gangrene had set in. The doctors had told her that if they didn't perform this operation, the poison would spread through her whole body and kill her. With

typical courage, she asked them to amputate as soon as possible. The operation was her fourteenth in sixteen years.

Following the loss of her leg, Frida became deeply depressed. She no longer even wanted to hear me tell her of my love affairs, which she had enjoyed hearing about after our remarriage. She had lost her will to live.

Often, during her convalescence, her nurse would phone to me that Frida was crying and saying she wanted to die. I would immediately stop painting and rush home to comfort her. When Frida was resting peacefully again, I would return to my painting and work overtime to make up for the lost hours. Some days I was so tired that I would fall asleep in my chair, high up on the scaffold.

Eventually I set up a round-the-clock watch of nurses to tend to Frida's needs. The expense of this, coupled with other medical costs, exceeded what I was earning painting murals, so I supplemented my income by doing water colors, sometimes tossing off two big water colors a day.

In May, 1954, Frida seemed to be rallying. One raw night in June she insisted upon attending a demonstration and caught pneumonia. She was put back in bed for three weeks more. Almost recovered, she arose one night in July and against the doctor's orders, took a bath.

Three days later she began to feel violently ill. I sat beside her bed until 2:30 in the morning. At four o'clock she complained of severe discomfort. When the doctor arrived at daybreak, he found that she had died a short time before of an embolism of the lungs.

When I went into her room to look at her, her face was tranquil and seemed more beautiful than ever. The night before she had given me a ring she had bought me as a gift for our twenty-fifth anniversary, still seventeen days away. I had asked her why she was presenting it so early and she had replied, "Because I feel I am going to leave you very soon."

But though she knew she would die, she must have put up a struggle for life. Otherwise, why should death have been obliged to surprise her by stealing away her breath while she was asleep?

According to her wish, her coffin was draped with the Mexican Communist flag, and thus she lay in state in the Palace of Fine Arts. Reactionary government officials raised a cry against this display of a revolutionary symbol, and our good friend Dr. Andrés Iduarte, Director of the Fine Arts Institute, was fired from his post for permitting it. The newspapers amplified the noise and it was heard throughout the world.

I was oblivious to it all. July 13, 1954, was the most tragic day of my life. I had lost my beloved Frida forever.

When I left, I turned over our house in Coyoacán to the government as a museum for those paintings of mine which Frida had owned. I made only one other stipulation: that a corner be set aside for me, alone, for whenever I felt the need to return to the atmosphere which recreated Frida's presence.

Once out of Coyoacán, I went on a mad tear of the night clubs. I hate them, and yet I couldn't bear being alone with my thoughts. My only consolation now was my readmission into the Communist Party.

EMMA—I AM HERE STILL

 ABOUT NINE MONTHS after Frida's death, I had a recurrence of my cancer of the penis. The Mexican doctors again wanted to amputate. I informed them that though it meant my life, I would still withhold my permission. I had already lived for nearly seventy years, and that was enough if I could not continue to enjoy a normal life.

I now gave up all thought of remarrying; it would be unfair to encumber any desirable woman with whom I could not share a normal social and sexual life.

But my friend Emma Hurtado loved me enough, despite my condition, to want to marry and take care of me. Emma, a magazine publisher, had always been interested in my work. In fact, ten years before, she had opened a gallery for the sole purpose of displaying and selling Rivera paintings. During the ten years we had known one another, a warm feeling of mutuality had always existed between us. Frida was already dead for a year when we decided to become man and wife. Because of our understandable uncertainty, we kept the news of our marriage a secret, even from the most immediate members of our families, for almost a month.

A short time later Emma and I left for Moscow, where I had been invited. As soon as it was learned that I was sick with cancer, the Soviet doctors offered to try to cure me with cobalt treatments not yet available in Mexico. The treatments and in fact everything in Russia cost neither Emma nor me a penny.

I was treated for seven months in the finest hospital in Moscow and then released as cured. The doctors, four-fifths of whom, inci-

dentally, were women, told me that had I come to them four years before at the onset of the cancer, they could have cured me in a month. Before I left the hospital, I was given a complete physical examination and advised that I was now in the pink of health.

During my long stay in bed, I thought often of Emma's kindness, tenderness, and self-sacrifice, and of how very much like Frida she was. It made me happy to feel thus brought back to Frida. Too late now I realized that the most wonderful part of my life had been my love for Frida. But I could not really say that, given "another chance," I would have behaved toward her any differently than I had. Every man is the product of the social atmosphere in which he grows up and I am what I am.

And what sort of man was I? I had never had any morals at all and had lived only for pleasure where I found it. I was not good. I could discern other people's weaknesses easily, especially men's, and then I would play upon them for no worthwhile reason. If I loved a woman, the more I loved her, the more I wanted to hurt her. Frida was only the most obvious victim of this disgusting trait.

Yet my life had not been an easy one. Everything I had gotten, I had had to struggle for. And having got it, I had had to fight even harder to keep it. This was true of such disparate things as material goods and human affection. Of the two, I had, fortunately, managed to secure more of the latter than of the former.

As I lay in the hospital, I tried to sum up the meaning of my life. It occurred to me that I had never experienced what is commonly called "happiness." For me, "happiness" has always had a banal sound, like "inspiration." Both "happiness" and "inspiration" are the words of amateurs.

All I could say was that the most joyous moments of my life were those I had spent in painting; most others had been boring or sad. For even with women, unless they were interested enough in my work to spend their time with me while I painted, I knew I would certainly lose their love, not being able to spare the time away from my painting that they demanded. When I had to interrupt my painting to spend days in courting a woman, I would be unhappy for losing the never-to-be-recovered time. Therefore, the women who were best for me were those who also loved painting.

As for my work, whenever I looked at the paintings I had done in the past, I would feel a strong repugnance to each of them. It was like the feeling I had toward a woman who asked me to make love to her after I had tired of her.

So I was unfit to judge my own work. The paintings I most preferred were invariably the most recent ones. Time and change of circumstance invariably led to new forms of expression, new atti-

tudes, and I was constitutionally a revolutionary as opposed to a classical artist. Since everything about me had changed over the past twenty, thirty, and forty years, the work I did in those years now repelled me. Of the three completed works which I found the most interesting, two were recent—the Lerma Water Supply murals and the wall of the stadium of the new University City. The third was the series of frescoes I had done in the Detroit Arts Institute; but perhaps my appreciation of these was due to the warm reception the people gave them.

Upon my release from the hospital, I began to glow again with plans for the future. After traveling about Europe for a few weeks, I returned with Emma to Mexico.

Emma and I were met at the airport by a crowd of friends and relatives. One of them had written a song for the occasion, "The Story of Diego Rivera's Return." The words were: "The fourth day of April, 1956, Diego Rivera returned to his country. He was cured with cobalt, which is used to make bombs, but which will now be used to make men well. Diego Rivera came back to continue painting in the National Palace. And the end of this ditty serves to make us know that Diego and his wife have returned here, back to their dear country."

The tune was very pretty. My daughters Lupe and Ruth sang it to us as a duet, accompanying themselves with maracas, on the night after Emma and I came home.

One of my greatest excitements now is seeing my newest grandson, Ruth's baby. Ruth calls him Zopito, meaning "Little Frog," because he is fat like me, whom she calls Zoporana, "Big Frog." It's funny that people I love most think I look like a frog, because the city of Guanajuato where I was born means "Many Singing Frogs in Water." I am certainly not a singing frog, though I do burst forth on rare happy occasions into a song.

So now I am home again. With the rest and the superior medical treatment I received in Russia, I should live ten years more. Right now my fingers and I are literally itching to start work on my next mural.

[The last session of dictation took place in the summer of 1956. In the summer of 1957, Diego Rivera went over and approved the first draft of the manuscript. The finished manuscript was read and approved by Emma Hurtado Rivera.—G. M.]

Appendix

Statement by Angeline Belloff

It is true that because of Diego I suffered very much for many years, yet I have never once regretted those ten years we lived together. When Diego first met me, I had just come to France from my home in Russia to study painting.

At that time, I was exceedingly depressed and lonely and afraid. My parents had recently died, and I was all alone in a strange country. Diego was very kind to me then.

It was in 1910 that we first met and fell in love. When, soon after, Diego proposed that we set up housekeeping together, I was fearful; I thought him much too exotic for me. I told him that he should first return to his home in Mexico for one year and then come back to me in Paris. If we found that we still loved each other then, I would gladly accept his proposal.

Diego returned to me as agreed, in 1911. He greeted me with two gold wedding rings sent by his mother. There was never any doubt in my mind, when I accepted my ring, that I would love Diego for the rest of my life. I still wear my ring. You see, it says on it, "D.M.R. to A.B." Of course, we never had a legal marriage ceremony. I guess neither of us thought that necessary.

We lived together as man and wife, and Diego made me ecstatically happy. We made wonderful companions for each other. We traveled through all of Europe together, observing, painting, and loving.

Diego took me to all the art museums and explained everything he had learned about art with infinite patience. He loved me very much in those early years.

His father sent me many warm, tender letters, addressing me as "daughter." In fact, both of his parents continually extended cordial invitations for me to visit Mexico. I have always treasured in my memory how perpetually thrilling life in Paris was at the beginning.

Diego introduced me to all his artist friends, including Matisse and Picasso. He even arranged for Matisse to give me art lessons.

When I became pregnant, Diego began to broach the subject of having our marriage legalized. Yet he would also shout and threaten that if the child cried and disturbed him, he would toss it right out the window. He would say that if the child grew up to be anything like me, he would really cry with grief and disappointment.

All in all, Diego was very annoyed at having to play the role of a father. He insisted that the baby would deprive him of his peace and that besides, we couldn't afford to support another mouth. But then Diego always became maniacal whenever he felt that his work was in danger of being interrupted. He carried on in the same childish manner when he heard that his mother was coming from Mexico just to visit him in Paris.

In one of his periodic tantrums, Diego even threatened to kill himself if she showed up; he said he had no time to devote to her.

Diego has always seemed to do everything unconventionally, to provide himself with more stimulation to paint. He likes to dramatize pain and tragedy, as if he thrives on the emotional delights he experiences from them.

Years later, I realized that I never offered him enough excitement of this kind. I was too agreeable and placid and did not like to manufacture or play up nerve-wracking crises.

After our son was born, Diego had an adventure with the Russian painter Marievna. He left our apartment and went to live with her for five months. When he finally returned home to me, I was too weak-spirited to ask him to leave. Besides, I loved him so terribly I was willing to take him back under any circumstances. But the one thing I have always held against Diego is the way he acted when our one-and-a-half-year-old baby lay sick and dying. From the beginning of the child's illness, Diego would stay away from the house for days at a time, cavorting with his friends in the cafés.

He kept up this infantile routine even during the last three days and nights of our baby's life. Diego knew that I was keeping a constant vigil over the baby in a last desperate effort to save its life; still he didn't come home at all. When the child finally died, Diego, naturally, was the one to have the nervous collapse.

When Diego returned to Mexico for good in 1921, I was obliged to remain behind in Paris. He didn't have enough money for both our fares, so he went alone, promising to send for me soon. Five months later, he did send a cable for me to come to Mexico, but no money. Since I hadn't any myself, I couldn't go. After that, I didn't hear from him again.

I started working, supporting myself by painting for commercial books and magazines.

In 1932, I came to Mexico because I had many friends who told me how beautiful the country was. I did not come to see Diego. In fact, I have seen him only a few times in all the years I have been residing here, and those meetings were accidental.

I have earned my living in Mexico by teaching art to high-school students as well as to private pupils.

I never much cared for the company of Diego's other wives, Lupe Marín and Frida, as we had nothing really in common. I have, however, maintained a friendship with Diego's younger sister, María. It was María who remarked that, of all Diego's wives, I was the most unique and loved him most truly, since I loved him when he was poor and obscure.

Given the opportunity to live my life over again, I would still choose to spend those same ten years with Diego, despite all the pain I suffered afterwards, because those years were by far the most intense and happy of my whole life.

In this reminiscence of my life with Diego, I do not mean to say anything derogatory about him. He has never been a vicious man, but simply an amoral one. His painting is all he has ever lived for and deeply loved. And to his art, he has given the fidelity he could never find within him to give to a woman.

STATEMENT BY LUPE MARÍN

When I first met Diego, I thought he was very ugly. Nevertheless, I fell very much in love with him at that first meeting. I think he fell in love with me then, too. Despite what everyone has said in the past, when Diego was living with me, he had no other woman. As a husband, he was wonderful, always being *muy hombre*.

During the time we were married, we were quite poor, and many times we did not have enough to eat. Whatever money Diego made, he spent on his idols or donated to the C.P. He never thought of any practical ways to spend his money. Such prosaic things as food, clothing, or the rent were his last considerations.

It seems that my whole life was centered around Diego then. I accompanied him to the buildings where he was painting and remained at his side through all the day. I left him only to prepare his hot lunches, which I served to him on the scaffold.

During the seven years of our marriage, we had many arguments. The more furious and violent I became, the more Diego laughed and ignored me. After our girls were born, he gave me very little money to support them; otherwise, he was a good papa.

I think that the nudes Diego did of me are excellent, but I feel that they are independent of me, that each has its own personal identity. Of course, I believe that next to Picasso, Diego is the greatest contemporary painter in the world.

After Diego left me, I had an unfortunate marriage which lasted three years and have not remarried since. I had been tied down for so long to Diego, and then Cuesta, that I came to value my freedom more than any possible new husband. Besides, after those two marriages, I completely lost the faculty to love. That deficiency is still in me.

Since my marriages, I have earned my living as a writer, sewing teacher, and high-fashion designer. I have written two books, in parts of which I described my marriages, using fictitious names, naturally.

By the time Diego married Frida, my initial deep hurt had worn off, and I even attended the wedding. It has been written about me that Diego and I were separated once because I found him making love to my sister. That is not true; it was Frida's sister he made love to, and that's why Frida left him once, too. The real reason we parted was that he carried on so flagrantly with the model Tina Modotti. I couldn't stand that! I was beyond being angry. I felt deeply injured and deceived.

Diego has always paid much attention to women throughout his life, but he has always been respectful toward them. However, I don't believe for a minute that he likes any of them for themselves, for if he did, he would be faithful to them. One thing Diego truly likes about women is the money they can give him, since the majority of his mistresses have been women of great wealth. It is my opinion that they flock around him so because his fame, not he himself, is so interesting.

But I still love Diego, both as a friend and as the father of my children. My older daughter, Lupe, while not being exactly like either of us, has some of the characteristics of Diego. I am violent-tempered, but Lupe is more easygoing, like Diego. Ruth is closer to possessing all of the qualities of her father's temperament.

Over the years Diego has not changed much, except in one respect. As he has gotten older, he has gradually become cleaner. He hardly ever bathed when we lived together, but he bathes every day now because he knows that women hate a dirty man, and an old man has to be much more fastidious than a young one.

In this respect he has begun to resemble a gentleman.

STATEMENT BY FRIDA KAHLO

(Frida was ill and already near death when I met with her. Aside from a few interesting observations about Rivera, which are included at the end of her statement here, I found the notes of my interview with her less satisfactory than an article she had prepared earlier, in connection with the half-century exhibition of Rivera's work by the Fine Arts Institute of Mexico City. The article, brought to my attention by Rivera himself, was published by the Institute in a souvenir book, and is reproduced with permission of the Institute.—G.M.)

I WARN YOU that in this picture I am painting of Diego there will be colors which even I am not fully acquainted with. Besides, I love Diego so much I cannot be an objective spectator of him or his life. . . . I cannot speak of Diego as my husband because that term, when applied to him, is an absurdity. He never has been, nor will he ever be, anybody's husband. I also cannot speak of him as my lover because to me, he transcends by far the domain of sex. And if I attempt to speak of him purely, as a soul, I shall only end up by painting my own emotions. Yet considering these obstacles of sentiment, I shall try to sketch his image to the best of my ability.

Growing up from his Asiatic-type head is his fine, thin hair, which somehow gives the impression that it is floating in air. He looks like an immense baby with an amiable but sad-looking face. His wide, dark, and intelligent bulging eyes appear to be barely held in place by his swollen eyelids. They protrude like the eyes of a frog, each separated from the other in a most extraordinary way. They thus seem to enlarge his field of vision beyond that of most persons. It is almost as if they were constructed exclusively for a painter of vast spaces and multitudes. The effect produced by these unusual eyes, situated so far away from each other, encourages one to speculate on the ages-old oriental knowledge contained behind them.

On rare occasions, an ironic yet tender smile appears on his Buddha-like lips. Seeing him in the nude, one is immediately reminded of a young boy-frog standing on his hind legs. His skin is greenish-white, very like that of an aquatic animal. The only dark parts of his whole body are his hands and face, and that is because they are sunburned. His shoulders are like a child's, narrow and round. They progress without any visible hint of angles, their tapering rotundity making them seem almost feminine. The arms diminish regularly into small, sensitive hands. . . . It is incredible to think

that these hands have been capable of achieving such a prodigious number of paintings. Another wonder is that they can still work as indefatigably as they do.

Diego's chest—of it we have to say, that had he landed on an island governed by Sappho, where male invaders were apt to be executed, Diego would never have been in danger. The sensitivity of his marvelous breasts would have insured his welcome, although his masculine virility, specific and strange, would have made him equally desired in the lands of these queens avidly hungering for masculine love.

His enormous belly, smooth, tightly drawn, and sphere-shaped, is supported by two strong legs which are as beautifully solid as classical columns. They end in feet which point outward at an obtuse angle, as if moulded for a stance wide enough to cover the entire earth.

He sleeps in a foetal position. In his waking hours, he walks with a languorous elegance as if accustomed to living in a liquefied medium. By his movements, one would think that he found air denser to wade through than water.

I suppose everyone expects me to give a very feminine report about him, full of derogatory gossip and indecent revelations. Perhaps it is expected that I should lament about how I have suffered living with a man like Diego. But I do not think that the banks of a river suffer because they let the river flow, nor does the earth suffer because of the rains, nor does the atom suffer for letting its energy escape. To my way of thinking, everything has its natural compensation.

To Diego painting is everything. He prefers his work to anything else in the world. It is his vocation and his vacation in one. For as long as I have known him, he has spent most of his waking hours at painting: between twelve and eighteen a day.

Therefore he cannot lead a normal life. Nor does he ever have the time to think whether what he does is moral, amoral, or immoral.

He has only one great social concern: to raise the standard of living of the Mexican Indians, whom he loves so deeply. This love he has conveyed in painting after painting.

His temperament is invariably a happy one. He is irritated by only two things: loss of time from his work—and stupidity. He has said many times that he would rather have many intelligent enemies than one stupid friend.

STATEMENT BY EMMA HURTADO

I HAVE KNOWN DIEGO for twelve years, in the last two of which I have been his wife.

I married Diego when he was very sick with cancer, just shortly before we went to Russia for him to be treated. At that time I had no idea whether he would live or die.

Upon our arrival, Diego was hospitalized from September, 1955, until the end of January, 1956, practically all of which time he was in bed.

I was at the hospital with him every day from eight in the morning until eight at night. It was an exceptional arrangement, which the hospital permitted because we had traveled from so far away.

I lived in a hotel near the hospital. It was not easy to be all alone in a foreign country, and with no knowledge of the language, especially in this terrible situation. There was the continually nerve-wracking task of dealing with the newspaper people, all of whom seemed to be momentarily expecting some dramatic announcement. One reporter, more impatient than the rest, wrote that Diego and I were being held prisoner by the government. How he could have reached such a conclusion I cannot imagine, for all during our stay we received nothing but attention and courtesy.

Diego was an extraordinarily good patient. He made no objection to anything the nurses or doctors suggested. At the beginning, he sketched everything around him: patients, doctors, nurses, and apparatus. He always kept a sketch book and pencil beside his bed. After he had received many cobalt treatments, however, he became very weak, so weak in fact, that he couldn't draw a single line.

This made him despondent, and considering it a bad sign, the doctors arranged to move him to a hotel room where he could view the November 7th parade in Red Square. The parade excited him so, that he moved away from his chair and started making sketches. I was relieved to see this change of spirit, as were his doctors.

By January, he was well again and painting furiously and with much gusto. Within the next six months, he completed over four hundred pieces of work in Russia, Germany, Czechoslovakia, and Poland, where we traveled briefly before flying home. After arriving in Mexico, we went to Acapulco, where he did many marvelous oils, water colors, and sketches.

We had an exhibition of all this work, here in Mexico, in November, 1956. The show was such a success that practically every piece was sold.

As a husband, Diego has always been very good to me, even the times when he was sick and uncomfortable. Of course he still has many other women friends. But for a man like Diego, that is necessary; he needs to feel many different kinds of emotions in order to be able to paint as he does. And yet, I must say, it is the women who are always chasing after him, not he after them. He is always polite and attentive to them; they respond to his chivalry; and before he is fully aware of it, he is already involved.

The more he lives the greater grows the desire of collectors to buy his paintings. It is no longer a question of what he says or does, or what the world thinks of him. He is already a classic. And his greatness insures him against everything.

INDEX

A CATALOG OF SELECTED
DOVER BOOKS
IN ALL FIELDS OF INTEREST

A CATALOG OF SELECTED DOVER
BOOKS IN ALL FIELDS OF INTEREST

CONCERNING THE SPIRITUAL IN ART, Wassily Kandinsky. Pioneering work by father of abstract art. Thoughts on color theory, nature of art. Analysis of earlier masters. 12 illustrations. 80pp. of text. 5⅜ x 8½. 23411-8 Pa. $3.95

ANIMALS: 1,419 Copyright-Free Illustrations of Mammals, Birds, Fish, Insects, etc., Jim Harter (ed.). Clear wood engravings present, in extremely lifelike poses, over 1,000 species of animals. One of the most extensive pictorial sourcebooks of its kind. Captions. Index. 284pp. 9 x 12. 23766-4 Pa. $12.95

CELTIC ART: The Methods of Construction, George Bain. Simple geometric techniques for making Celtic interlacements, spirals, Kells-type initials, animals, humans, etc. Over 500 illustrations. 160pp. 9 x 12. (USO) 22923-8 Pa. $9.95

AN ATLAS OF ANATOMY FOR ARTISTS, Fritz Schider. Most thorough reference work on art anatomy in the world. Hundreds of illustrations, including selections from works by Vesalius, Leonardo, Goya, Ingres, Michelangelo, others. 593 illustrations. 192pp. 7⅛ x 10¼. 20241-0 Pa. $9 95

CELTIC HAND STROKE-BY-STROKE (Irish Half-Uncial from "The Book of Kells"): An Arthur Baker Calligraphy Manual, Arthur Baker. Complete guide to creating each letter of the alphabet in distinctive Celtic manner. Covers hand position, strokes, pens, inks, paper, more. Illustrated. 48pp. 8¼ x 11. 24336-2 Pa. $3.95

EASY ORIGAMI, John Montroll. Charming collection of 32 projects (hat, cup, pelican, piano, swan, many more) specially designed for the novice origami hobbyist. Clearly illustrated easy-to-follow instructions insure that even beginning papercrafters will achieve successful results. 48pp. 8¼ x 11. 27298-2 Pa. $2.95

THE COMPLETE BOOK OF BIRDHOUSE CONSTRUCTION FOR WOODWORKERS, Scott D. Campbell. Detailed instructions, illustrations, tables. Also data on bird habitat and instinct patterns. Bibliography. 3 tables. 63 illustrations in 15 figures. 48pp. 5¼ x 8½. 24407-5 Pa. $2.50

BLOOMINGDALE'S ILLUSTRATED 1886 CATALOG: Fashions, Dry Goods and Housewares, Bloomingdale Brothers. Famed merchants' extremely rare catalog depicting about 1,700 products: clothing, housewares, firearms, dry goods, jewelry, more. Invaluable for dating, identifying vintage items. Also, copyright-free graphics for artists, designers. Co-published with Henry Ford Museum & Greenfield Village. 160pp. 8¼ x 11. 25780-0 Pa. $9.95

HISTORIC COSTUME IN PICTURES, Braun & Schneider. Over 1,450 costumed figures in clearly detailed engravings—from dawn of civilization to end of 19th century. Captions. Many folk costumes. 256pp. 8⅜ x 11¾. 23150-X Pa. $12.95

STICKLEY CRAFTSMAN FURNITURE CATALOGS, Gustav Stickley and L. & J. G. Stickley. Beautiful, functional furniture in two authentic catalogs from 1910. 594 illustrations, including 277 photos, show settles, rockers, armchairs, reclining chairs, bookcases, desks, tables. 183pp. 6½ x 9¼. 23838-5 Pa. $9.95

AMERICAN LOCOMOTIVES IN HISTORIC PHOTOGRAPHS: 1858 to 1949, Ron Ziel (ed.). A rare collection of 126 meticulously detailed official photographs, called "builder portraits," of American locomotives that majestically chronicle the rise of steam locomotive power in America. Introduction. Detailed captions. xi + 129pp. 9 x 12. 27393-8 Pa. $12.95

AMERICA'S LIGHTHOUSES: An Illustrated History, Francis Ross Holland, Jr. Delightfully written, profusely illustrated fact-filled survey of over 200 American lighthouses since 1716. History, anecdotes, technological advances, more. 240pp. 8 x 10¾.
 25576-X Pa. $12.95

TOWARDS A NEW ARCHITECTURE, Le Corbusier. Pioneering manifesto by founder of "International School." Technical and aesthetic theories, views of industry, economics, relation of form to function, "mass-production split" and much more. Profusely illustrated. 320pp. 6⅛ x 9¼. (USO) 25023-7 Pa. $9.95

HOW THE OTHER HALF LIVES, Jacob Riis. Famous journalistic record, exposing poverty and degradation of New York slums around 1900, by major social reformer. 100 striking and influential photographs. 233pp. 10 x 7⅞.
 22012-5 Pa. $10.95

FRUIT KEY AND TWIG KEY TO TREES AND SHRUBS, William M. Harlow. One of the handiest and most widely used identification aids. Fruit key covers 120 deciduous and evergreen species; twig key 160 deciduous species. Easily used. Over 300 photographs. 126pp. 5⅜ x 8½. 20511-8 Pa. $3.95

COMMON BIRD SONGS, Dr. Donald J. Borror. Songs of 60 most common U.S. birds: robins, sparrows, cardinals, bluejays, finches, more—arranged in order of increasing complexity. Up to 9 variations of songs of each species.
 Cassette and manual 99911-4 $8.95

ORCHIDS AS HOUSE PLANTS, Rebecca Tyson Northen. Grow cattleyas and many other kinds of orchids—in a window, in a case, or under artificial light. 63 illustrations. 148pp. 5⅜ x 8½. 23261-1 Pa. $4.95

MONSTER MAZES, Dave Phillips. Masterful mazes at four levels of difficulty. Avoid deadly perils and evil creatures to find magical treasures. Solutions for all 32 exciting illustrated puzzles. 48pp. 8¼ x 11. 26005-4 Pa. $2.95

MOZART'S DON GIOVANNI (DOVER OPERA LIBRETTO SERIES), Wolfgang Amadeus Mozart. Introduced and translated by Ellen H. Bleiler. Standard Italian libretto, with complete English translation. Convenient and thoroughly portable—an ideal companion for reading along with a recording or the performance itself. Introduction. List of characters. Plot summary. 121pp. 5¼ x 8½.
 24944-1 Pa. $2.95

TECHNICAL MANUAL AND DICTIONARY OF CLASSICAL BALLET, Gail Grant. Defines, explains, comments on steps, movements, poses and concepts. 15-page pictorial section. Basic book for student, viewer. 127pp. 5⅜ x 8½.
 21843-0 Pa. $4.95

BRASS INSTRUMENTS: Their History and Development, Anthony Baines. Authoritative, updated survey of the evolution of trumpets, trombones, bugles, cornets, French horns, tubas and other brass wind instruments. Over 140 illustrations and 48 music examples. Corrected and updated by author. New preface. Bibliography. 320pp. 5⅜ x 8½. 27574-4 Pa. $9.95

HOLLYWOOD GLAMOR PORTRAITS, John Kobal (ed.). 145 photos from 1926-49. Harlow, Gable, Bogart, Bacall; 94 stars in all. Full background on photographers, technical aspects. 160pp. 8⅜ x 11¼. 23352-9 Pa. $11.95

MAX AND MORITZ, Wilhelm Busch. Great humor classic in both German and English. Also 10 other works: "Cat and Mouse," "Plisch and Plumm," etc. 216pp. 5⅜ x 8½. 20181-3 Pa. $6.95

THE RAVEN AND OTHER FAVORITE POEMS, Edgar Allan Poe. Over 40 of the author's most memorable poems: "The Bells," "Ulalume," "Israfel," "To Helen," "The Conqueror Worm," "Eldorado," "Annabel Lee," many more. Alphabetic lists of titles and first lines. 64pp. 5³⁄₁₆ x 8¼. 26685-0 Pa. $1.00

PERSONAL MEMOIRS OF U. S. GRANT, Ulysses Simpson Grant. Intelligent, deeply moving firsthand account of Civil War campaigns, considered by many the finest military memoirs ever written. Includes letters, historic photographs, maps and more. 528pp. 6⅛ x 9¼. 28587-1 Pa. $11.95

AMULETS AND SUPERSTITIONS, E. A. Wallis Budge. Comprehensive discourse on origin, powers of amulets in many ancient cultures: Arab, Persian Babylonian, Assyrian, Egyptian, Gnostic, Hebrew, Phoenician, Syriac, etc. Covers cross, swastika, crucifix, seals, rings, stones, etc. 584pp. 5⅜ x 8½. 23573-4 Pa. $12.95

RUSSIAN STORIES/PYCCKNE PACCKA3bl: A Dual-Language Book, edited by Gleb Struve. Twelve tales by such masters as Chekhov, Tolstoy, Dostoevsky, Pushkin, others. Excellent word-for-word English translations on facing pages, plus teaching and study aids, Russian/English vocabulary, biographical/critical introductions, more. 416pp. 5⅜ x 8½. 26244-8 Pa. $8.95

PHILADELPHIA THEN AND NOW: 60 Sites Photographed in the Past and Present, Kenneth Finkel and Susan Oyama. Rare photographs of City Hall, Logan Square, Independence Hall, Betsy Ross House, other landmarks juxtaposed with contemporary views. Captures changing face of historic city. Introduction. Captions. 128pp. 8¼ x 11. 25790-8 Pa. $9.95

AIA ARCHITECTURAL GUIDE TO NASSAU AND SUFFOLK COUNTIES, LONG ISLAND, The American Institute of Architects, Long Island Chapter, and the Society for the Preservation of Long Island Antiquities. Comprehensive, well-researched and generously illustrated volume brings to life over three centuries of Long Island's great architectural heritage. More than 240 photographs with authoritative, extensively detailed captions. 176pp. 8¼ x 11. 26946-9 Pa. $14.95

NORTH AMERICAN INDIAN LIFE: Customs and Traditions of 23 Tribes, Elsie Clews Parsons (ed.). 27 fictionalized essays by noted anthropologists examine religion, customs, government, additional facets of life among the Winnebago, Crow, Zuni, Eskimo, other tribes. 480pp. 6⅛ x 9¼. 27377-6 Pa. $10.95

CATALOG OF DOVER BOOKS

FRANK LLOYD WRIGHT'S HOLLYHOCK HOUSE, Donald Hoffmann. Lavishly illustrated, carefully documented study of one of Wright's most controversial residential designs. Over 120 photographs, floor plans, elevations, etc. Detailed perceptive text by noted Wright scholar. Index. 128pp. 9¼ x 10¾. 27133-1 Pa. $11.95

THE MALE AND FEMALE FIGURE IN MOTION: 60 Classic Photographic Sequences, Eadweard Muybridge. 60 true-action photographs of men and women walking, running, climbing, bending, turning, etc., reproduced from rare 19th-century masterpiece. vi + 121pp. 9 x 12. 24745-7 Pa. $10.95

1001 QUESTIONS ANSWERED ABOUT THE SEASHORE, N. J. Berrill and Jacquelyn Berrill. Queries answered about dolphins, sea snails, sponges, starfish, fishes, shore birds, many others. Covers appearance, breeding, growth, feeding, much more. 305pp. 5¼ x 8¼. 23366-9 Pa. $8.95

GUIDE TO OWL WATCHING IN NORTH AMERICA, Donald S. Heintzelman. Superb guide offers complete data and descriptions of 19 species: barn owl, screech owl, snowy owl, many more. Expert coverage of owl-watching equipment, conservation, migrations and invasions, etc. Guide to observing sites. 84 illustrations. xiii + 193pp. 5⅜ x 8½. 27344-X Pa. $8.95

MEDICINAL AND OTHER USES OF NORTH AMERICAN PLANTS: A Historical Survey with Special Reference to the Eastern Indian Tribes, Charlotte Erichsen-Brown. Chronological historical citations document 500 years of usage of plants, trees, shrubs native to eastern Canada, northeastern U.S. Also complete identifying information. 343 illustrations. 544pp. 6½ x 9¼. 25951-X Pa. $12.95

STORYBOOK MAZES, Dave Phillips. 23 stories and mazes on two-page spreads: Wizard of Oz, Treasure Island, Robin Hood, etc. Solutions. 64pp. 8¼ x 11. 23628-5 Pa. $2.95

NEGRO FOLK MUSIC, U.S.A., Harold Courlander. Noted folklorist's scholarly yet readable analysis of rich and varied musical tradition. Includes authentic versions of over 40 folk songs. Valuable bibliography and discography. xi + 324pp. 5⅜ x 8½. 27350-4 Pa. $7.95

MOVIE-STAR PORTRAITS OF THE FORTIES, John Kobal (ed.). 163 glamor, studio photos of 106 stars of the 1940s: Rita Hayworth, Ava Gardner, Marlon Brando, Clark Gable, many more. 176pp. 8⅜ x 11¼. 23546-7 Pa. $12.95

BENCHLEY LOST AND FOUND, Robert Benchley. Finest humor from early 30s, about pet peeves, child psychologists, post office and others. Mostly unavailable elsewhere. 73 illustrations by Peter Arno and others. 183pp. 5⅜ x 8½. 22410-4 Pa. $6.95

YEKL and THE IMPORTED BRIDEGROOM AND OTHER STORIES OF YIDDISH NEW YORK, Abraham Cahan. Film Hester Street based on Yekl (1896). Novel, other stories among first about Jewish immigrants on N.Y.'s East Side. 240pp. 5⅜ x 8½. 22427-9 Pa. $6.95

SELECTED POEMS, Walt Whitman. Generous sampling from *Leaves of Grass.* Twenty-four poems include "I Hear America Singing," "Song of the Open Road," "I Sing the Body Electric," "When Lilacs Last in the Dooryard Bloom'd," "O Captain! My Captain!"–all reprinted from an authoritative edition. Lists of titles and first lines. 128pp. 5³⁄₁₆ x 8¼. 26878-0 Pa. $1.00

THE BEST TALES OF HOFFMANN, E. T. A. Hoffmann. 10 of Hoffmann's most important stories: "Nutcracker and the King of Mice," "The Golden Flowerpot," etc. 458pp. 5⅜ x 8½. 21793-0 Pa. $9.95

FROM FETISH TO GOD IN ANCIENT EGYPT, E. A. Wallis Budge. Rich detailed survey of Egyptian conception of "God" and gods, magic, cult of animals, Osiris, more. Also, superb English translations of hymns and legends. 240 illustrations. 545pp. 5⅜ x 8½. 25803-3 Pa. $11.95

FRENCH STORIES/CONTES FRANÇAIS: A Dual-Language Book, Wallace Fowlie. Ten stories by French masters, Voltaire to Camus: "Micromegas" by Voltaire; "The Atheist's Mass" by Balzac; "Minuet" by de Maupassant; "The Guest" by Camus, six more. Excellent English translations on facing pages. Also French-English vocabulary list, exercises, more. 352pp. 5⅜ x 8½. 26443-2 Pa. $8.95

CHICAGO AT THE TURN OF THE CENTURY IN PHOTOGRAPHS: 122 Historic Views from the Collections of the Chicago Historical Society, Larry A. Viskochil. Rare large-format prints offer detailed views of City Hall, State Street, the Loop, Hull House, Union Station, many other landmarks, circa 1904-1913. Introduction. Captions. Maps. 144pp. 9⅜ x 12¼. 24656-6 Pa. $12.95

OLD BROOKLYN IN EARLY PHOTOGRAPHS, 1865-1929, William Lee Younger. Luna Park, Gravesend race track, construction of Grand Army Plaza, moving of Hotel Brighton, etc. 157 previously unpublished photographs. 165pp. 8⅜ x 11¼.
 23587-4 Pa. $13.95

THE MYTHS OF THE NORTH AMERICAN INDIANS, Lewis Spence. Rich anthology of the myths and legends of the Algonquins, Iroquois, Pawnees and Sioux, prefaced by an extensive historical and ethnological commentary. 36 illustrations. 480pp. 5⅜ x 8½. 25967-6 Pa. $8.95

AN ENCYCLOPEDIA OF BATTLES: Accounts of Over 1,560 Battles from 1479 B.C. to the Present, David Eggenberger. Essential details of every major battle in recorded history from the first battle of Megiddo in 1479 B.C. to Grenada in 1984. List of Battle Maps. New Appendix covering the years 1967-1984. Index. 99 illustrations. 544pp. 6½ x 9¼. 24913-1 Pa. $14.95

SAILING ALONE AROUND THE WORLD, Captain Joshua Slocum. First man to sail around the world, alone, in small boat. One of great feats of seamanship told in delightful manner. 67 illustrations. 294pp. 5⅜ x 8½. 20326-3 Pa. $5.95

ANARCHISM AND OTHER ESSAYS, Emma Goldman. Powerful, penetrating, prophetic essays on direct action, role of minorities, prison reform, puritan hypocrisy, violence, etc. 271pp. 5⅜ x 8½. 22484-8 Pa. $6.95

MYTHS OF THE HINDUS AND BUDDHISTS, Ananda K. Coomaraswamy and Sister Nivedita. Great stories of the epics; deeds of Krishna, Shiva, taken from puranas, Vedas, folk tales; etc. 32 illustrations. 400pp. 5⅜ x 8½. 21759-0 Pa. $10.95

BEYOND PSYCHOLOGY, Otto Rank. Fear of death, desire of immortality, nature of sexuality, social organization, creativity, according to Rankian system. 291pp. 5⅜ x 8½.
 20485-5 Pa. $8.95

A THEOLOGICO-POLITICAL TREATISE, Benedict Spinoza. Also contains unfinished Political Treatise. Great classic on religious liberty, theory of government on common consent. R. Elwes translation. Total of 421pp. 5⅜ x 8½. 20249-6 Pa. $9.95

MY BONDAGE AND MY FREEDOM, Frederick Douglass. Born a slave, Douglass became outspoken force in antislavery movement. The best of Douglass' autobiographies. Graphic description of slave life. 464pp. 5⅜ x 8½. 22457-0 Pa. $8.95

FOLLOWING THE EQUATOR: A Journey Around the World, Mark Twain. Fascinating humorous account of 1897 voyage to Hawaii, Australia, India, New Zealand, etc. Ironic, bemused reports on peoples, customs, climate, flora and fauna, politics, much more. 197 illustrations. 720pp. 5⅜ x 8½. 26113-1 Pa. $15.95

THE PEOPLE CALLED SHAKERS, Edward D. Andrews. Definitive study of Shakers: origins, beliefs, practices, dances, social organization, furniture and crafts, etc. 33 illustrations. 351pp. 5⅜ x 8½. 21081-2 Pa. $8.95

THE MYTHS OF GREECE AND ROME, H. A. Guerber. A classic of mythology, generously illustrated, long prized for its simple, graphic, accurate retelling of the principal myths of Greece and Rome, and for its commentary on their origins and significance. With 64 illustrations by Michelangelo, Raphael, Titian, Rubens, Canova, Bernini and others. 480pp. 5⅜ x 8½. 27584-1 Pa. $9.95

PSYCHOLOGY OF MUSIC, Carl E. Seashore. Classic work discusses music as a medium from psychological viewpoint. Clear treatment of physical acoustics, auditory apparatus, sound perception, development of musical skills, nature of musical feeling, host of other topics. 88 figures. 408pp. 5⅜ x 8½. 21851-1 Pa. $10.95

THE PHILOSOPHY OF HISTORY, Georg W. Hegel. Great classic of Western thought develops concept that history is not chance but rational process, the evolution of freedom. 457pp. 5⅜ x 8½. 20112-0 Pa. $9.95

THE BOOK OF TEA, Kakuzo Okakura. Minor classic of the Orient: entertaining, charming explanation, interpretation of traditional Japanese culture in terms of tea ceremony. 94pp. 5⅜ x 8½. 20070-1 Pa. $3.95

LIFE IN ANCIENT EGYPT, Adolf Erman. Fullest, most thorough, detailed older account with much not in more recent books, domestic life, religion, magic, medicine, commerce, much more. Many illustrations reproduce tomb paintings, carvings, hieroglyphs, etc. 597pp. 5⅜ x 8½. 22632-8 Pa. $11.95

SUNDIALS, Their Theory and Construction, Albert Waugh. Far and away the best, most thorough coverage of ideas, mathematics concerned, types, construction, adjusting anywhere. Simple, nontechnical treatment allows even children to build several of these dials. Over 100 illustrations. 230pp. 5⅜ x 8½. 22947-5 Pa. $7.95

DYNAMICS OF FLUIDS IN POROUS MEDIA, Jacob Bear. For advanced students of ground water hydrology, soil mechanics and physics, drainage and irrigation engineering, and more. 335 illustrations. Exercises, with answers. 784pp. 6⅛ x 9¼. 65675-6 Pa. $19.95

SONGS OF EXPERIENCE: Facsimile Reproduction with 26 Plates in Full Color, William Blake. 26 full-color plates from a rare 1826 edition. Includes "TheTyger," "London," "Holy Thursday," and other poems. Printed text of poems. 48pp. 5¼ x 7. 24636-1 Pa. $4.95

OLD-TIME VIGNETTES IN FULL COLOR, Carol Belanger Grafton (ed.). Over 390 charming, often sentimental illustrations, selected from archives of Victorian graphics—pretty women posing, children playing, food, flowers, kittens and puppies, smiling cherubs, birds and butterflies, much more. All copyright-free. 48pp. 9¼ x 12¼. 27269-9 Pa. $5.95

PERSPECTIVE FOR ARTISTS, Rex Vicat Cole. Depth, perspective of sky and sea, shadows, much more, not usually covered. 391 diagrams, 81 reproductions of drawings and paintings. 279pp. 5⅜ x 8½. 22487-2 Pa. $6.95

DRAWING THE LIVING FIGURE, Joseph Sheppard. Innovative approach to artistic anatomy focuses on specifics of surface anatomy, rather than muscles and bones. Over 170 drawings of live models in front, back and side views, and in widely varying poses. Accompanying diagrams. 177 illustrations. Introduction. Index. 144pp. 8⅜ x11¼. 26723-7 Pa. $8.95

GOTHIC AND OLD ENGLISH ALPHABETS: 100 Complete Fonts, Dan X. Solo. Add power, elegance to posters, signs, other graphics with 100 stunning copyright-free alphabets: Blackstone, Dolbey, Germania, 97 more—including many lower-case, numerals, punctuation marks. 104pp. 8⅛ x 11. 24695-7 Pa. $8.95

HOW TO DO BEADWORK, Mary White. Fundamental book on craft from simple projects to five-bead chains and woven works. 106 illustrations. 142pp. 5⅜ x 8. 20697-1 Pa. $4.95

THE BOOK OF WOOD CARVING, Charles Marshall Sayers. Finest book for beginners discusses fundamentals and offers 34 designs. "Absolutely first rate . . . well thought out and well executed."–E. J. Tangerman. 118pp. 7¾ x 10⅝. 23654-4 Pa. $6.95

ILLUSTRATED CATALOG OF CIVIL WAR MILITARY GOODS: Union Army Weapons, Insignia, Uniform Accessories, and Other Equipment, Schuyler, Hartley, and Graham. Rare, profusely illustrated 1846 catalog includes Union Army uniform and dress regulations, arms and ammunition, coats, insignia, flags, swords, rifles, etc. 226 illustrations. 160pp. 9 x 12. 24939-5 Pa. $10.95

WOMEN'S FASHIONS OF THE EARLY 1900s: An Unabridged Republication of "New York Fashions, 1909," National Cloak & Suit Co. Rare catalog of mail-order fashions documents women's and children's clothing styles shortly after the turn of the century. Captions offer full descriptions, prices. Invaluable resource for fashion, costume historians. Approximately 725 illustrations. 128pp. 8⅜ x 11¼. 27276-1 Pa. $11.95

THE 1912 AND 1915 GUSTAV STICKLEY FURNITURE CATALOGS, Gustav Stickley. With over 200 detailed illustrations and descriptions, these two catalogs are essential reading and reference materials and identification guides for Stickley furniture. Captions cite materials, dimensions and prices. 112pp. 6½ x 9¼. 26676-1 Pa. $9.95

EARLY AMERICAN LOCOMOTIVES, John H. White, Jr. Finest locomotive engravings from early 19th century: historical (1804–74), main-line (after 1870), special, foreign, etc. 147 plates. 142pp. 11⅜ x 8¼. 22772-3 Pa. $10.95

THE TALL SHIPS OF TODAY IN PHOTOGRAPHS, Frank O. Braynard. Lavishly illustrated tribute to nearly 100 majestic contemporary sailing vessels: Amerigo Vespucci, Clearwater, Constitution, Eagle, Mayflower, Sea Cloud, Victory, many more. Authoritative captions provide statistics, background on each ship. 190 black-and-white photographs and illustrations. Introduction. 128pp. 8⅜ x 11¼. 27163-3 Pa. $13.95

CATALOG OF DOVER BOOKS

EARLY NINETEENTH-CENTURY CRAFTS AND TRADES, Peter Stockham (ed.). Extremely rare 1807 volume describes to youngsters the crafts and trades of the day: brickmaker, weaver, dressmaker, bookbinder, ropemaker, saddler, many more. Quaint prose, charming illustrations for each craft. 20 black-and-white line illustrations. 192pp. 4⅝ x 6. 27293-1 Pa. $4.95

VICTORIAN FASHIONS AND COSTUMES FROM HARPER'S BAZAR, 1867–1898, Stella Blum (ed.). Day costumes, evening wear, sports clothes, shoes, hats, other accessories in over 1,000 detailed engravings. 320pp. 9⅜ x 12¼.
22990-4 Pa. $14.95

GUSTAV STICKLEY, THE CRAFTSMAN, Mary Ann Smith. Superb study surveys broad scope of Stickley's achievement, especially in architecture. Design philosophy, rise and fall of the Craftsman empire, descriptions and floor plans for many Craftsman houses, more. 86 black-and-white halftones. 31 line illustrations. Introduction 208pp. 6½ x 9¼. 27210-9 Pa. $9.95

THE LONG ISLAND RAIL ROAD IN EARLY PHOTOGRAPHS, Ron Ziel. Over 220 rare photos, informative text document origin (1844) and development of rail service on Long Island. Vintage views of early trains, locomotives, stations, passengers, crews, much more. Captions. 8⅞ x 11¾. 26301-0 Pa. $13.95

THE BOOK OF OLD SHIPS: From Egyptian Galleys to Clipper Ships, Henry B. Culver. Superb, authoritative history of sailing vessels, with 80 magnificent line illustrations. Galley, bark, caravel, longship, whaler, many more. Detailed, informative text on each vessel by noted naval historian. Introduction. 256pp. 5⅜ x 8½.
27332-6 Pa. $7.95

TEN BOOKS ON ARCHITECTURE, Vitruvius. The most important book ever written on architecture. Early Roman aesthetics, technology, classical orders, site selection, all other aspects. Morgan translation. 331pp. 5⅜ x 8½. 20645-9 Pa. $8.95

THE HUMAN FIGURE IN MOTION, Eadweard Muybridge. More than 4,500 stopped-action photos, in action series, showing undraped men, women, children jumping, lying down, throwing, sitting, wrestling, carrying, etc. 390pp. 7⅞ x 10⅝.
20204-6 Clothbd. $25.95

TREES OF THE EASTERN AND CENTRAL UNITED STATES AND CANADA, William M. Harlow. Best one-volume guide to 140 trees. Full descriptions, woodlore, range, etc. Over 600 illustrations. Handy size. 288pp. 4½ x 6⅜.
20395-6 Pa. $5.95

SONGS OF WESTERN BIRDS, Dr. Donald J. Borror. Complete song and call repertoire of 60 western species, including flycatchers, juncoes, cactus wrens, many more–includes fully illustrated booklet. Cassette and manual 99913-0 $8.95

GROWING AND USING HERBS AND SPICES, Milo Miloradovich. Versatile handbook provides all the information needed for cultivation and use of all the herbs and spices available in North America. 4 illustrations. Index. Glossary. 236pp. 5⅜ x 8½.
25058-X Pa. $6.95

BIG BOOK OF MAZES AND LABYRINTHS, Walter Shepherd. 50 mazes and labyrinths in all–classical, solid, ripple, and more–in one great volume. Perfect inexpensive puzzler for clever youngsters. Full solutions. 112pp. 8¼ x 11.
22951-3 Pa. $4.95

PIANO TUNING, J. Cree Fischer. Clearest, best book for beginner, amateur. Simple repairs, raising dropped notes, tuning by easy method of flattened fifths. No previous skills needed. 4 illustrations. 201pp. 5⅜ x 8½. 23267-0 Pa. $6.95

A SOURCE BOOK IN THEATRICAL HISTORY, A. M. Nagler. Contemporary observers on acting, directing, make-up, costuming, stage props, machinery, scene design, from Ancient Greece to Chekhov. 611pp. 5⅜ x 8½. 20515-0 Pa. $12.95

THE COMPLETE NONSENSE OF EDWARD LEAR, Edward Lear. All nonsense limericks, zany alphabets, Owl and Pussycat, songs, nonsense botany, etc., illustrated by Lear. Total of 320pp. 5⅜ x 8½. (USO) 20167-8 Pa. $6.95

VICTORIAN PARLOUR POETRY: An Annotated Anthology, Michael R. Turner. 117 gems by Longfellow, Tennyson, Browning, many lesser-known poets. "The Village Blacksmith," "Curfew Must Not Ring Tonight," "Only a Baby Small," dozens more, often difficult to find elsewhere. Index of poets, titles, first lines. xxiii + 325pp. 5⅜ x 8¼. 27044-0 Pa. $8.95

DUBLINERS, James Joyce. Fifteen stories offer vivid, tightly focused observations of the lives of Dublin's poorer classes. At least one, "The Dead," is considered a masterpiece. Reprinted complete and unabridged from standard edition. 160pp. 5%₆ x 8¼.
26870-5 Pa. $1.00

THE HAUNTED MONASTERY and THE CHINESE MAZE MURDERS, Robert van Gulik. Two full novels by van Gulik, set in 7th-century China, continue adventures of Judge Dee and his companions. An evil Taoist monastery, seemingly supernatural events; overgrown topiary maze hides strange crimes. 27 illustrations. 328pp. 5⅜ x 8½. 23502-5 Pa. $8.95

THE BOOK OF THE SACRED MAGIC OF ABRAMELIN THE MAGE, translated by S. MacGregor Mathers. Medieval manuscript of ceremonial magic. Basic document in Aleister Crowley, Golden Dawn groups. 268pp. 5⅜ x 8½.
23211-5 Pa. $8.95

NEW RUSSIAN-ENGLISH AND ENGLISH-RUSSIAN DICTIONARY, M. A. O'Brien. This is a remarkably handy Russian dictionary, containing a surprising amount of information, including over 70,000 entries. 366pp. 4½ x 6⅛.
20208-9 Pa. $9.95

HISTORIC HOMES OF THE AMERICAN PRESIDENTS, Second, Revised Edition, Irvin Haas. A traveler's guide to American Presidential homes, most open to the public, depicting and describing homes occupied by every American President from George Washington to George Bush. With visiting hours, admission charges, travel routes. 175 photographs. Index. 160pp. 8¼ x 11. 26751-2 Pa. $11.95

NEW YORK IN THE FORTIES, Andreas Feininger. 162 brilliant photographs by the well-known photographer, formerly with *Life* magazine. Commuters, shoppers, Times Square at night, much else from city at its peak. Captions by John von Hartz. 181pp. 9¼ x 10¾. 23585-8 Pa. $12.95

INDIAN SIGN LANGUAGE, William Tomkins. Over 525 signs developed by Sioux and other tribes. Written instructions and diagrams. Also 290 pictographs. 111pp. 6⅛ x 9¼. 22029-X Pa. $3.95

ANATOMY: A Complete Guide for Artists, Joseph Sheppard. A master of figure drawing shows artists how to render human anatomy convincingly. Over 460 illustrations. 224pp. 8⅜ x 11¼. 27279-6 Pa. $10.95

MEDIEVAL CALLIGRAPHY: Its History and Technique, Marc Drogin. Spirited history, comprehensive instruction manual covers 13 styles (ca. 4th century thru 15th). Excellent photographs; directions for duplicating medieval techniques with modern tools. 224pp. 8⅜ x 11¼. 26142-5 Pa. $11.95

DRIED FLOWERS: How to Prepare Them, Sarah Whitlock and Martha Rankin. Complete instructions on how to use silica gel, meal and borax, perlite aggregate, sand and borax, glycerine and water to create attractive permanent flower arrangements. 12 illustrations. 32pp. 5⅜ x 8½. 21802-3 Pa. $1.00

EASY-TO-MAKE BIRD FEEDERS FOR WOODWORKERS, Scott D. Campbell. Detailed, simple-to-use guide for designing, constructing, caring for and using feeders. Text, illustrations for 12 classic and contemporary designs. 96pp. 5⅜ x 8½.
25847-5 Pa. $2.95

SCOTTISH WONDER TALES FROM MYTH AND LEGEND, Donald A. Mackenzie. 16 lively tales tell of giants rumbling down mountainsides, of a magic wand that turns stone pillars into warriors, of gods and goddesses, evil hags, powerful forces and more. 240pp. 5⅜ x 8½. 29677-6 Pa. $6.95

THE HISTORY OF UNDERCLOTHES, C. Willett Cunnington and Phyllis Cunnington. Fascinating, well-documented survey covering six centuries of English undergarments, enhanced with over 100 illustrations: 12th-century laced-up bodice, footed long drawers (1795), 19th-century bustles, 19th-century corsets for men, Victorian "bust improvers," much more. 272pp. 5⅜ x 8¼. 27124-2 Pa. $9.95

ARTS AND CRAFTS FURNITURE: The Complete Brooks Catalog of 1912, Brooks Manufacturing Co. Photos and detailed descriptions of more than 150 now very collectible furniture designs from the Arts and Crafts movement depict davenports, settees, buffets, desks, tables, chairs, bedsteads, dressers and more, all built of solid, quarter-sawed oak. Invaluable for students and enthusiasts of antiques, Americana and the decorative arts. 80pp. 6½ x 9¾. 27471-3 Pa. $7.95

HOW WE INVENTED THE AIRPLANE: An Illustrated History, Orville Wright. Fascinating firsthand account covers early experiments, construction of planes and motors, first flights, much more. Introduction and commentary by Fred C. Kelly. 76 photographs. 96pp. 8¼ x 11. 25662-6 Pa. $8.95

THE ARTS OF THE SAILOR: Knotting, Splicing and Ropework, Hervey Garrett Smith. Indispensable shipboard reference covers tools, basic knots and useful hitches; handsewing and canvas work, more. Over 100 illustrations. Delightful reading for sea lovers. 256pp. 5⅜ x 8½. 26440-8 Pa. $7.95

FRANK LLOYD WRIGHT'S FALLINGWATER: The House and Its History, Second, Revised Edition, Donald Hoffmann. A total revision—both in text and illustrations—of the standard document on Fallingwater, the boldest, most personal architectural statement of Wright's mature years, updated with valuable new material from the recently opened Frank Lloyd Wright Archives. "Fascinating"—*The New York Times*. 116 illustrations. 128pp. 9¼ x 10¾. 27430-6 Pa. $11.95

AUTOBIOGRAPHY: The Story of My Experiments with Truth, Mohandas K. Gandhi. Boyhood, legal studies, purification, the growth of the Satyagraha (nonviolent protest) movement. Critical, inspiring work of the man responsible for the freedom of India. 480pp. 5⅜ x 8½. (USO) 24593-4 Pa. $8.95

CELTIC MYTHS AND LEGENDS, T. W. Rolleston. Masterful retelling of Irish and Welsh stories and tales. Cuchulain, King Arthur, Deirdre, the Grail, many more. First paperback edition. 58 full-page illustrations. 512pp. 5⅜ x 8½. 26507-2 Pa. $9.95

THE PRINCIPLES OF PSYCHOLOGY, William James. Famous long course complete, unabridged. Stream of thought, time perception, memory, experimental methods; great work decades ahead of its time. 94 figures. 1,391pp. 5⅜ x 8½. 2-vol. set.
Vol. I: 20381-6 Pa. $12.95
Vol. II: 20382-4 Pa. $12.95

THE WORLD AS WILL AND REPRESENTATION, Arthur Schopenhauer. Definitive English translation of Schopenhauer's life work, correcting more than 1,000 errors, omissions in earlier translations. Translated by E. F. J. Payne. Total of 1,269pp. 5⅜ x 8½. 2-vol. set.
Vol. 1: 21761-2 Pa. $11.95
Vol. 2: 21762-0 Pa. $11.95

MAGIC AND MYSTERY IN TIBET, Madame Alexandra David-Neel. Experiences among lamas, magicians, sages, sorcerers, Bonpa wizards. A true psychic discovery. 32 illustrations. 321pp. 5⅜ x 8½. (USO) 22682-4 Pa. $8.95

THE EGYPTIAN BOOK OF THE DEAD, E. A. Wallis Budge. Complete reproduction of Ani's papyrus, finest ever found. Full hieroglyphic text, interlinear transliteration, word-for-word translation, smooth translation. 533pp. 6½ x 9¼. 21866-X Pa. $10.95

MATHEMATICS FOR THE NONMATHEMATICIAN, Morris Kline. Detailed, college-level treatment of mathematics in cultural and historical context, with numerous exercises. Recommended Reading Lists. Tables. Numerous figures. 641pp. 5⅜ x 8½. 24823-2 Pa. $11.95

THEORY OF WING SECTIONS: Including a Summary of Airfoil Data, Ira H. Abbott and A. E. von Doenhoff. Concise compilation of subsonic aerodynamic characteristics of NACA wing sections, plus description of theory. 350pp. of tables. 693pp. 5⅜ x 8½. 60586-8 Pa. $14.95

THE RIME OF THE ANCIENT MARINER, Gustave Doré, S. T. Coleridge. Doré's finest work; 34 plates capture moods, subtleties of poem. Flawless full-size reproductions printed on facing pages with authoritative text of poem. "Beautiful. Simply beautiful."—*Publisher's Weekly.* 77pp. 9¼ x 12. 22305-1 Pa. $6.95

NORTH AMERICAN INDIAN DESIGNS FOR ARTISTS AND CRAFTSPEOPLE, Eva Wilson. Over 360 authentic copyright-free designs adapted from Navajo blankets, Hopi pottery, Sioux buffalo hides, more. Geometrics, symbolic figures, plant and animal motifs, etc. 128pp. 8⅜ x 11. (EUK) 25341-4 Pa. $8.95

SCULPTURE: Principles and Practice, Louis Slobodkin. Step-by-step approach to clay, plaster, metals, stone; classical and modern. 253 drawings, photos. 255pp. 8⅛ x 11. 22960-2 Pa. $10.95

PHOTOGRAPHIC SKETCHBOOK OF THE CIVIL WAR, Alexander Gardner. 100 photos taken on field during the Civil War. Famous shots of Manassas Harper's Ferry, Lincoln, Richmond, slave pens, etc. 244pp. 10⅝ x 8¼. 22731-6 Pa. $9.95

FIVE ACRES AND INDEPENDENCE, Maurice G. Kains. Great back-to-the-land classic explains basics of self-sufficient farming. The one book to get. 95 illustrations. 397pp. 5⅜ x 8½. 20974-1 Pa. $7.95

SONGS OF EASTERN BIRDS, Dr. Donald J. Borror. Songs and calls of 60 species most common to eastern U.S.: warblers, woodpeckers, flycatchers, thrushes, larks, many more in high-quality recording. Cassette and manual 99912-2 $8.95

A MODERN HERBAL, Margaret Grieve. Much the fullest, most exact, most useful compilation of herbal material. Gigantic alphabetical encyclopedia, from aconite to zedoary, gives botanical information, medical properties, folklore, economic uses, much else. Indispensable to serious reader. 161 illustrations. 888pp. 6½ x 9¼. 2-vol. set. (USO) Vol. I: 22798-7 Pa. $9.95
Vol. II: 22799-5 Pa. $9.95

HIDDEN TREASURE MAZE BOOK, Dave Phillips. Solve 34 challenging mazes accompanied by heroic tales of adventure. Evil dragons, people-eating plants, bloodthirsty giants, many more dangerous adversaries lurk at every twist and turn. 34 mazes, stories, solutions. 48pp. 8¼ x 11. 24566-7 Pa. $2.95

LETTERS OF W. A. MOZART, Wolfgang A. Mozart. Remarkable letters show bawdy wit, humor, imagination, musical insights, contemporary musical world; includes some letters from Leopold Mozart. 276pp. 5⅜ x 8½. 22859-2 Pa. $7.95

BASIC PRINCIPLES OF CLASSICAL BALLET, Agrippina Vaganova. Great Russian theoretician, teacher explains methods for teaching classical ballet. 118 illustrations. 175pp. 5⅜ x 8½. 22036-2 Pa. $5.95

THE JUMPING FROG, Mark Twain. Revenge edition. The original story of The Celebrated Jumping Frog of Calaveras County, a hapless French translation, and Twain's hilarious "retranslation" from the French. 12 illustrations. 66pp. 5⅜ x 8½. 22686-7 Pa. $3.95

BEST REMEMBERED POEMS, Martin Gardner (ed.). The 126 poems in this superb collection of 19th- and 20th-century British and American verse range from Shelley's "To a Skylark" to the impassioned "Renascence" of Edna St. Vincent Millay and to Edward Lear's whimsical "The Owl and the Pussycat." 224pp. 5⅜ x 8½. 27165-X Pa. $4.95

COMPLETE SONNETS, William Shakespeare. Over 150 exquisite poems deal with love, friendship, the tyranny of time, beauty's evanescence, death and other themes in language of remarkable power, precision and beauty. Glossary of archaic terms. 80pp. 5¾₆ x 8¼. 26686-9 Pa. $1.00

BODIES IN A BOOKSHOP, R. T. Campbell. Challenging mystery of blackmail and murder with ingenious plot and superbly drawn characters. In the best tradition of British suspense fiction. 192pp. 5⅜ x 8½. 24720-1 Pa. $6.95

THE WIT AND HUMOR OF OSCAR WILDE, Alvin Redman (ed.). More than 1,000 ripostes, paradoxes, wisecracks: Work is the curse of the drinking classes; I can resist everything except temptation; etc. 258pp. 5⅜ x 8½.　　　20602-5 Pa. $5.95

SHAKESPEARE LEXICON AND QUOTATION DICTIONARY, Alexander Schmidt. Full definitions, locations, shades of meaning in every word in plays and poems. More than 50,000 exact quotations. 1,485pp. 6½ x 9¼. 2-vol. set.
Vol. 1: 22726-X Pa. $16.95
Vol. 2: 22727-8 Pa. $16.95

SELECTED POEMS, Emily Dickinson. Over 100 best-known, best-loved poems by one of America's foremost poets, reprinted from authoritative early editions. No comparable edition at this price. Index of first lines. 64pp. 5³⁄₁₆ x 8¼.
26466-1 Pa. $1.00

CELEBRATED CASES OF JUDGE DEE (DEE GOONG AN), translated by Robert van Gulik. Authentic 18th-century Chinese detective novel; Dee and associates solve three interlocked cases. Led to van Gulik's own stories with same characters. Extensive introduction. 9 illustrations. 237pp. 5⅜ x 8½.　　　23337-5 Pa. $6.95

THE MALLEUS MALEFICARUM OF KRAMER AND SPRENGER, translated by Montague Summers. Full text of most important witchhunter's "bible," used by both Catholics and Protestants. 278pp. 6⅝ x 10.　　　22802-9 Pa. $12.95

SPANISH STORIES/CUENTOS ESPAÑOLES: A Dual-Language Book, Angel Flores (ed.). Unique format offers 13 great stories in Spanish by Cervantes, Borges, others. Faithful English translations on facing pages. 352pp. 5⅜ x 8½.
25399-6 Pa. $8.95

THE CHICAGO WORLD'S FAIR OF 1893: A Photographic Record, Stanley Appelbaum (ed.). 128 rare photos show 200 buildings, Beaux-Arts architecture, Midway, original Ferris Wheel, Edison's kinetoscope, more. Architectural emphasis; full text. 116pp. 8¼ x 11.　　　23990-X Pa. $9.95

OLD QUEENS, N.Y., IN EARLY PHOTOGRAPHS, Vincent F. Seyfried and William Asadorian. Over 160 rare photographs of Maspeth, Jamaica, Jackson Heights, and other areas. Vintage views of DeWitt Clinton mansion, 1939 World's Fair and more. Captions. 192pp. 8⅞ x 11.　　　26358-4 Pa. $12.95

CAPTURED BY THE INDIANS: 15 Firsthand Accounts, 1750-1870, Frederick Drimmer. Astounding true historical accounts of grisly torture, bloody conflicts, relentless pursuits, miraculous escapes and more, by people who lived to tell the tale. 384pp. 5⅜ x 8½.　　　24901-8 Pa. $8.95

THE WORLD'S GREAT SPEECHES, Lewis Copeland and Lawrence W. Lamm (eds.). Vast collection of 278 speeches of Greeks to 1970. Powerful and effective models; unique look at history. 842pp. 5⅜ x 8½.　　　20468-5 Pa. $14.95

THE BOOK OF THE SWORD, Sir Richard F. Burton. Great Victorian scholar/adventurer's eloquent, erudite history of the "queen of weapons"—from prehistory to early Roman Empire. Evolution and development of early swords, variations (sabre, broadsword, cutlass, scimitar, etc.), much more. 336pp. 6⅛ x 9¼.
25434-8 Pa. $9.95

THE INFLUENCE OF SEA POWER UPON HISTORY, 1660–1783, A. T. Mahan. Influential classic of naval history and tactics still used as text in war colleges. First paperback edition. 4 maps. 24 battle plans. 640pp. 5⅜ x 8½. 25509-3 Pa. $12.95

THE STORY OF THE TITANIC AS TOLD BY ITS SURVIVORS, Jack Winocour (ed.). What it was really like. Panic, despair, shocking inefficiency, and a little heroism. More thrilling than any fictional account. 26 illustrations. 320pp. 5⅜ x 8½.
20610-6 Pa. $8.95

FAIRY AND FOLK TALES OF THE IRISH PEASANTRY, William Butler Yeats (ed.). Treasury of 64 tales from the twilight world of Celtic myth and legend: "The Soul Cages," "The Kildare Pooka," "King O'Toole and his Goose," many more. Introduction and Notes by W. B. Yeats. 352pp. 5⅜ x 8½. 26941-8 Pa. $8.95

BUDDHIST MAHAYANA TEXTS, E. B. Cowell and Others (eds.). Superb, accurate translations of basic documents in Mahayana Buddhism, highly important in history of religions. The Buddha-karita of Asvaghosha, Larger Sukhavativyuha, more. 448pp. 5⅜ x 8½. 25552-2 Pa. $9.95

ONE TWO THREE . . . INFINITY: Facts and Speculations of Science, George Gamow. Great physicist's fascinating, readable overview of contemporary science: number theory, relativity, fourth dimension, entropy, genes, atomic structure, much more. 128 illustrations. Index. 352pp. 5⅜ x 8½. 25664-2 Pa. $8.95

ENGINEERING IN HISTORY, Richard Shelton Kirby, et al. Broad, nontechnical survey of history's major technological advances: birth of Greek science, industrial revolution, electricity and applied science, 20th-century automation, much more. 181 illustrations. ". . . excellent . . ."–*Isis.* Bibliography. vii + 530pp. 5⅜ x 8¼.
26412-2 Pa. $14.95

DALÍ ON MODERN ART: The Cuckolds of Antiquated Modern Art, Salvador Dalí. Influential painter skewers modern art and its practitioners. Outrageous evaluations of Picasso, Cézanne, Turner, more. 15 renderings of paintings discussed. 44 calligraphic decorations by Dalí. 96pp. 5⅜ x 8½. (USO) 29220-7 Pa. $4.95

ANTIQUE PLAYING CARDS: A Pictorial History, Henry René D'Allemagne. Over 900 elaborate, decorative images from rare playing cards (14th–20th centuries): Bacchus, death, dancing dogs, hunting scenes, royal coats of arms, players cheating, much more. 96pp. 9¼ x 12¼. 29265-7 Pa. $11.95

MAKING FURNITURE MASTERPIECES: 30 Projects with Measured Drawings, Franklin H. Gottshall. Step-by-step instructions, illustrations for constructing handsome, useful pieces, among them a Sheraton desk, Chippendale chair, Spanish desk, Queen Anne table and a William and Mary dressing mirror. 224pp. 8⅛ x 11¼.
29338-6 Pa. $13.95

THE FOSSIL BOOK: A Record of Prehistoric Life, Patricia V. Rich et al. Profusely illustrated definitive guide covers everything from single-celled organisms and dinosaurs to birds and mammals and the interplay between climate and man. Over 1,500 illustrations. 760pp. 7½ x 10⅛. 29371-8 Pa. $29.95

Prices subject to change without notice.
Available at your book dealer or write for free catalog to Dept. GI, Dover Publications, Inc., 31 East 2nd St., Mineola, N.Y. 11501. Dover publishes more than 500 books each year on science, elementary and advanced mathematics, biology, music, art, literary history, social sciences and other areas.